THE GREAT BOOK OF
DRAWING
Zentangle®

How to create amazing designs

JANE MARBAIX

SIRIUS

SIRIUS

This edition published in 2024 by Sirius Publishing, a division of Arcturus Publishing Limited,
26/27 Bickels Yard, 151–153 Bermondsey Street,
London SE1 3HA

ISBN: 978-1-3988-3520-7
AD011493US

Printed in China

THE GREAT BOOK OF
DRAWING
Zentangle®

Contents

The philosophy of Zentangle

The Zentangle mantra is "Anything is possible, one stroke at a time"—a philosophy that both inspires confidence and instils a sense of calm. This form of art is one that can be practiced successfully by everyone, for even if you think you have no drawing skills you will soon discover that you can achieve lovely results. One of the keys to Zentangle art is always to relax and take your time; the focus is on the present moment, never on the result. It is all about the journey, not the destination.

The Zentangle method was created by Maria Thomas, a talented lettering and botanical artist, and Rick Roberts, the zen of the partnership, having lived as a monk for a period of his life. Rick noticed that while Maria was working she was in a very calm, focused state, so they set about breaking down the patterns they created in an easy-to-follow format so that anyone could create beautiful images by repeating the patterns, known as tangles. Thus, the Zentangle method was born.

Zentangle art is created on a tile which is 9 cm (3½ in) square. The official Zentangle tile is created from Fabriano Tiepolo paper (available from good art shops and online), but some tanglers just use good-quality card stock. In fact, you can tangle on anything, but good materials make all the difference. An artwork bigger than 9 cm (3½ in) square is categorized as Zentangle Inspired Art (ZIA).

You can begin making tangles with just a soft pencil, an 01 (0.25 mm) black pen (my preference is for Sakura Pigma Micron) and a blending stump, also known as a tortillon. An 08 (0.50 mm) pen or Pigma Graphic 1 is ideal for darker areas. I also use stencils and rubber stamps, and for this book a compass and protractor are handy. A good starting point is the kit available from www.zentangle.com.

Dreamweaver metal stencils come in a wide range of amazing designs (example left), created by Lynell Harlow. Her husband, Wayne, has done the most beautiful work transforming them (below).

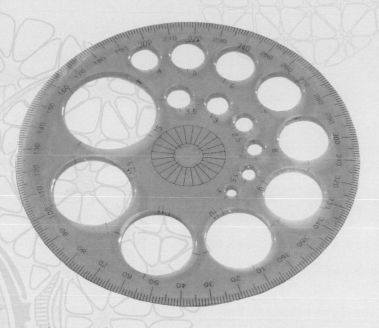

Zentangle is a mindful way of self-expression that lends itself to the creation of imagery that aids meditation or at the very least puts the maker into a very calm state of mind. Tangling enables us to create a safe and joyful inner space even when real life may be confronting us with difficult challenges.

In this book you will find a great selection of Zentangle projects to inspire you. They include many items based around mandalas—or Zendalas—which are much more free-form than traditional mandalas. There are many inspirational designs as well as a library of tangles, many of them created by leading practitioners. Many of the Zentangle artists whose designs are shown here have shared their inspirations and tips that they use when producing new designs.

We hope you derive hours of calm and creativity from the designs contained in this book.

A protractor (above) is a useful tool for creating mandalas. The inner circle of the Zendala below was made with the help of one.

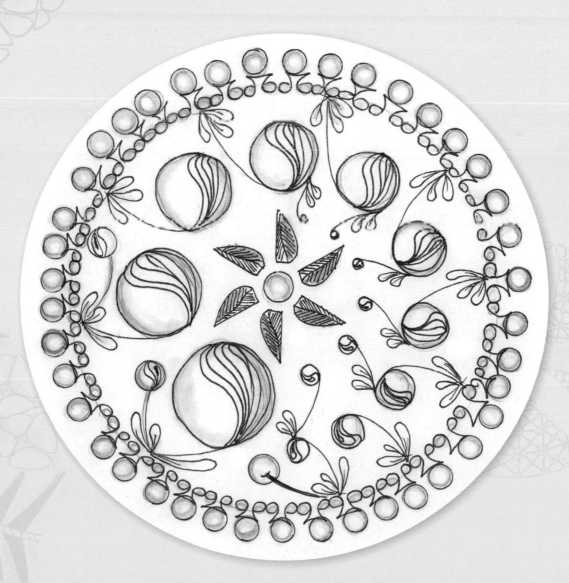

Getting started with tangles

In the Zentangle method, tangles (patterns) are broken down into simple steps so that it is easy to re-create each tangle. Each tile (or square piece of card) is divided into spaces by "strings" and each space will have a different tangle in it. There are many tangles to choose from. In the tiles below, Crescent Moon, Tortuca, Poke Root, and Tipple are used, all of them original Zentangle patterns created by Rick Roberts and Maria Thomas or their daughter, Molly Hollibaugh.

Tile No. 1 with Z string

Draw a pencil line, known as a string, to create spaces within the tile. Here we shall draw a string in the shape of a Z.

Using your pencil, draw a dot in each corner of the tile.

Join up the dots lightly with your pencil to form a border (this line does not need to be straight).

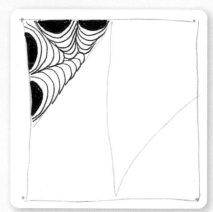

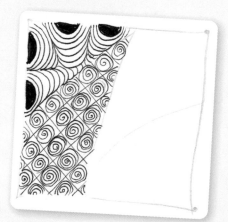

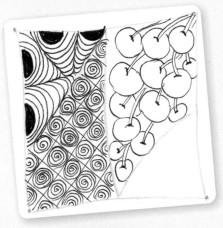

Then draw Poke Root.

Now take your pen (Sakura Pigma Micron 01 black), choose a tangle and fill one of the spaces you have created. The first tangle used here is Crescent Moon, put in the top left-hand corner space.

Next, draw Tortuca.

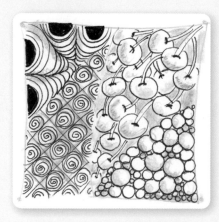

Lastly, draw Tipple in the remaining space, making different-sized circles for a pleasing effect. Now shade the completed tile with your pencil.

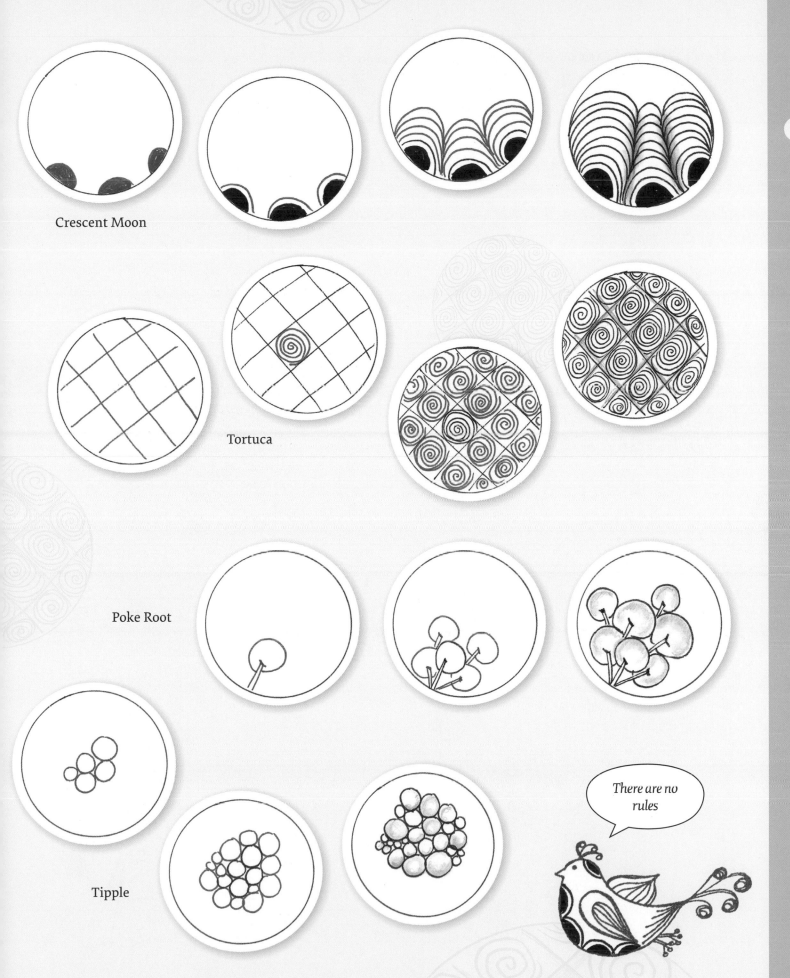

Crescent Moon

Tortuca

Poke Root

Tipple

There are no rules

Tile No. 2 with triangle string

Start this string the same way as the first one, by making a dot in each corner and drawing a line between the dots. This string is in the shape of a triangle—it doesn't need to be a uniform shape. This will give you four spaces for your tangles.

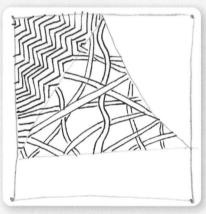

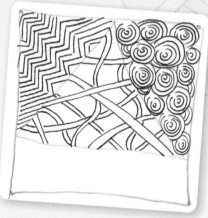

In the first space draw Static, which looks simple but can be greatly enhanced with shading to give it a three-dimensional look. In the final step opposite I have used two different types of shading.

The next space will be the central triangle, filled in with Hollibaugh. You can make the lines straight or wavy, thick, or thin.

Next is Printemps in the top right-hand corner. Go slowly with this tangle, leaving a small gap in the lines to create a highlight.

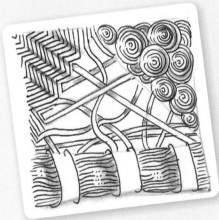

The tangle at the bottom of the tile is Zander. Create highlights by leaving some gaps between the lines, with two or three dots in the gap. Finally, shade the tangles.

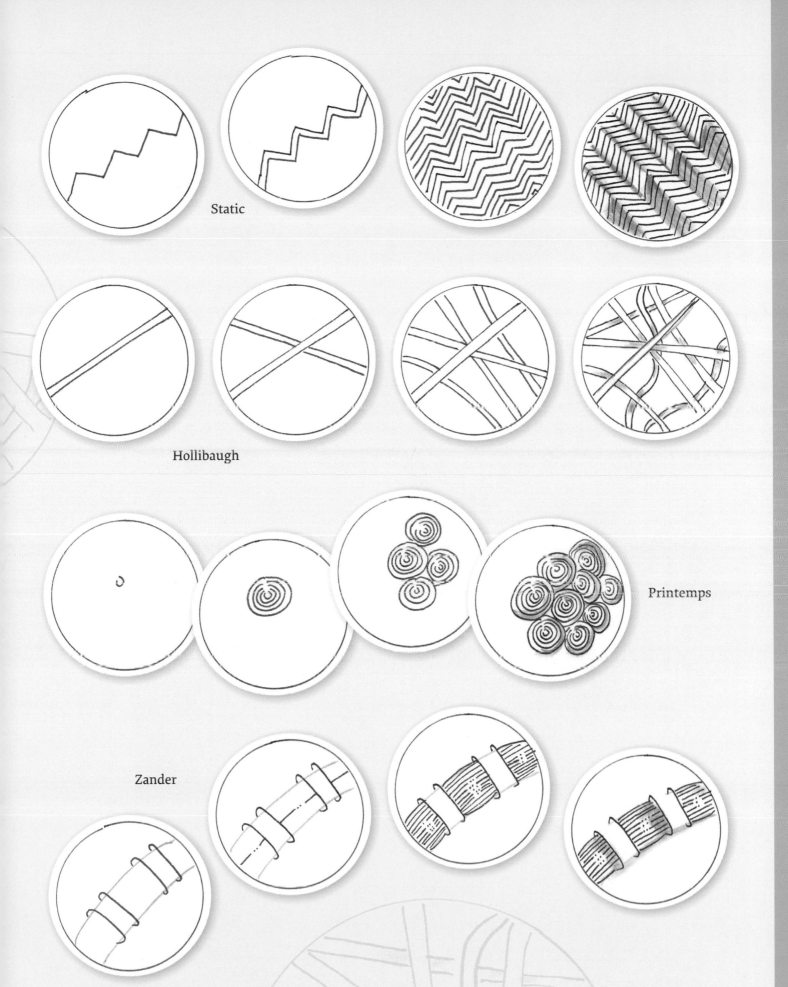

Static

Hollibaugh

Printemps

Zander

Strings

You can easily create your own strings for your Zentangle tiles, but if you want inspiration, go to www.tanglepatterns.com and look up Strings in the alphabetical list of tangles at the top of the page. There you will find about 200 strings. Here are six to get you started.

1 String 003

2 String 008

3 String 018

4 String 049

5 String 025

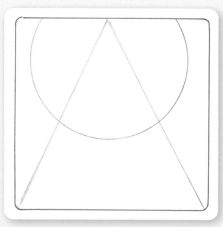

6 String 028

Try using just one of these strings to make a few tiles and see how different they can look depending on the tangles you have chosen and which way up they are. You'll soon begin to realize the huge variety of images you could make by using all six.

These are the examples I have done using some of the strings shown opposite—two from each to demonstrate how designs from the same string can look very different. The top two are string 049; the middle two are 018 and the bottom two are both 025.

One stroke at a time

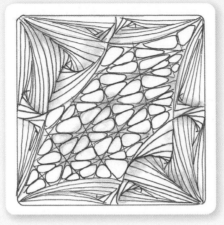

Paradox and 'NZeppel

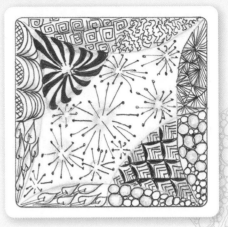

Crescent Moon variation, Pepper, Amaze, Aah, Munchin, Warble, Tipple, and Poke Leaf

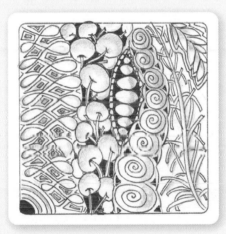

Ynix, Verdigogh, Poke Root, Snails, and Echoism

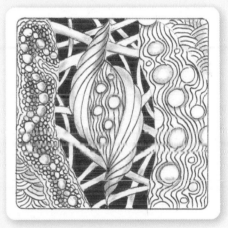

Quibble, Hollibaugh, Abundies (Nipa in the middle), and Shattuck

Macramé, Maryhill, Marasu, Msst, and Printemps

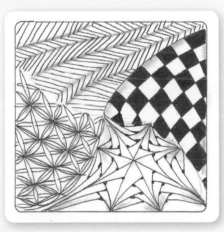

Static, Knightsbridge, Fife, and Betweed

Shading

Shading gives a real sense of three dimensions to a tangle and I find it contributes to the enjoyment of tangling as well as adding to the final artwork. An artist drawing objects will study where the light comes from and shade accordingly, but because there is no right way up or down with Zentangle you just go by what suits the shape of the tangle when it comes to shading.

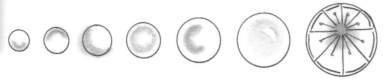

Circles These can be shaded in many different ways, depending on the look you want. The tangles here are Poke Root, Mooka, and Marbaix.

Ovals The tangles used here to demonstrate the shading of oval shapes are Sparkle and Poke Leaf.

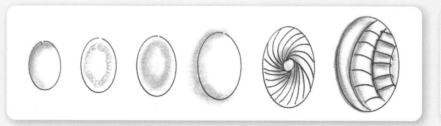

Squares Cubine is a good example of a square tangle. These drawings show different ways of adding shading to Cubine as well as to a straightforward square and a cube (far left).

Triangles Paradox is a tangle often done in triangular shapes. Shading makes it appear to have different planes.

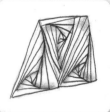

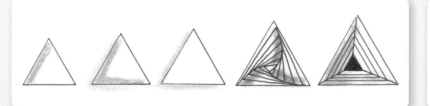

Curves Shading a curved line can give the appearance of "mountains" and "valleys." If one lies behind another you can shade where a shadow would naturally be formed. Zander is fun to shade on the curved area around the "bands."

Enhancements

Enhancements really add something to your creations and make them more exciting. Many tangles naturally have auras, such as Crescent Moon and Frondous, but you can add an aura to any tangle to create light in your work. Sparkle can be added to many tangles by just leaving a little gap, as in Printemps or Zander. Shading enhances your work more than anything else and you will find many books on the art of shading to explore.

Auras Shown left, Poke Root with an aura; below, Btl Joos can be added to an aura as a variation.

Sparkle This is achieved by leaving a gap or pausing while drawing your tangle. The illustrations here are Printemps and Static with and without a sparkle, plus Shattuck.

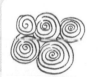

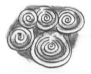

Shading Adding depth with grey tones is done with pencil after completing your tangle. The tangles here are Knightsbridge, Printemps, and Shattuck.

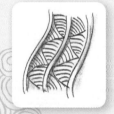

Rounding Darkening the crevices of a tangle with a pen is another way of adding depth.

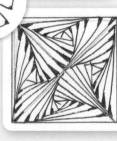

Perfs These pearl-like dots are little circles that form an aura around a tangle.

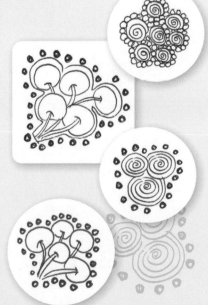

Dew drops This clever enhancement is a matter of drawing a magnified version of a tangle.

Adding dew drops to your Zentangle drawings

LYNN MEAD CZT

Lynn Mead chose to show dew drops for a project because, although they are one of the six tangle enhancers taught as part of the Zentangle method, most tanglers seem intimidated by them. In reality they are fairly easy if you break them down into manageable steps, and they provide a very dramatic effect. You can use them with many tangles; Lynn thinks they work particularly well with a botanical theme, so that is what she decided to do for her example tile.

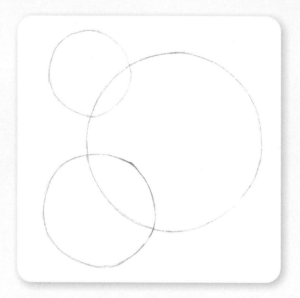

1 Using a pencil, draw your string.

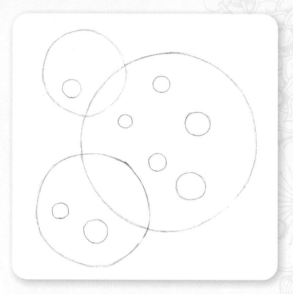

2 Draw some circles to indicate where your dew drops will be on the finished drawing.

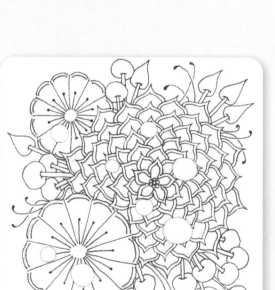

3 Using your pen, draw tangles as usual, making sure you stop and start your lines at the edges of where your dew drops will be. Leave the area defined for dew drops empty for now.

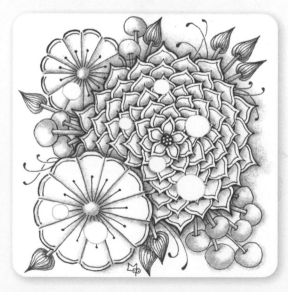

4 Using your pencil, shade your tangles as you normally would, again leaving the area defined for dew drops empty.

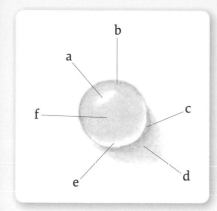

5 With your pencil, shade each dew drop as follows:

a Leave an area white for the highlight.

b Define the edge on the side with the highlight with a thin dark pencil line.

c Define the edge opposite the highlight with a darker shadow.

d Extend the shadow outwards, fading it away from the dew drop.

e Leave a white area along the inside edge opposite the highlight.

f Fill in the rest of the dew drop with a mid-grey tone. Do not make this grey too light as it is what defines the highlight. Use a tortillion (paper stump) to smooth the pencil, leaving the lines defining the edges sharp.

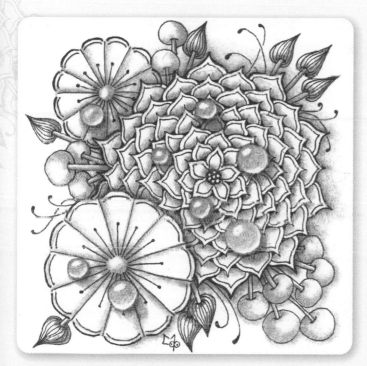

Tile with dew drop shaded

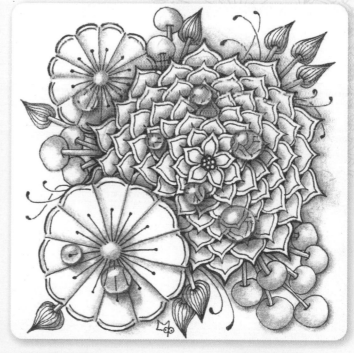

6 With your pen, add the lines from the underlying tangle, making sure you do not draw where the highlight is—it must remain white. Dew drops magnify what is beneath. To achieve this effect, increase the spacing between lines. Stop the lines just short of the edge of the dew drop. Remember to stop and start your lines at the edges of the highlight.

Tangles used:
Marbaix, Cyme, Poke Root, Poke Leaf variation, and Fescue.

Borders

Making a border around your artwork can be fun, whether you want to frame a quote or maybe a photo. You can pick a single tangle or draw several on one frame. Draw an outline of the border in pencil if you like, or just go with the flow.

Here are three beautiful frames drawn by Lesley Roberts CZT. The first has a square drawn inside a larger square and then filled in with Poke Leaf, Printemps, and Onamato.

The second one is a Poke Leaf with Tipple design. The shading is a real feature in this tile, leaving a small space in the middle.

The third tile has a little frame in the middle with a heart design around it. The tangle around the outside is Printemps.

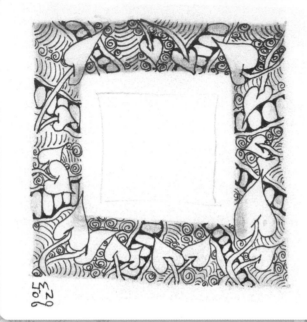

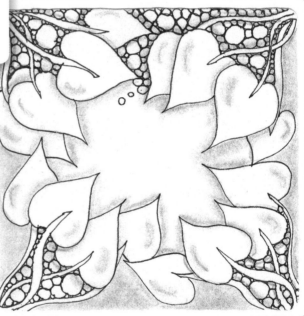

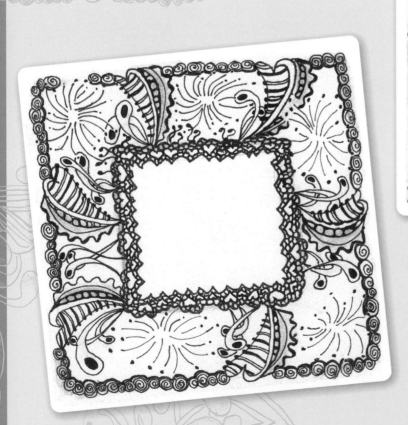

Here I have done four tiles with borders. These tiles are quite quick to do. The first one is just Mooka, which could be colored as well; the second one is Heartline, done as a border and also in a flowery way on the left-hand side. The third tile is Steps, colored with a Koh-I-Noor Magic Pencil and with a little sparkle added with Stickles Glitter Glue, while the fourth tile is a simple one with Poke Root and Poke Leaf. All these tiles would be good colored if you wanted to mount them on to a blank card.

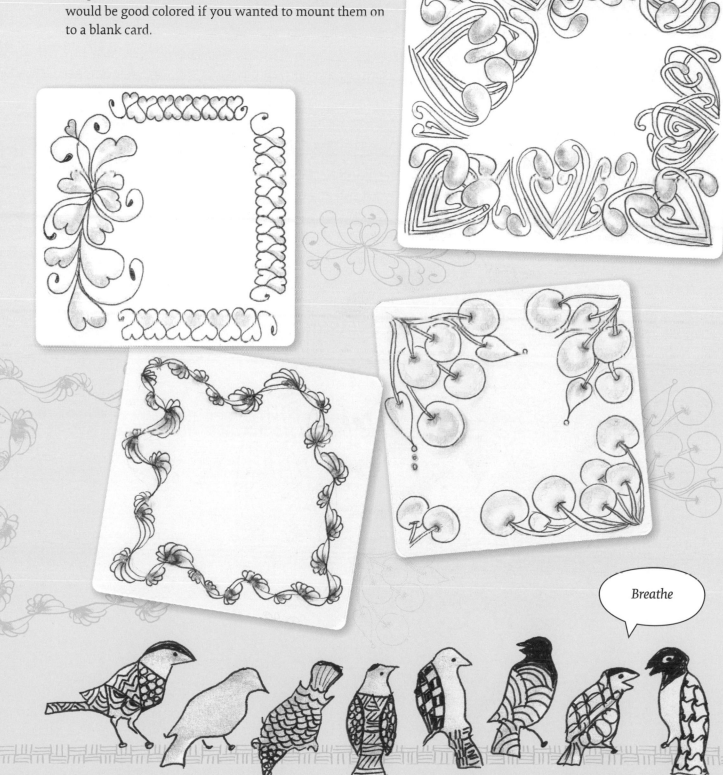

Random strings

Using a circular protractor, make a circle and then draw some random strings—just go with the flow and then fill in with tangles. Strings are only guidelines and you don't need to keep strictly within their borders. I have used Crescent Moon, Poke Root, Static, Zander, Tipple, Hollibaugh, and Tortuca tangles.

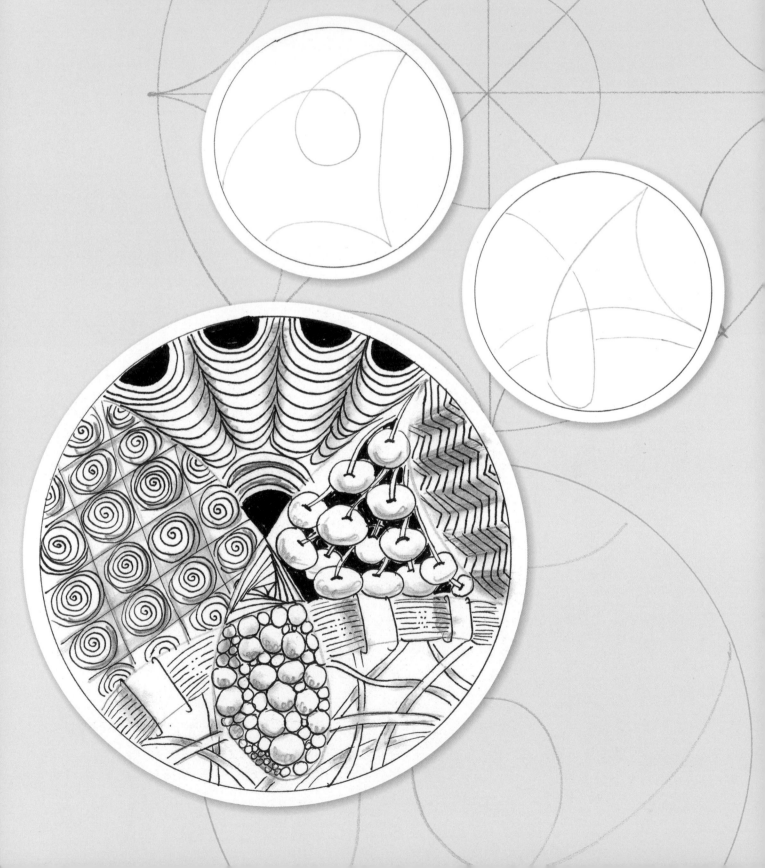

Making a Zendala

The next step is a Zendala with a random string. There is no set pattern to this—just draw a circle with your circular protractor and then use it to draw semi-circles anywhere and any which way within the outer circle.

The tangles used here are Crescent Moon, N'Zeppel, Florz (variation), Flux, Meer, Onamato, Poke Leaf, Hollibaugh filled in with a bit of Tipple and black background, Poke Root, and Paradox. It is surprising just how many tangles you can fit in one circle.

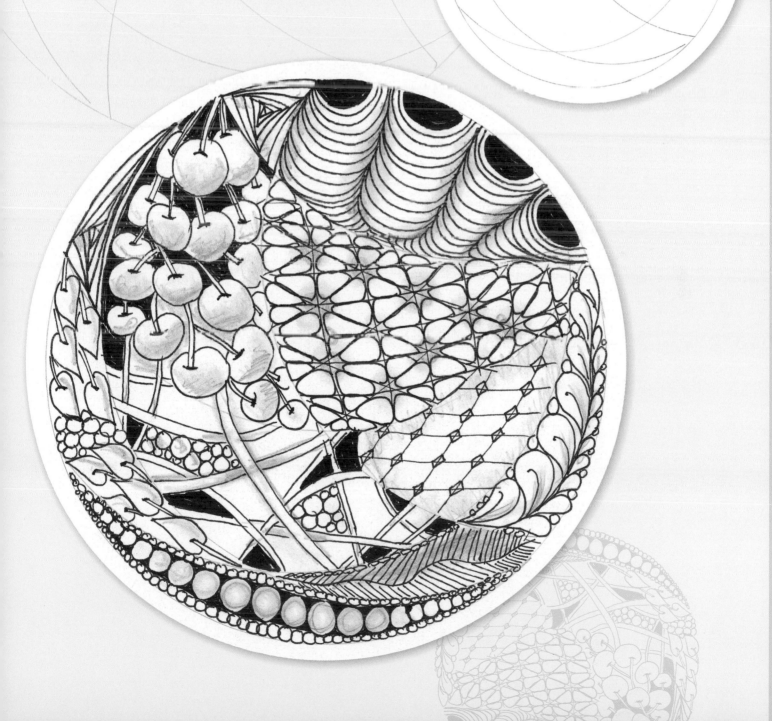

Using a compass

This is one of the simplest forms to make with a compass. Draw a circle, then make a point on the circle and draw a part circle going through the center. Next, place the point of the compass at the end of the circle you have drawn and draw another part circle. Continue in this way all round the circle until you have formed a flower shape. The "petals" can be filled in with tangles or you can leave them blank and fill in the background. The top circle has Tipple and N'Zeppel; below, I have used Fassett in the background, and Marbaix on the petals.

45-degree mandala

To create a true mandala, use a compass to draw the outer size you would like. Mark points on the circumference at each 45 degrees and then draw lines through the circle to divide the mandala into eight equal parts. Here I used my protractor to draw some semi-circles between the spaces and add a circle in the middle.

I started in the center, which is where one often starts drawing a mandala. I used the tangle Maryfield, then added another line beside the ones I had already drawn and drew these lines in pen. I added some small circles for effect and then used the tangle Betweed in between the lines, and a variation of Marbaix in the semi-circles around the edge.

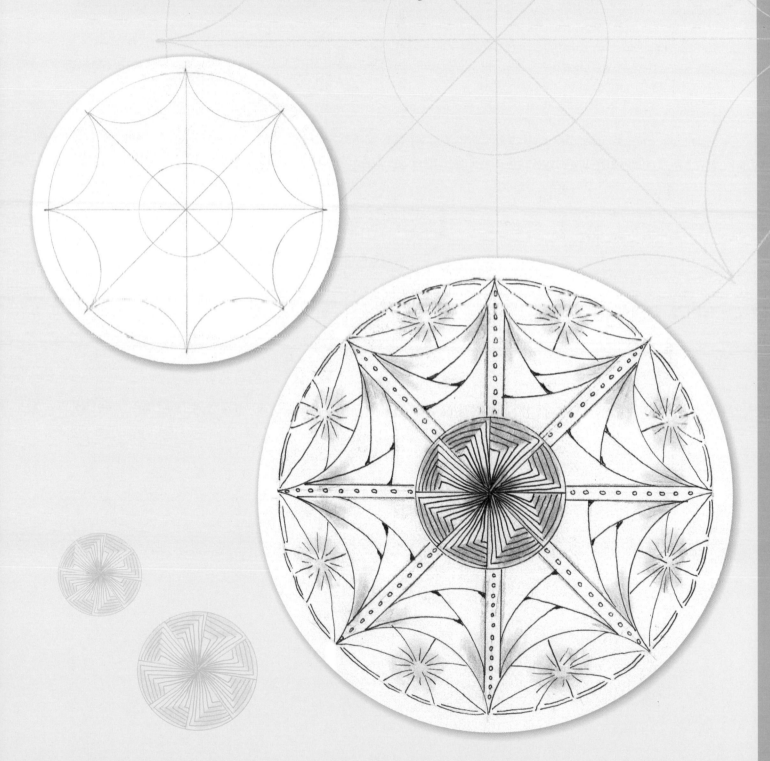

Decorating letters and numbers

You can create attractive effects by decorating letters and numbers for yourself or for gifts. One way to do this is to buy balsawood ones, cover them with some acrylic paint and then tangle them with a Micron pen or a fine Sharpie. Here I have decorated an R and an M in honour of Rick and Maria! They are colored with a Koh-I-Noor Magic Pencil.

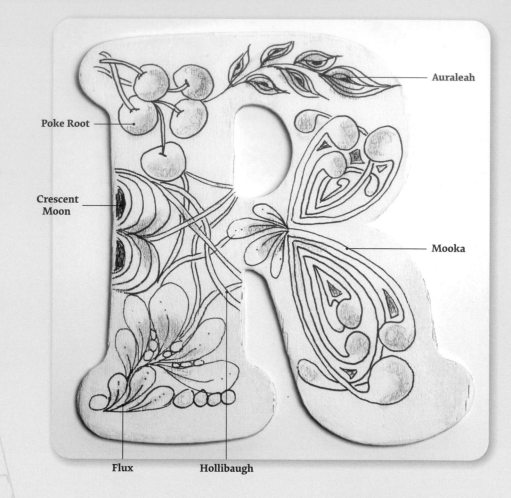

Auraleah

Poke Root

Crescent Moon

Mooka

Flux Hollibaugh

Ahh

Marbaix

W2

Yew-dee

Flux and Stipple

Yincut Mooka

Tangles used:
R: Poke Root, Auraleah, Mooka, Crescent Moon, Hollibaugh, and Flux.

M: Ahh, Flux and Stipple, Marbaix, Mooka, W2, Yew-dee, Yincut.

If you prefer to decorate letters and numbers on card, make broad shapes to allow you plenty of room on which to draw your tangles. These designs are by Maria Vennekens.

Making cards

Handmade cards are always appreciated by the recipient as they signify that you have put time and effort into the card rather than just buying one from a shop. Using a name or initials adds an extra personal touch. You can find stencils online or just draw letters freehand in a style to suit you. It's your choice as to how simple or complex your tangling is—either approach can look great.

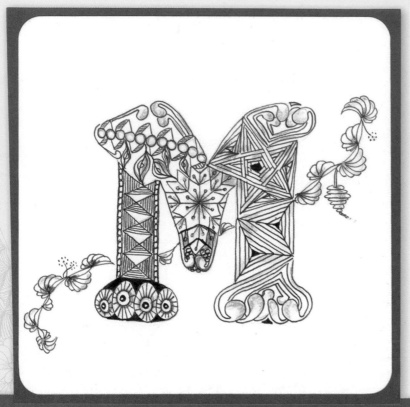

This card has a lot of tangles but you could do it with a single tangle. The tangles used are Auseklis, Auraknot, Paradox, Fassett, Mooka, Avreal, Bookee, and Auraleah.

The tangle outside the M is Steps, with a Zinger hanging from it.

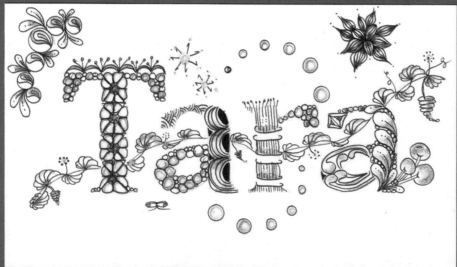

The TARA card also has many tangles, as follows:

T: Puff Border, Tipple, 'NZeppel;
A: Shattuck, Crescent Moon, Tipple;
R: Zander, Tipple;
A: Fassett, Flux, Mooka.

The outer decoration is with Cruffle, Flux, Garlic Cloves, Steps, and Antz.

Shaped cards offer an attractive start to your tangling. You will be able to find them in craft shops. The tangles I used for this butterfly are Showgirl in the middle, and Steps and Sails for the wings.

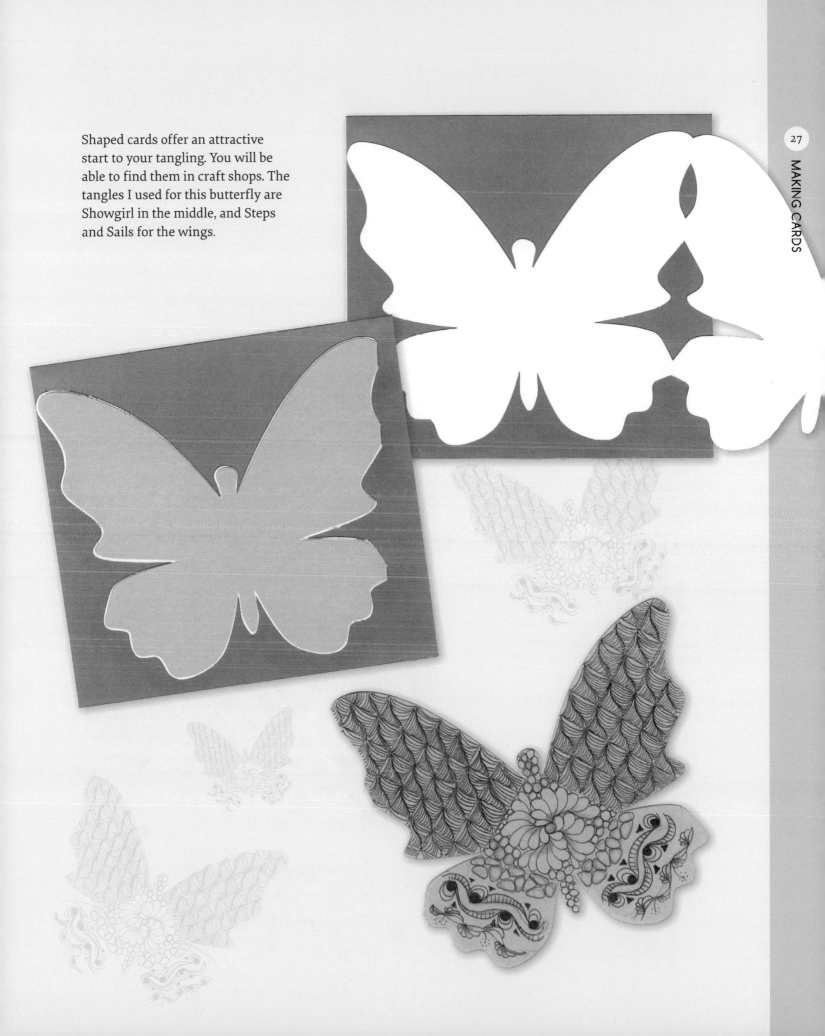

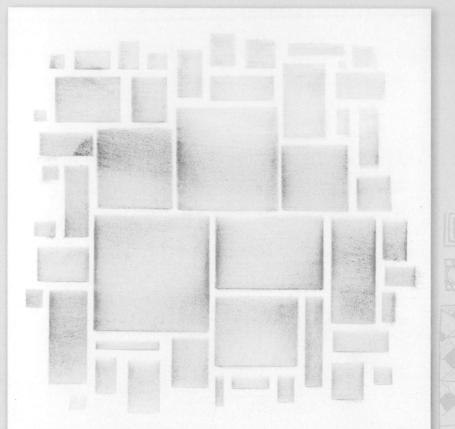

Clarity Stamps

Stencils offer a good start for tangle designs. Clarity Stamps produce a great range that can be used in many different ways.

This stencil has a variety of squares and rectangles. You can use a Clarity stencil brush to color the background through the stencil first if you wish (above) and then tangle the shapes. The one I have tangled here is without the background color and shaded in pencil for a monochrome design. Many tangles are used here, including Zander, Emingle, Printemps, Fescu, Tipple, Kathy's Dilemma, Copada, Flukes, Flux, Onamato, W2, Doodleedo, Bales, Cubine, 'NZeppel, Betweed, BB, Msst, Hibred, Hollibaugh, Mooka, Crescent Moon, Fassett, Paradox, Barberpole, and Knightsbridge.

Rectangle stencil

This is an interesting Clarity stencil because it can be used in two ways: first just by tracing the outlines in pen before tangling the spaces (see right) or, as in the one below, joining the lines to make it into Hollibaugh, with bands going over and under, before adding the tangles. The bands could also be tangled.

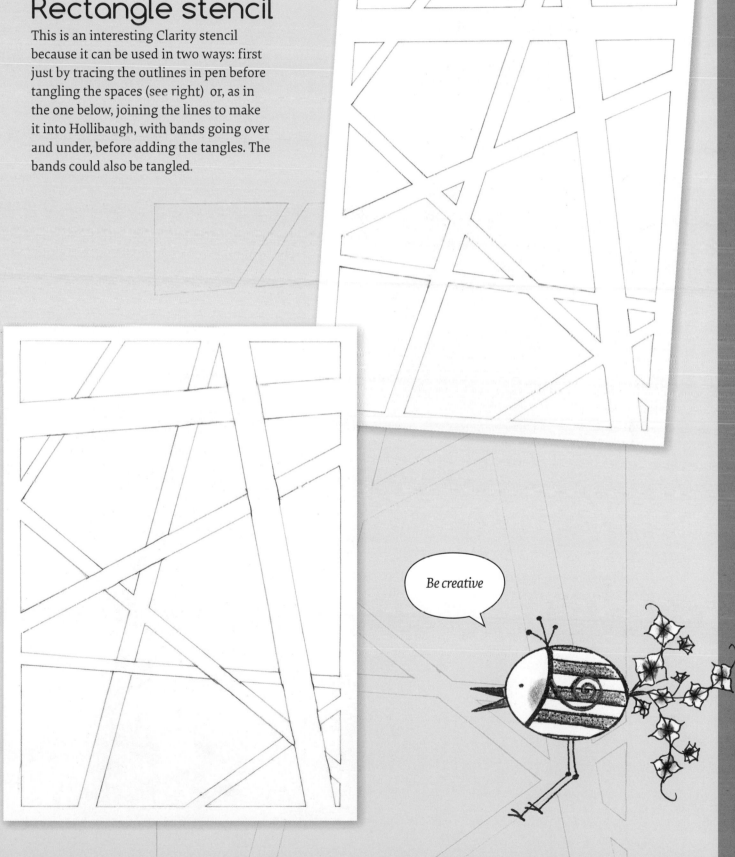

Be creative

The tangles used in the first example are Paradox, Fassett, Bales, and Nipa. I have done this stencil "stacked and tangled" fashion.

The tangles used in the second, "Hollibaugh-style" rectangle are Emingle, Indyrella, Keeko, 'NZeppel, Crescent Moon, Diva Dance, Bales, Florz, Cubine, Logjam, Chemystery, Crusade, and Tipple.

Clarity Madeleine stencil

One of my favorite rubber stamps is Clarity's Madeleine, which comes in two sizes. Clarity also produce a stencil, which is larger. I started here by adding some color with a Clarity stencil brush and distress inks in three different colors. I then tangled everything but the face, leaving that to stand out.

Tangles used: Fassett, Keeko, Hertzlbee, Steps, Jujubeedze, Onamato, Puf border, Sparkle, Onion Drops, and Florz.

Triple Zendala

On this page I have drawn three overlapping circles, using a compass, to make a triple Zendala. Experiment to see what pleasing structures you can come up with using overlapping forms.

For my first circle I used a KalaDalas stencil and filled it in with Paradox and Flux; the next one has a random string with Poke Root, N'Zeppel, Florz, Cadent, and Onamato. The lower Zendala again has a random string and is filled in with Bales, W2, Crescent Moon, Zander, Tipple, and Knightsbridge.

Shaded Zendala

This Zendala starts with a circle and is then divided into four by means of straight lines through the middle. I formed triangles randomly around the lines, which gives a very angular finish.

The tangles used are Cubine, Paradox, Crescent Moon, Fassett, Emingle, Marbaix, Howda, Cruze with Luv-a, Tipple, LaCePa, single Fassett, Bales, N'Zeppel, Static, LogJam, and Hollibaugh.

Heart mandala

I have a hearts template that I used for this mandala. I used three different sizes of hearts. In the center heart I used Mooka with Emingle and Tipple in the circle behind; the small hearts are alternately Mooka and Oolo. The Oolo hearts have Organza around the edge.

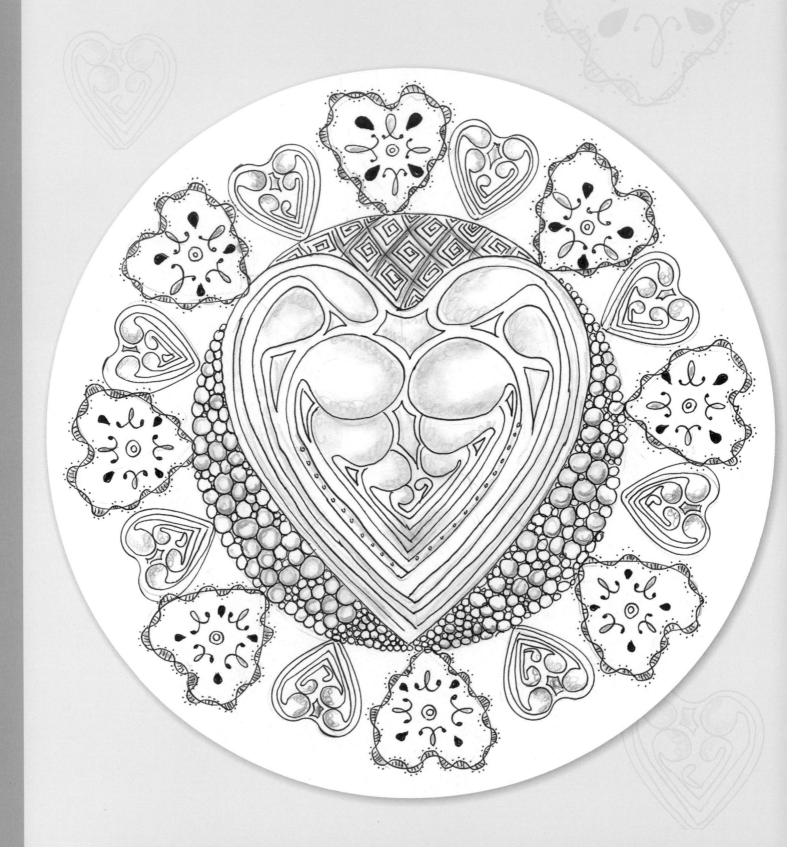

Traditional mandala

This was made by using a compass to divide a circle into eight, marking the points at 45 degrees on a protractor. I started by drawing Flux on each line. I then drew triangles around the edge with Paradox inside and from there I drew a straight line down the middle, coloring one side and drawing straight lines across the other. It is the coloring that adds depth to this simple mandala. I used a Copic marker for the color, which gives a very even finish, as does a Promarker.

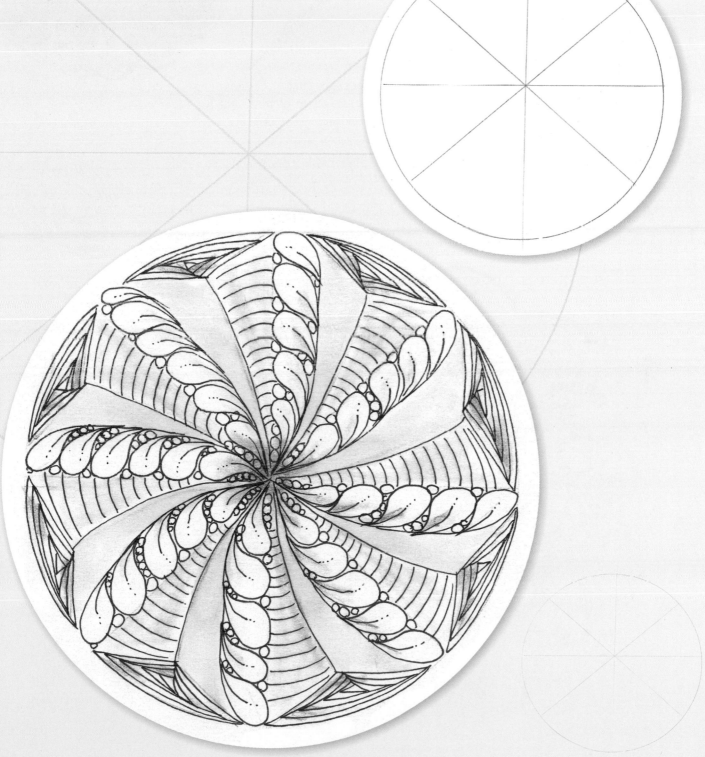

Mooka Zendalas

DR LESLEY ROBERTS

The three beautiful Zendalas here and overleaf are by Dr Lesley Roberts, and as you can see a lot of time has gone into creating them. They are all Mooka. Lesley has become a real expert on this tangle and she explains it in depth in her Mooka step-outs.

I have spent many happy hours drawing different forms of Mooka, "infurled" and "unfurled." The more I practice it, the more I continue to love it—it is definitely not a tangle that is easy to get the hang of at the first attempt. I wanted to create all three of these Zendalas using only Mooka, just to see what sort of variations I could find!

Although I used pre-strung white, black and Renaissance tiles, I soon went "off-piste" and ignored the strings, since I don't enjoy creating perfectly symmetrical patterns—I prefer my designs to be more free-flowing. One thing that is immediately evident in these Zendalas is that the white gel pen is far thicker than the Micron 01 pen and lends itself to a less detailed approach. These tiles look quite different, partly because of the background color and also because of the amount of detail in the tangling.

I have created step-outs for three versions of Mooka to help Zentangle enthusiasts who have had difficulties with this tangle to draw all the variations of it, infurled and unfurled.

Version 1

Version 2

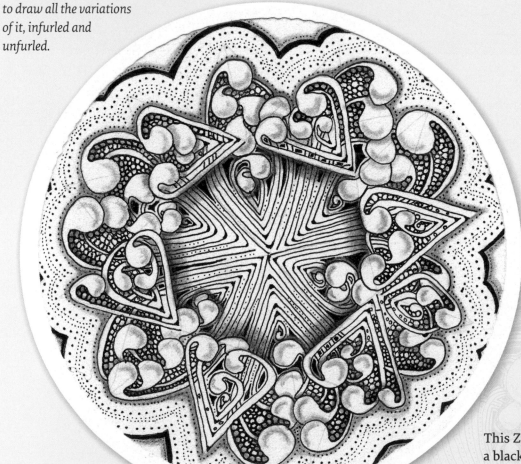

Version 3

This Zendala was created with a black Micron pen, which can describe fine detail.

For the Zendala shown left, I used a white Gelly Roll pen on a black pre-strung tile.

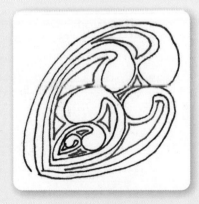

VERSION 1:
Mooka infurled, no overlaps, one continuous line

This is the place to begin learning Mooka, because there are no overlaps in the "pods," which means that it can be drawn as one continuous line. After you have drawn the outer pods on the left and then on the right the pods diminish until the space inside is filled. Although the step-outs are spread over eight stages here, you can see that there is actually just one long line which goes in different directions.

To finish off the pattern, I like to infill the spaces between the lines of the pods, simply following the curves that are there already. In this example I also added a line of fine dots and some shading—as I did in my Zendalas, too.

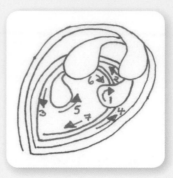
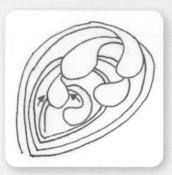

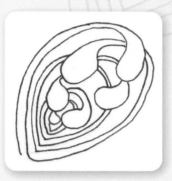
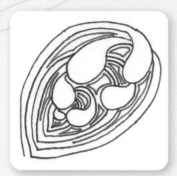

VERSION 2:
Mooka infurled, overlapping, broken line

I recommend having a go at this infurled version of Mooka next, as it will make it much easier to progress to the unfurled version. This time, after the first pod is drawn, the next one goes behind it and subsequent ones go behind both of them, which makes them more complicated to draw as you progress inwards.

So, the continuous line from Version 1 becomes an imagined continuous one, as you now have to lift your pen and then place it down on the other side of the pod to begin again. Once you get this idea of drawing one pod behind another, you just keep going until you have filled the space within the first two outer pods.

Again, there is usually space to add infills between the pods, simply following their curves. This time I filled the spaces with the Zentangle pattern Tipple, which is really useful for helping to draw something like this together. Finally I shaded it, in a slightly different way to Version 1.

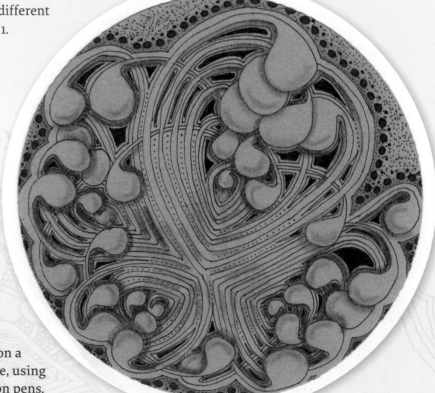

This mandala is drawn on a pre-strung Renaissance tile, using brown and sepia Micron pens.

VERSION 3: Mooka unfurled

This version of Mooka is a natural progression from the previous ones. In order to create an unfurled mooka, after the first pod the subsequent ones go behind each other, as in Version 2. Again you can only imagine the continuous line being created—in reality it is a broken line, which has to go behind those pods that are closer to the front.

I decided not to infill the spaces in the final step-out pattern for this version, so that it is easier to see the finished result. It also demonstrates better how shading really brings the finished tangle to life.

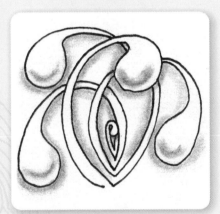

I hope that these Zendalas and step-outs help people to develop their confidence to tangle more with Mooka, as it is a very satisfying and beautiful tangle to draw. It keeps you very focused, and you gain so many of the benefits of Zentangle from drawing it, such as patience; relaxation; confidence; development of hand-eye coordination; and sheer happiness!

You can develop your own variations of Mooka by changing all sorts of elements:

- *The width or length of each long pod.*
- *The size of the "bulb" on the end of a pod—it could be tiny or enormous.*
- *The numbers of pods in each Mooka.*
- *The patterns and colors you choose to infill the gaps between the pods.*
- *The way you shade the finished Mooka.*

I would love to see any Mooka patterns that people complete, so please feel free to email me a photo at lesley@theartsoflife. co.uk, or post them on the Facebook page that some of my students set up for me, *The Arts of Tangling*.

Tangles and ink methods

AMY BROADY CZT, USA

Amy has contributed not only her own tangles but also some of her creative ways with inks. She spends much time choosing names for her tangles— sometimes as much time as she puts into designing them.

Jest

Ving

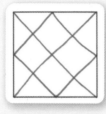
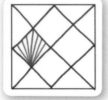

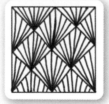

Vink

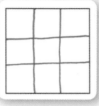
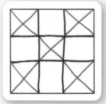
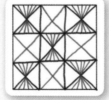
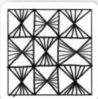

Jest on a String and Star Strand

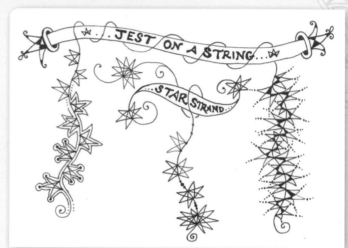

Riveting

Ameliachele and Paisley Boa can be done with two different approaches, both illustrated here. I find that some prefer one method of construction, while others prefer the next. The name "Ameliachele" (pronounced "Amelia-shell") acknowledges that this tangle resembles both a wing (referencing aviator Amelia Earhart) and a shell. It also is self-referential: my mother named me "Amy Michele" and sometimes called me "Amy-chele."

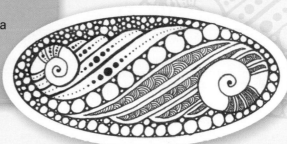

Ameliachele

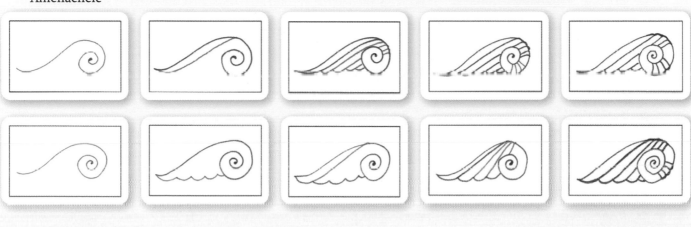

Paisley Boa

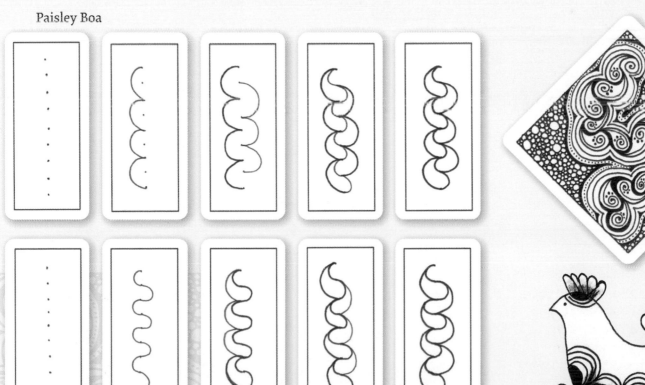

ZENINKEDGE

Inkpads can be used to enhance a Zentangle tile and provide the structure for a composition. The three methods described here can be featured alone or together to bring color without complication to a Zentangle tile or ZIA (Zentangle Inspired Art).

I admire color in the work of other tanglers, but I often used to avoid it myself. I developed this approach to make use of my inkpads while the rubber stamps from my card-making days lay idle and discovered it turned coloring my tiles into a simple and fun process. Once I start inking tiles, I have a hard time stopping!

Materials

- **Ink pads:** *there are so many colors and types of inks to try! Remember that pigment inks require more drying time than dye-based inks.*
- **Applicators:** *sponge wedges (cut from a round synthetic ceramics sponge), cotton balls, gift cards or hotel card keys, paintbrushes*
- **Paper for cutting/tearing**
- **Tiles:** *traditional tiles, Zendala tiles, ATCs (artist trading cards, size/ 3½ x 2½in/(9 x 6cm), and so forth*
- **Tools:** *pens and pencils in your choice of colors.*

Method A: Inked tile edges

With a sponge wedge or cotton ball, pick up some ink from an inkpad. Holding your tile face upwards, scrape the inked surface of the sponge along the edge of your tile in a downward stroke. Continue around the perimeter for a soft-edge frame in the color or colors of your choice. Tangle as usual in the traditional black pen or with matching, coordinating or contrasting colored pens.

Method B: Printed string

Use an old gift card or plastic hotel card key to create your string. Apply ink from the inkpad to one edge of the card and press onto your tile. Repeat until you have a good string structure in which to begin tangling, curving the applicator card as you wish. You can employ a single color or use multiple inkpads (or choose an ink pad that features a color range).

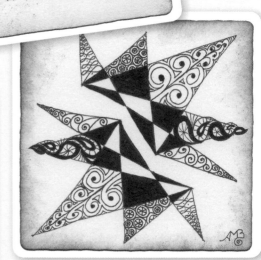

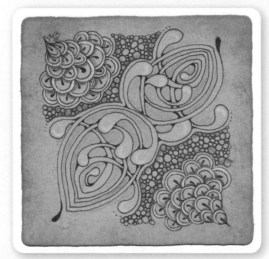

These tiles make use of only Method A. The blue and black ones were done on traditional Zentangle tiles, while the green-inked one (tangles in brown and sepia ink) was done on a Renaissance tile from zentangle.com.

The next three tiles make use of Method A plus Method B, using the edge of a plastic gift card. The red one and the green and brown one were done on traditional Zentangle tiles, while the aqua and brown one was done on a tile cut from a manila folder. I cut it to size with a paper trimmer and rounded the corners.

Method C: Masking

Cut or tear paper to create a mask for your tile. The mask can be a specific shape, or you can simply use the cut or torn edge of a piece of paper to create a linear mask across your tile. Lay the mask in place and stipple ink from the inkpad with a stiff, round paintbrush at the edges of the mask. I find that an inexpensive bulky child's brush works well for this. Remove the mask to reveal a hard edge with a soft side. Multiple masks can be used on the same tile. The resulting divisions on the tile can be your string, or they can be broken down with pencil into smaller string sections.

The two square tiles feature Method C, while the ATC demonstrates Method B.

A NOTE ABOUT TILES
While practicing this technique I worked my way through many tiles and had to find a practical alternative to the official Zentangle tiles, which I love. I discovered old manila folders to be my solution! I used a paper trimmer to cut the folders into tiles and ATC blanks and rounded the corners with a scrapbooking corner rounder. Recycling manila folders like this is an affordable way to keep a stash of tiles on hand. The pale, neutral color of the folders also allows for highlights to be added with a white gel pen or colored pencil.

Framing ideas

Bijou tiles have become very popular with CZTs and their students. You can buy them from www.zentangle.com or create them yourself by cutting 5cm (2in) squares, rounding the corners if you wish with a small corner rounder.

I arranged nine of them on a piece of black card. The tangles used are:

1 Onion Drops
2 'NZeppel and Zander
3 Narwal
4 Crescent Moon, Florz, Static, and Tipple
5 Bales, Cadent, Crescent Moon, Fassett, Hollibaugh, Meer, Paradox, Tipple, and W2

6 Hollibaugh, Msst, Poke Root, and Zander
7 Hollibaugh variation.
8 Garlic Cloves and Puf Border
9 Abundies

Tangles used:
Hollibaugh, Mooka,
Onion Drops, and Steps.

Sometimes an attractive picture frame inspires you to create an artwork for it. I was lucky enough to pick up this red frame in a sale. When I got it home, I set about cutting out a long strip of card and tangling it in one piece before putting it behind the apertures in the mount.

Creating your own pictures

This enjoyable project would make a great picture for framing, or indeed for a card or book cover.

I started by brushing some blue distress ink through a Clarity stencil. Next, I drew a fish just below the center and worked around it. I then used some colored pencils in different shades of blue.

I worked on Fabriano Tiepolo paper, but smooth watercolor paper would be equally suitable. I tore the edges with a ruler and then added distress ink to them.

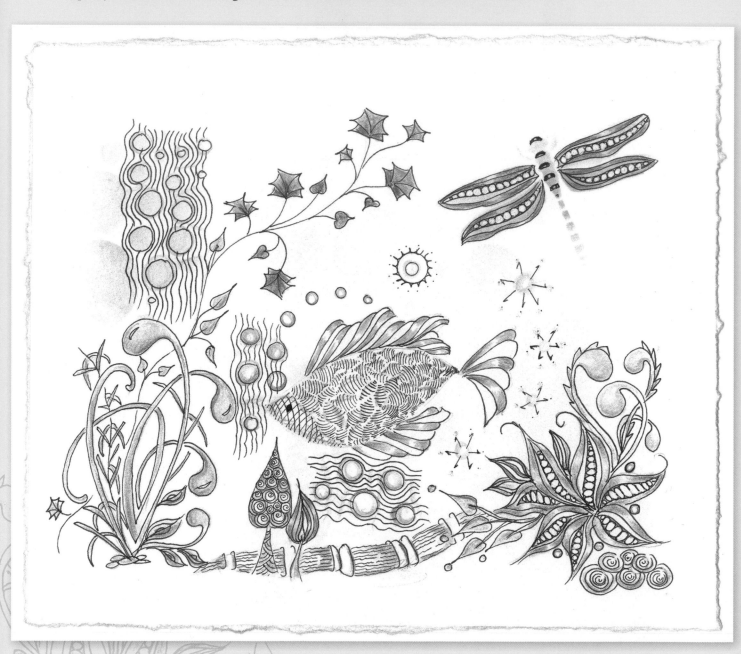

Tangles used: Aquafleur variation and Indyrella for the fish, Nipa, Mooka, Verdigogh, Onamato variation, Joy, Widget, Printemps, Poke Leaf, Zander , Morning Glory, and Auraleah.

This project is an example of Zentangle Inspired Art (ZIA), which is larger than the standard tile and gives scope to use lots of tangles. It's easier to cut your paper to fit a frame rather than finding a frame of the right size for your artwork. Here, I drew a string on a 8 x 8in (20 x 20 cm) piece of Fabriano Tiepolo paper. I put Abundies in three places and tangled around it using Zander, Garlic Cloves, Onion Drops, Hollibaugh, Crescent Moon, Tipple, Poke Root, Mooka, Btl Joos, and Florz.

Creating a ZIA with colored markers and pencils

ENI OKEN, USA
www.enioken.com

Eni Oken is an artist with 30 years of experience in working with color and ornamental design. She has kindly contributed her Yellow Abundies artwork to this book, with steps to show you how it was done. You can find a step-out for Abundies by Hanny Waldburger CZT on www.tanglepatterns.com.

Scale is always a concern when you work with color: shading with markers and colored pencils is not easy to do on such small tiles, since good shading requires room for color transitions and gradients. I particularly chose a large Abundies as the focal shape for this piece on account of its expansive structure. Arukas was a bigger challenge, since the thin ribbons don't offer much scope for creating proper gradients. Arckles was the last challenge: a purely decorative line pattern on the surface of the Abundies tangle using super-thin markers, yet I managed to get some shading to show underneath.

The original piece is only 5 x 5 in (12.5 x 12.5 cm), created on Bristol Vellum paper. I used markers as an underglaze and Prismacolor wax-based colored pencils for gradients and shading. The final touch was added with an opaque white gel pen.

1 This is the line art for the picture. You can still see the pencil string underneath the sepia pen. I used sepia rather than black ink because I wanted it to virtually disappear under the colored work.

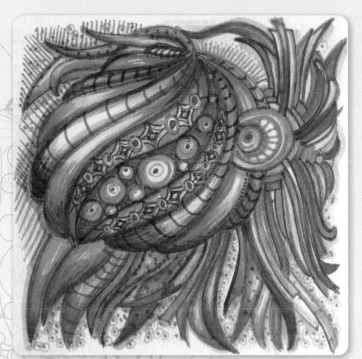

2 The next step was to make an underglaze, using only markers. The work looks a bit crude at this point, but it's important to plug along and get quickly to the blending stage. I used similar shades and tones to add some rough shading at the tips of the shapes, always coloring in long, linear strokes.

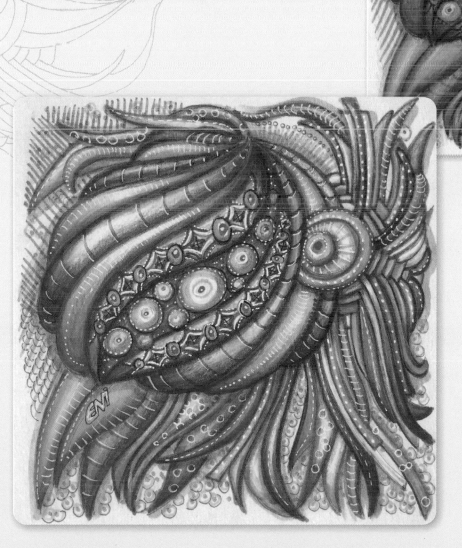

3 In the picture above, I have almost finished the work with colored pencils. Notice how the marker streaks are practically gone, except for a few outlines. The pencils provide smooth shading and modelling.

4 To add the final touches, I used a white gel pen to bring back some highlights and add an extra layer of ornamentation.

Go with the flow!

Here I created something a little different, using a Dreamweaver Unicorn stencil. I started with the unicorn in the middle—I did not tangle it, merely colored it with a lilac Copic marker and blacked out some of the mane and tail.

I then drew a series of pencil lines across and around the unicorn to create shapes. After doing this you can then decide which tangle you want to use. The tangles here are Btl Joos, Howda, and Steps, with a bit of Joy in three places. Don't think about how you want it to turn out—just do the tangles, add lines as you need them and be open-minded about where the drawing takes you.

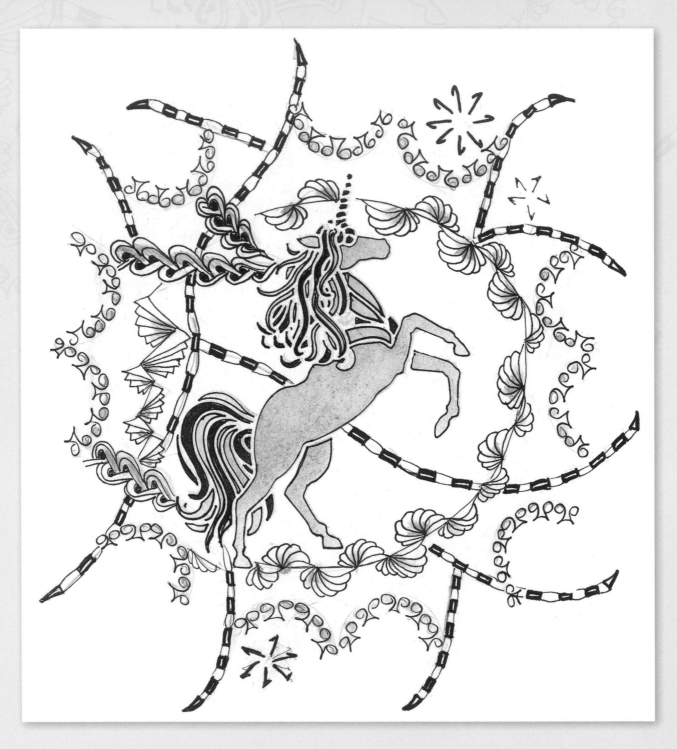

QUABOG
This tangle by Rick Roberts and Maria Thomas does not need much explanation. In the illustration I have colored the background with Distress Ink, using an Inkduster brush. In the center is part of the Dreamweaver unicorn stencil.

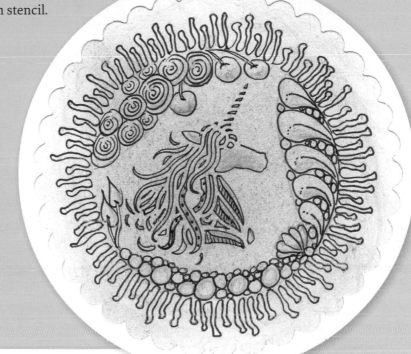

In the top illustration the tangles used are Flux, Poke Root, Printemps, Quabog, and Tipple; the lower one is Quabog with Curly Bracket Feather.

COLORING IN

You may not have done any coloring in since you were a child, but today it's very popular with adults too. It can be quite meditative and very calming, and there's lots of enjoyment to be had in choosing the colors. Here I have used one of Barbara Gray's Clarity stamps, available from claritycrafts. com, which lends itself well to a Zendala. I did not tangle the fairy, instead taking my time to color him in with Copic markers (Promarkers are similar but with finer points). I drew a circle around him with my protractor then moved it down slightly at the top to make an inner line in which to draw Btl Joos. I created a highlight by leaving a gap where the white paper shows through (this can also be done by using a white Gelly Roll pen on top of the black). I then drew Matuvu all around the edge and carefully shaded it for a more pleasing look. You might like to add some color of your choice to the area between the perimeter and the fairy stamp.

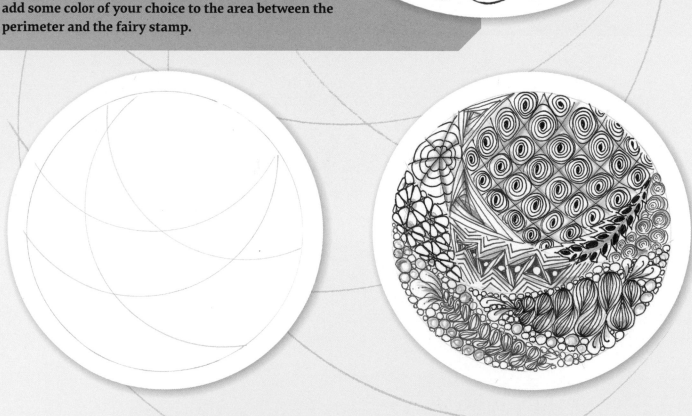

Red and white Zendala
I like the effect of a bit of red in a mainly black Zendala. You can experiment with the amount of red you put in. The tangles used here are Flux, N'Zeppel, Onion Drops, Printemps, Tipple, Tortuca, and Web.

Pre-strung Zendalas

While you will probably enjoy drawing your own strings, you can also buy pre-strung Zendalas with several designs by Rick and Maria from www.zentangle.com. All you need to do is fill in the spaces with tangles of your choice. Here I have used an Onion Drops variation in the middle and N'Zeppel and Steps alternated. The die-cut butterflies are tangled with Arukas, Fassett, and Barberpole variation.

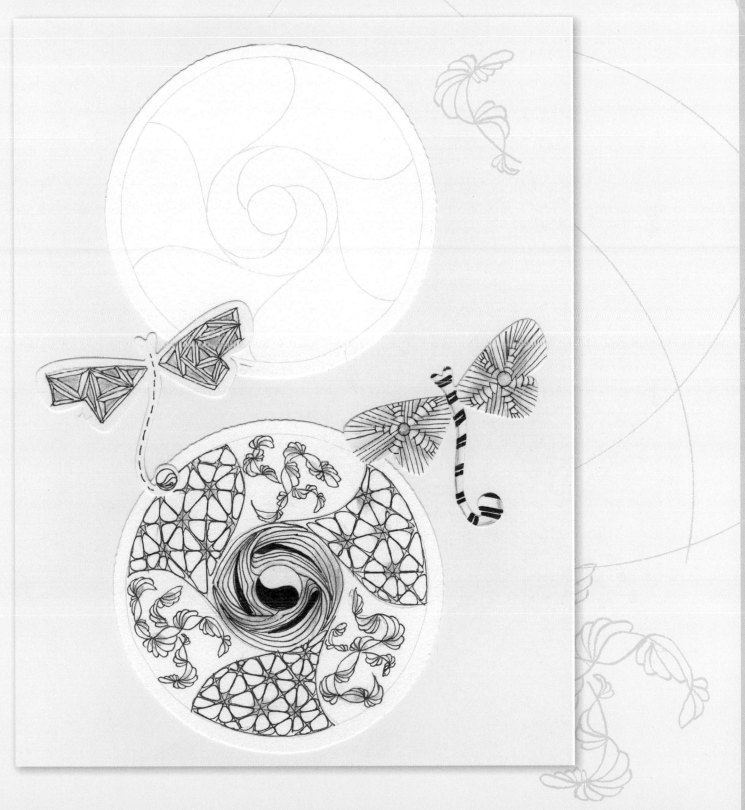

Flower Zendala

I started with a circle for the overall size and then added a circle in the center, in which I drew the "flower" with a compass. I added triangles going around the flower in the middle, using a ruler, then put in further triangles behind them. The final triangles extended to the original pencil circle, which I then erased. I added some color with a Promarker. The tangles used are Bales, Cubine, Florz, N'Zeppel, Paradox, Tipple, and Sparkle on the flower in the middle.

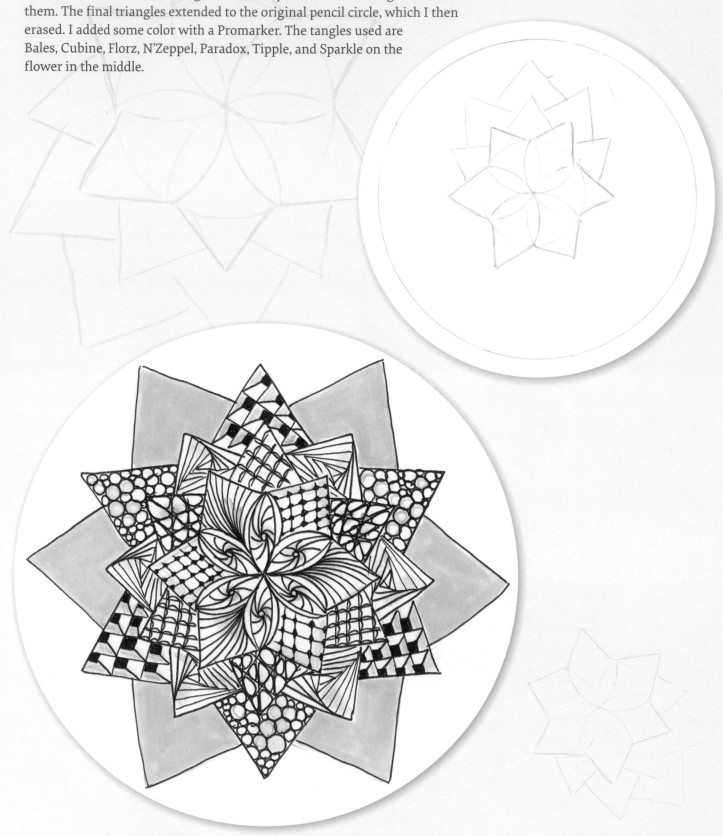

Creating a picture

Because we associate a beautiful natural landscape with peace and calm, designs featuring elements of the natural world tend to convey the same effect. I drew this tree and then had fun filling it with tangles. The only circular shape is the moon behind the tree with a couple of the branches across it. I used a Dreamweaver stencil for the toadstools.

For your own design, draw a basic shape for a tree, add some branches and tangle away. Some of the tangles included here are Nipa, Shattuck, Snails, Onion Drops, Printemps, and Poke Root, with Zingers, Poke Root, Poke Leaf, and Steps hanging off the branches.
I have added a little Distress Ink to the moon.

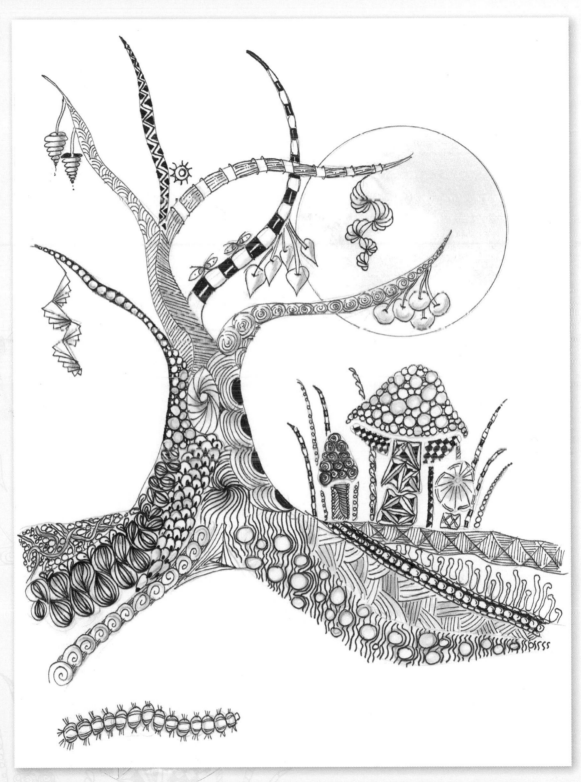

Mooka and mindfulness

I decided one day to concentrate on just one tangle and really focused in a mindful way on drawing Mooka with many different-sized "pods." I used a Koh-I-Noor Magic Pencil for an interesting effect and for ease of drawing. I started in about the middle of an A5 page and kept going until the page was full. It really was a "go with the flow" sort of exercise.

I then instinctively started to put words in the pods—anything that came into my mind. At this point, I assumed that I would just think of a few words but once I got going I couldn't stop and even started adding more words on the "stems." The tangle acted almost like a dumping ground for getting private thoughts out of my mind and on to paper. Try this for yourself—you may be surprised by what you write.

Tangles used: Yincut variation, Printemps, and Barberpole.

Dreamweaver stencils

WAYNE HARLOW CZT, USA

Wayne's wife Lynell is the creator of the Dreamweaver stencils range. Here he has colored and tangled a fairy and a sea creature, using a watercolor wash as a background for the latter. Both his artwork and the stencils used are very impressive.

Tangles used: Bask-it variation (wings), Printemps (hair), Tagh (dress), and Hatched (belt).

Rita's mandalas

RITA NIKOLAJEVA, CZT

Rita is multi-talented—she is an artist and also an interpreter of many languages. Originally from Latvia, she works in Belgium. I already thought I was very lucky when she agreed to do a Zendala for my book and when eight of them arrived I couldn't believe how wonderful they were. Rita has used some of her own very clever tangles and while most of us would find it hard to reach her standard it is certainly inspirational to see and admire them. Rita has provided in-depth instructions on what she has done for each one and has also offered us an insight into her methods and ideas. Below, I have stepped-out her beautiful tangle LaCePa.

The mandalas are all tangled on 135lb (220gsm) Canson paper, from which I punched circles with a 3in (7.5cm) round Artemio punch. The paper is good quality but cheaper than using original Zendala tiles, thus great for a quick meditation or for trying out tangles and techniques.

I like this size as it forces you to keep the design simple, with just a few tangles and a basic composition. I often don't even need a string. Sometimes I start in the central area by drawing a focus tangle and then radiating outwards, or I might begin at the outer edge and work inwards. If I use a string at all, it's mostly a circle traced around some object I have to hand, such as a plastic bottle cap.

In some mandalas, I use a Koh-i-Noor Magic Pencil 3400 with multicolored lead—four colors arranged in a checkerboard manner. I think it's a very Zen method of coloring, as you don't choose the actual color—it will change all by itself depending on the usage of the lead, the paper surface and so on.

LaCePa
by
Rita Nikolajeva
Shown here is a step-out of LaCePa, one of the tangles Rita used in her Zendala artwork on page 60.

Using a Sakura Micron 01 pen and a
graphite pencil for shading, I started
with Showgirl (a variation of LaCePa)
in the center and worked outwards,
without any strings. The other
tangle used is Quipple.

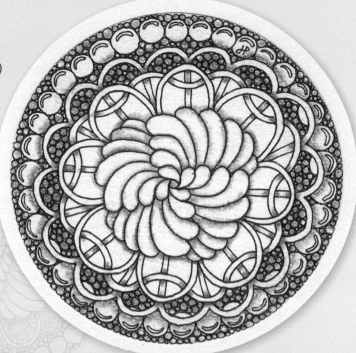

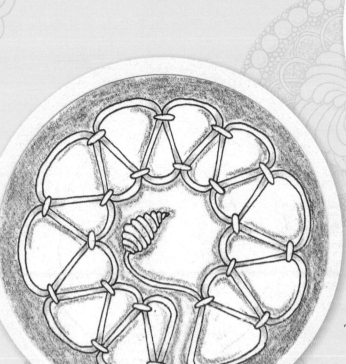

For the string, I drew a circle free-hand close to
the outer edge. I used a Sakura Micron 01 pen
for line work, a graphite pencil for shading and
a Koh-i-Noor Magic Pencil 3400 for coloring.
The tangles are Matuvu and Lampions.

This mandala was created with
a Sakura Micron 01 pen and a
graphite pencil for shading. For the
string, I traced a water-bottle cap
three times, overlapping the circles.
 The tangles used are Static plus Perfs
in the circles, Sanibelle in the overlapping
sections and Quipple with blackened spaces
at the border. I also blackened the center.

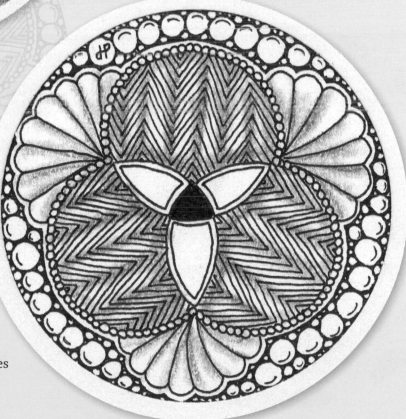

There was no string for this mandala. I started with the tangle Showgirl in the center, then added Aura around the outer edge and a black pearl in the center. I used a variation of my tangle LaCePa and colored in the spaces between the "bands."

Here I used the Micron pen along with a Faber-Castell Pitt artist pen (Cold Gray III) for shading. There are no strings. I started with a border of my tangle Borbz around the edge, added Borbz in the center and connected it to the border by Aurabridge. I added some Tipple as a filler all around.

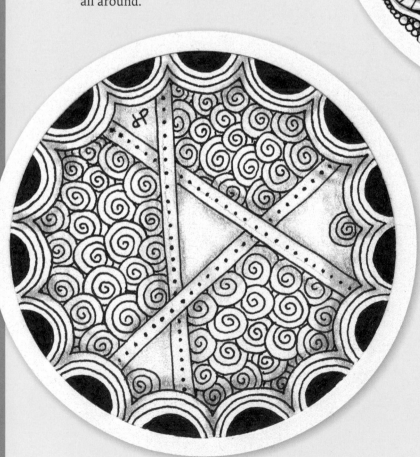

With the Micron pen and a graphite pencil for shading, I started with Crescent Moon at the outer edge, then used Hollibaugh embellished with dots. I finished by filling alternate sections with Printemps. Again there were no strings.

Without any strings, I started with the tangle Showgirl in the center, then added arcs around in two layers, crossing them in Hollibaugh-style, and finished with Quipple around the edge. I used a Koh-i-Noor Magic Pencil 3400 for the coloring.

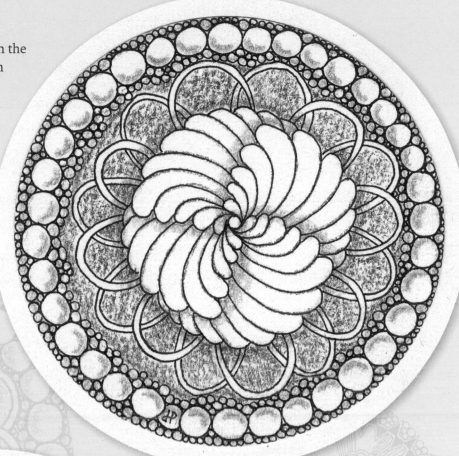

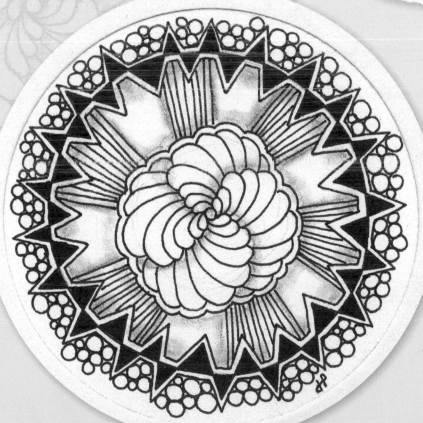

For the string, I traced the bottom of a goblet, making the base line of Rain. I added Tipple on the outer edge of Rain and used Showgirl with Aura in the center. The connections are just radiating stripes.

Celtic knots

This isn't a tangle as such but it is fun to do and to add to your Zentangle art. I found it challenging, but on YouTube.com you will find 21 very helpful videos on Celtic knots by David Nicholls. David is a great tutor, so have a go! Here is one of the easier designs, called Fish Entrails. I didn't get it right the first time, so be patient with your own attempts.

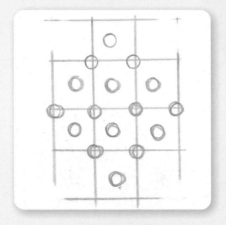 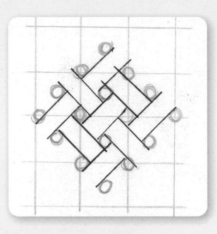 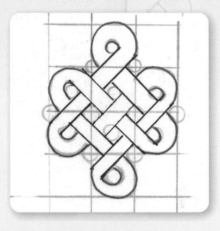

First draw a grid and then put your circles in—use a pencil as these lines will be erased later.

Next, take your pen and draw the "weave" lines as shown.

Follow the weave lines and round them off at the corners to give a natural effect, then erase all your pencil guidelines.

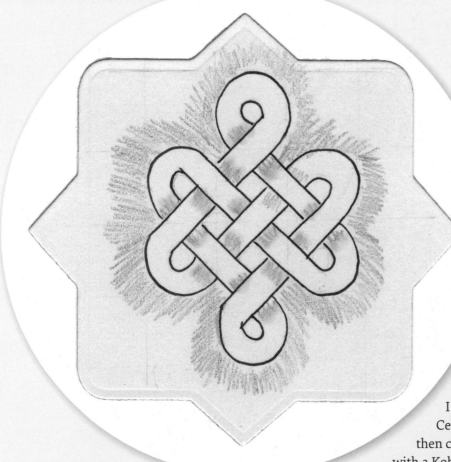

I have shaded this Celtic knot in pencil and then colored the background with a Koh-i-Noor Magic Pencil.

Stained-glass effect

Here I have used some die-cut church window designs. The first one has a star shape cut out, but this could just be drawn in. I have divided up each window and drawn many different tangles in each section, coloring them with Copic markers. The tangles used in the large window are Onamato, Shattuck, Tipple, Cadent, Fassett, Flux, Printemps, N'Zeppel, Keeko, Cubine, Heartrope, and Poke Root. The medium window is Fassett with some of the triangle colored in and the small one is N'Zeppel, always very effective.

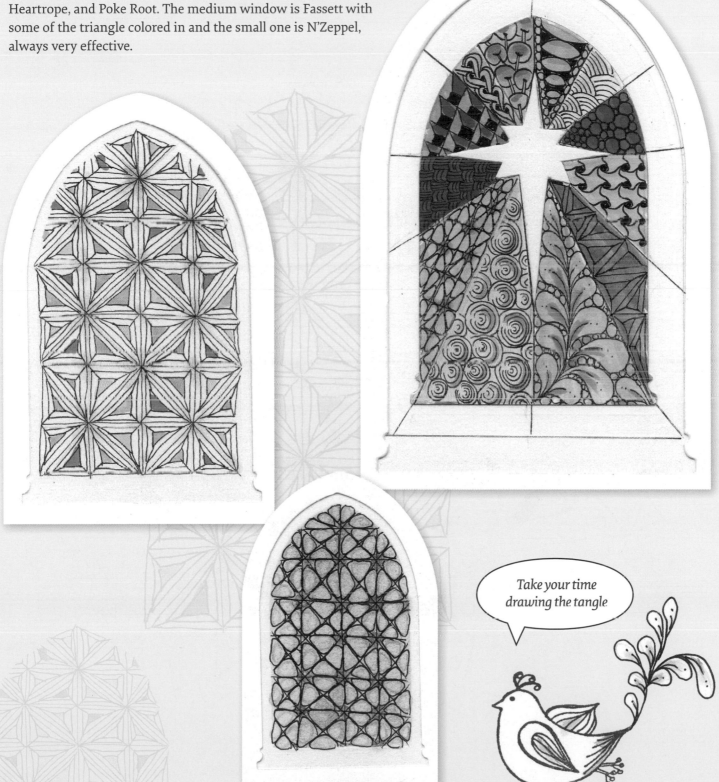

Take your time drawing the tangle.

Triangle mandala

Using triangles in a mandala provides an interesting geometric contrast with the circular shape.
I started this mandala with a square in the middle and then, using my triangle template, I started
forming triangles that overlaid each other until I had three "circles" of triangles. For the third
circle I added a halo, doing Braze on the inside and small circles in the halo. The other tangles
used are Arukas and Sanibelle.

Star-shaped Zendala

Stars often feature in Zendalas. I used a star template for this one as stars are not particularly easy to draw, though you can create the Star of David with two triangles. The tangles I used are Matuvu around the outside of the circle and Auraknot for the center of the star; a Meer variation forms the star points and a variation of Coral Seeds is between them.

Black and white Zendala

This is a very simple Zendala, using a protractor to draw the outline. If you have a protractor with cut-out smaller circles in it, draw some of them in a circle—I have used different sizes here. You can also draw them freehand. The center is part of a KalaDalas stencil. The tangles used are a variation of Howda (adding a small circle on top), while the circles are Cruffle with some stalks added and a bit of Flux for the leaves.

Mandala with color

This mandala is quite complex. I started by drawing squares within squares, the third one turned round so that the corners touch the sides of the previous square. I drew a circle inside that square and then went with the flow, adding half circles on the sides of the square. Then I set about tangling it, finishing by adding some color and mounting it on a piece of lilac card.

The tangles used are, in the middle, Hollibaugh, Knase variation, and Copada, with a simple border around the edge.

Rising towards the light

ZIA BY SHOSHI
shoshiplatypus.com

Shoshi lives in Devon, south-west England, and has contributed a Zia which is derived from her experience of facing cancer. Like many people coping with vicissitudes, she has found art both a solace and a source of inspiration.

Tangles used:
Barberpole, Bilt, B'twined, Copada, Cvetic, Finery, Floatfest, Footlites, Heart Rope, Intwine, Lily Pads, Lotus Pods, Miander, Zinger, Verdigogh, Y-Ful Power

My piece of Zentangle Inspired Art depicts my journey from my bowel cancer diagnosis, which is essentially a journey of the heart—it is all about attitude. It is not the circumstances and events in our lives which define us, but our attitude to them—we can either cave in and be miserable, which will affect everyone around us in a negative way, or we can face them head on, and make use of them, to help us become a better person, which will have the added bonus of inspiring those around us. This second choice is the one I have made.

This was a life-changing experience, which I have attempted to express in my art. The upward journey has not been a straightforward one but has taken some circuitous routes. From a relatively dark and cluttered existence I am rising towards the light; the butterfly represents metamorphosis from one state to another, taking flight from a lowly existence into the brighter light of hope and joy. This journey has changed my priorities—it is from a heart full of gratitude, and a desire to make a difference to the lives of others.

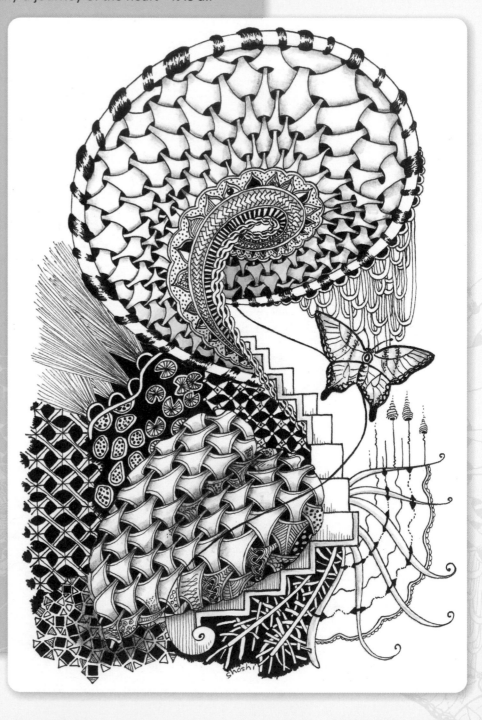

Y-Ful Power

My tangle Y-Ful Power was inspired by a ceramic vase with a woven pattern embossed on its surface. I thought it would make a beautiful tangle, so I set about deconstructing it. This proved to be quite a long and difficult process but eventually I succeeded, and as long as you concentrate and remember to draw the curved lines from the dots of the initial dot grid downwards to the outer edges of the "eyebrows" of the row beneath, all will be well. Thereafter, it is simply a matter of extending the lines, as you can see from the step-out.

Using a regular dot grid, you obtain a regular three-sided woven pattern, which is brought to life by the appropriate shading. In my drawing you can see that I have arranged the initial dot grid to follow the contours of the curved shapes of the underside of the spiral staircase and of a heart, which results in the pattern following their shape and giving the picture a sense of depth.

The name "Y-Ful Power" is a pun on "Eiffel Tower"—the iconic Parisian landmark—because if you draw the pattern using the extended dot grid as in the Variations, the resulting shape resembles this structure. It is also full of Ys!

It is a fun pattern to draw, and once you have mastered the step-out it is surprisingly easy, with quite an impressive result for very little effort.

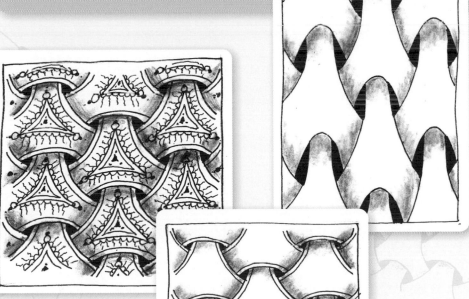

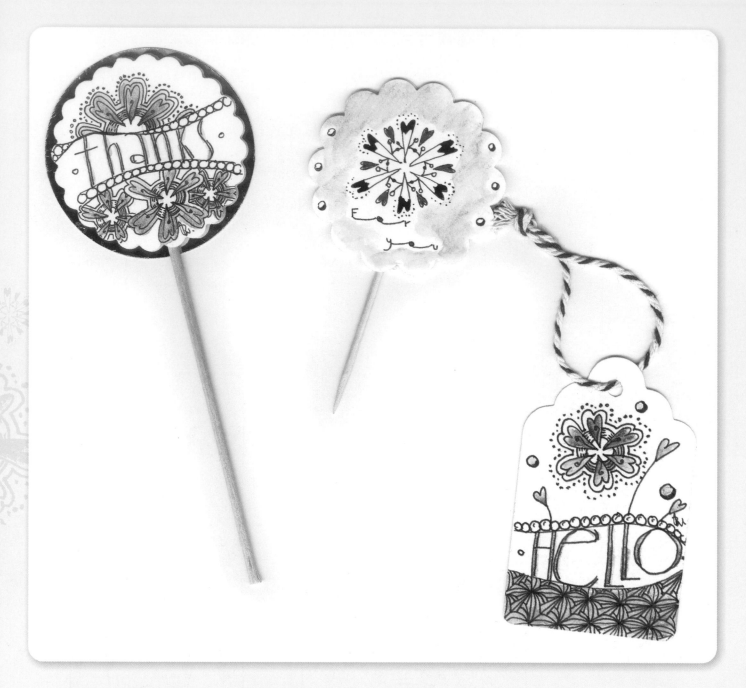

Herzlbee project

BEATE WINKLER CZT, GERMANY

Beate is the author of *Das Grosse Zentangle® Buch* and *Zentangle® für Kids*. She has designed many tangles, of which Herzlbee is featured here, among others. It is made up of elongated hearts in circles.

Beate's projects are fun and don't take too much time. Here you can see "tags" that could be used for "thank you" gifts, as flavor identifiers for cup cakes or muffins and so forth. The small bijou tile is a variation of Herzlbee and Diamantbee, another of her tangles.

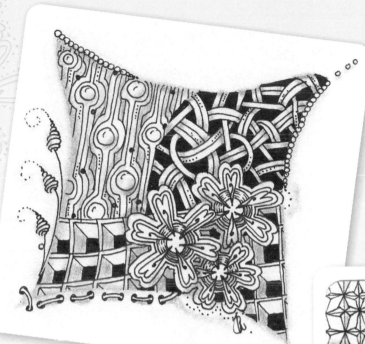

Tangles used:
Cubine, Herzlbee,
Laced, Nipa variation,
Yah, and Zinger.

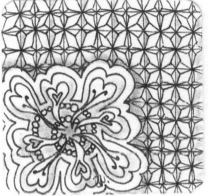

Herzlbee

Go slow!

Using an apple corer

One of the things you can use to create a "stencil" for a Zendala is an apple corer. Mine has twelve sections, though some have only eight. For the top Zendala I used all twelve sections and alternated Emingle and scrolled Feathers with a bit of color. In the second one I used every other section and tangled with Copada and Avreal. The third Zendala is drawn using two adjacent sections and leaving the next one out. It is tangled with Pia, using a purple fineliner.

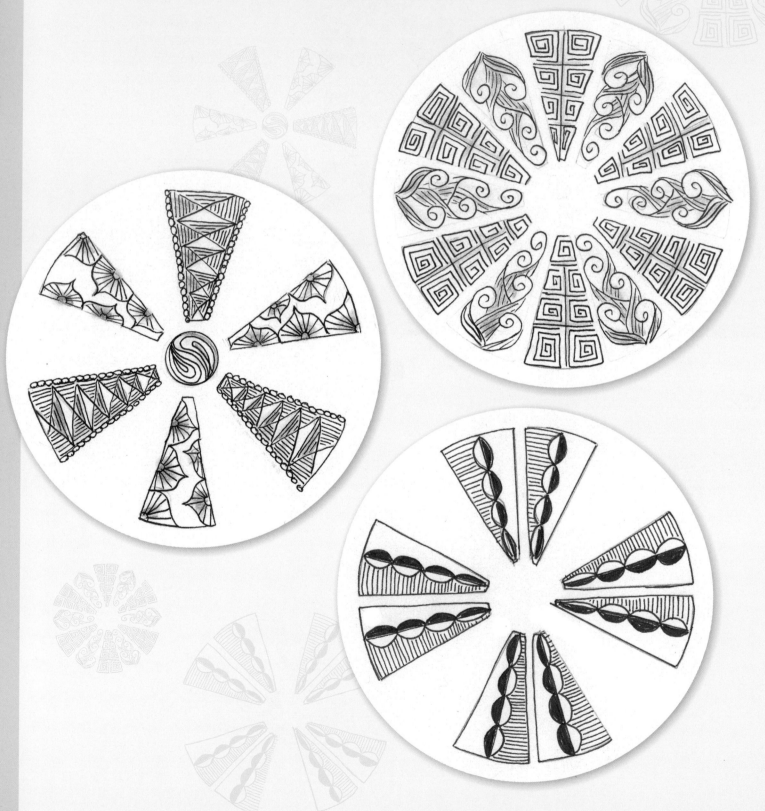

Decagon Zendala

A die-cutting machine allows you to cut out a wide range of shapes quickly and accurately, so if you are keen on papercraft you will find one a good investment. I used a decagon die to cut this shape. It is easy to use for tangling as the shape can be divided up easily from point to point. The tangles here are Thorns variation and N'Zeppel.

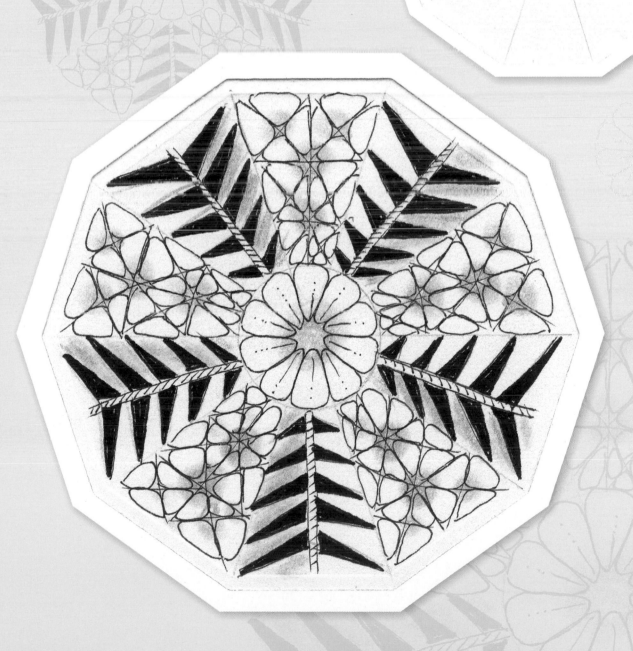

Using stencils

There are various brands of stencil available, offering many different designs and materials. Lightweight vinyl stencils (such as the one for the design used here by Julie Evans CZT) are much cheaper than metal ones, but less robust, so take more care when using them. Here I used Bales, Paradox around the outside, Flux and Tipple inside and Florz variation in the middle.

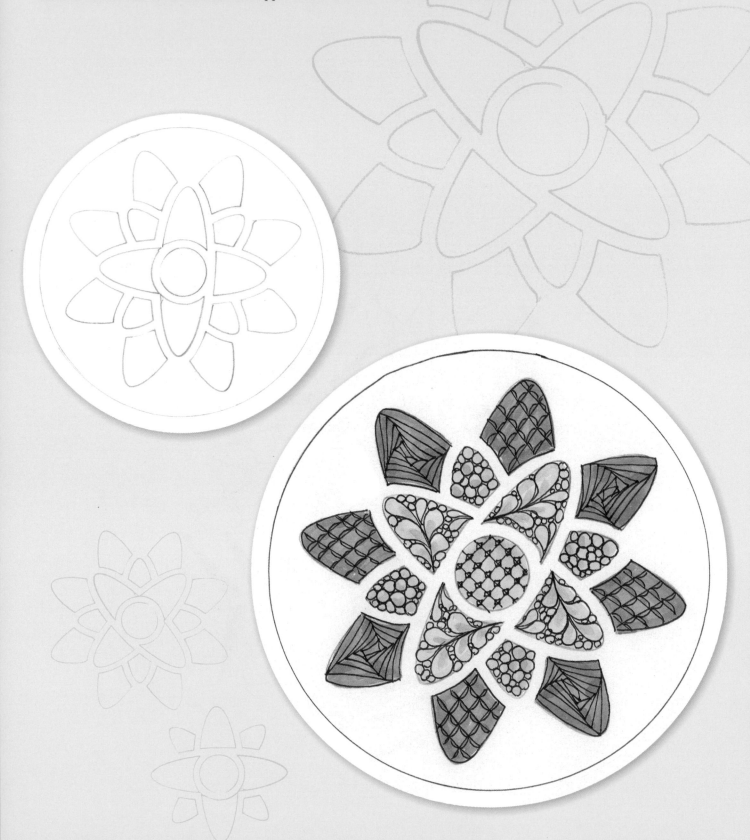

Stencils with background color

For the artworks shown on this page I started by applying color through some stencils with Ink Dusters and Distress Inks. I then used a stencil designed by Julie Evans, tracing through the outlines in pencil and then tangling various parts of the stencil to create three different effects. To make your own designs, erase any pencil lines when you have finished and then shade your design either with a graphite pencil or with colored pencils. You can use all or just part of the stencil as I have done.

The tangles are: first image, Paradox; second image, Dandi and Flux variation; third image, Dragonair, and N'Zeppel.

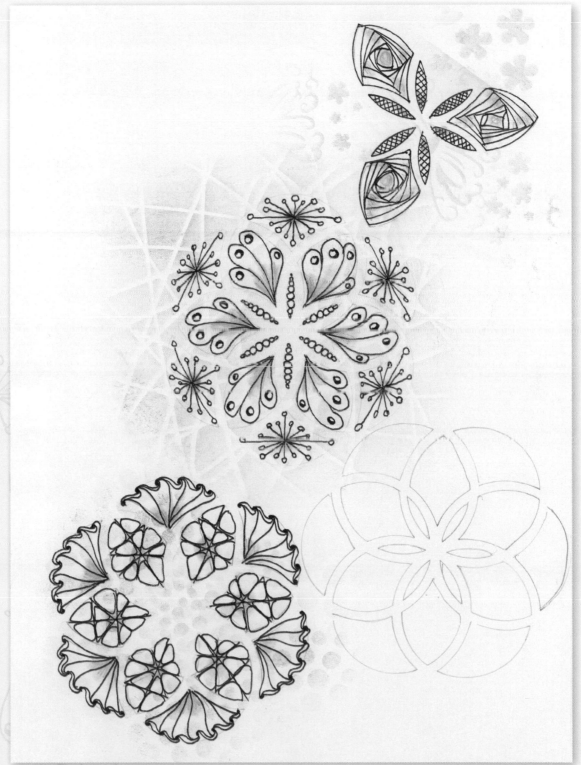

Background color

I cut out these owl shapes with a die-cutting machine. Before lifting the die off the shape, I used an Inkylicious Ink Duster brush with some Tim Holtz Distress Inks to add color to the finished shape. Claritystamp also do a very good set of four stencil brushes, or you can use a piece of make-up sponge and an ink pad for the same effect. Once the die was removed a white edge to the shape was revealed. I used Spellbinders owl dies and also a star stencil in the background.

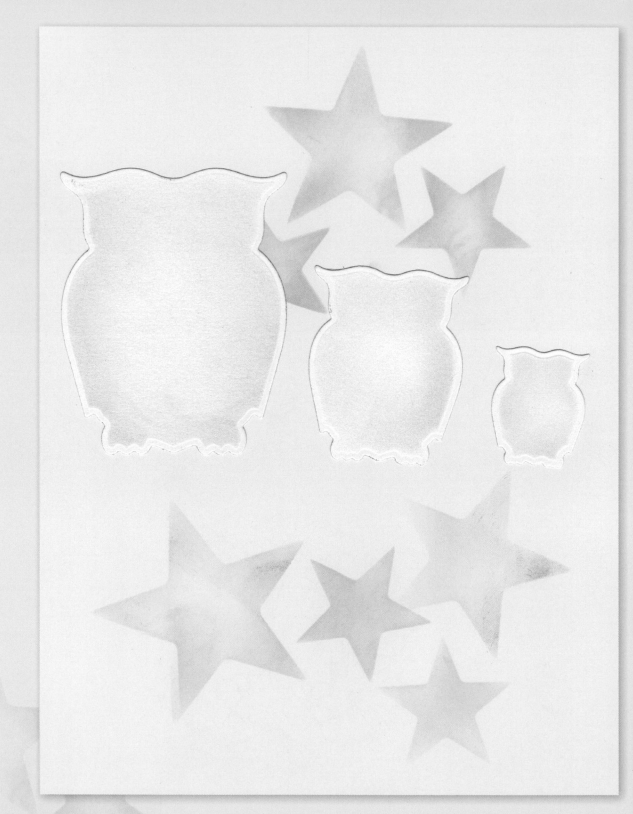

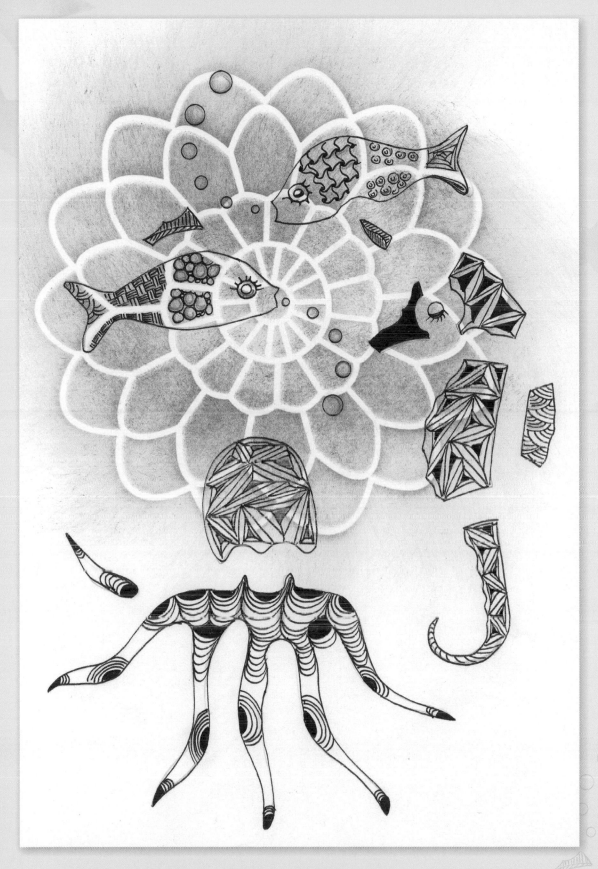

Here I used a stencil for the background, coloring it with some Distress Ink. I then added sea creatures, using stencils, and filled them in with various tangles.

Background color (continued)

This page was created by first coloring some inexpensive snowflake stencils with Distress Inks. I then used part of a larger stencil designed by Julie Evans CZT.

 The center is tangled with Auseklis, and next to that there is Copada and Dandi. The outer spaces are filled with Crescent Moon and Onion Drops with a bit of Cruffle.

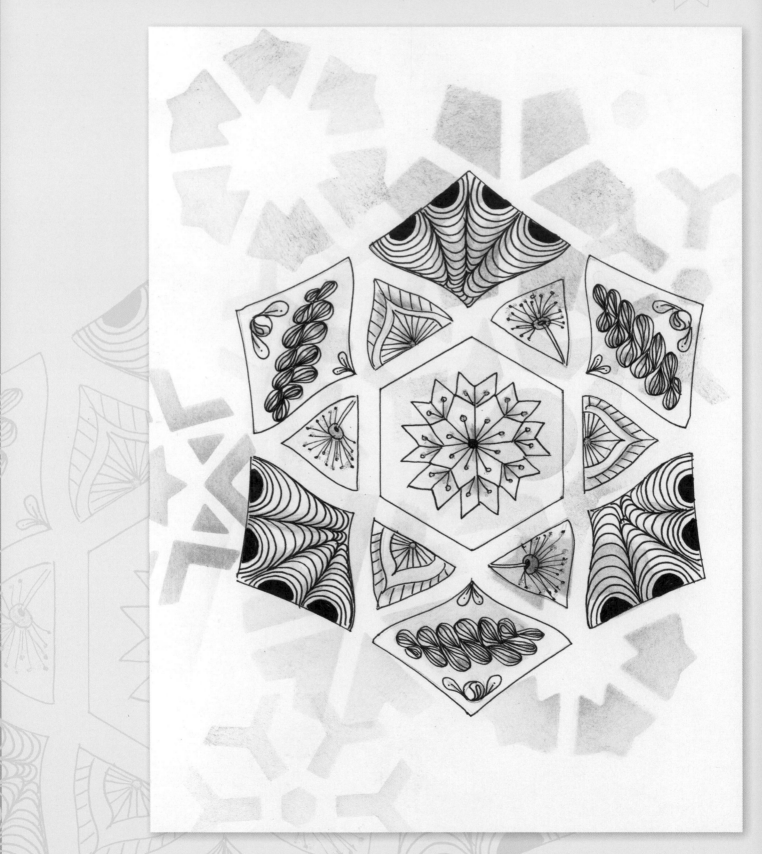

Shaving foam background color

This is a lovely messy way of making background color. You can buy little bottles of inks such as Posh Rainbow Ink in various colors; I also use pearlescent inks. Alternatively, acrylic or watercolor paints will work well. Take an old tray or dish, spread cheap shaving foam over it and sprinkle a few drops of color on the foam. With a fork or a cocktail stick, pull the color across to make lines and then repeat in the other direction. It will look a bit like marble at this stage.

Next, take some white card or heavyweight paper and press it on to the mixture. Lift it off, scrape off the foam, then wipe with paper towel and you will find you have a lovely colored sheet of card. You can repeat with many more pieces of card or paper, occasionally adding another drop of color.

I have left two of these "tiles" blank so that you can see the effect achieved with this technique—no two sheets will be the same. On the third one I have done a circle of N'Zeppel.

There are no mistakes

Using part of a stencil

I achieved this effect using part of the Dreamweaver elephant stencil four times in a circle to make a mandala. It is not obvious that it is the elephant unless it is pointed out. I used Btl Joos around the outside, a Meer variation on the trunk, Zander on the tusk and a bit of N'Zeppel for the head. Widget was ideal for the eye and the center.

In the second Zendala, the whole elephant is used with the same tangles as the first, but also Cadent, Crescent Moon, and Flux on the rest of the body.

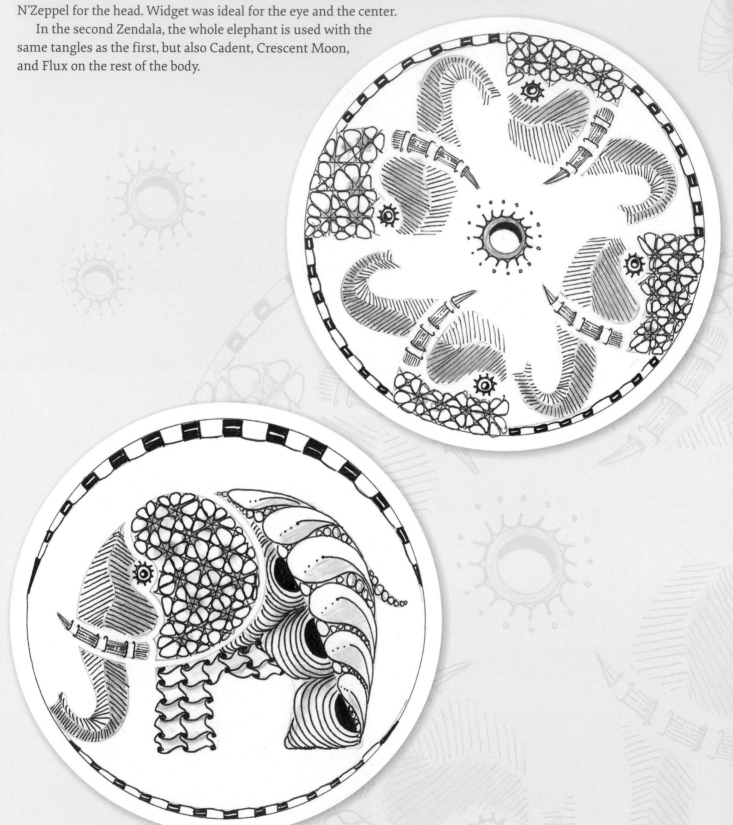

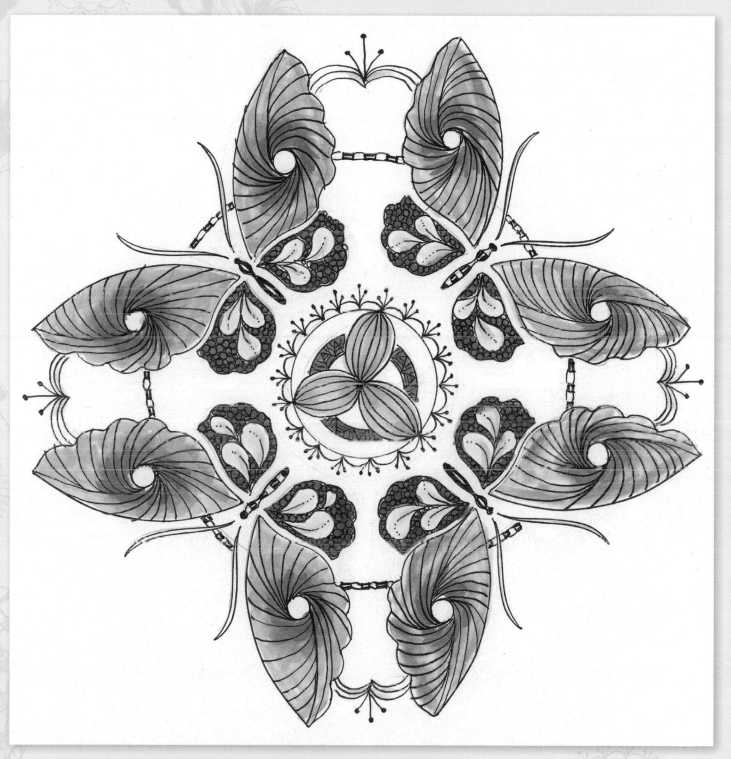

This is a Dreamweaver butterfly stencil, used four times in a circle like the elephant. Again the subject may not be obvious. The tangles used are Sparkle and Flux with Btl Joos on the body; the center is surrounded by Puf Border.

Creating a string with masking fluid

Masking fluid is used by artists to prevent color reaching the paper surface. You can buy it in a bottle with a little spout for drawing. Create a string of your choice with a line of masking fluid and once it is dry, brush on inks with a stencil brush or ink duster brush. When the ink is dry, remove the masking fluid—it will peel off easily—then draw your tangles in the spaces created.

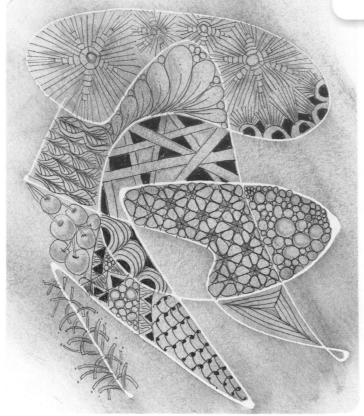

Coloring in

Sometimes you will want to color in your ZIAs rather than shading them in graphite. I used Faber-Castell colored pencils for the illustrations shown here. In the Mooka example I started with the lightest color and kept adding more blues until I had the result I wanted, then blended them with a paper stump. The mandala was done the same way, using purple, but with a complementary color of yellow added as well. The tangle used on this one was Crescent Moon, with a simple Garlic Cloves tangle for the petals.

Tangles used: Arukas, Crescent Moon, Flux, Footlites, Hollibaugh, Knase, Leaflet, Netting, 'NZeppel, Paradox, Poke Root, Tipple, and Verdigogh.

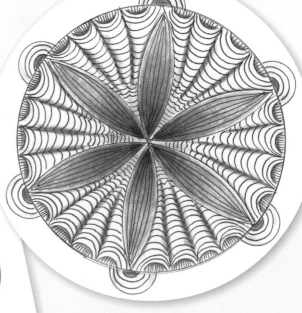

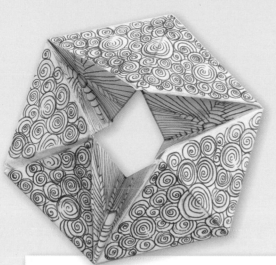

Making a flexagon

This was a really enjoyable project shared by Lynn Mead CZT when we were in Santa Fe for a CZT get-together. It takes quite a bit of time and patience to do. First of all you need to photocopy the template for the flexagon on to good-quality paper—card is too hard to fold.

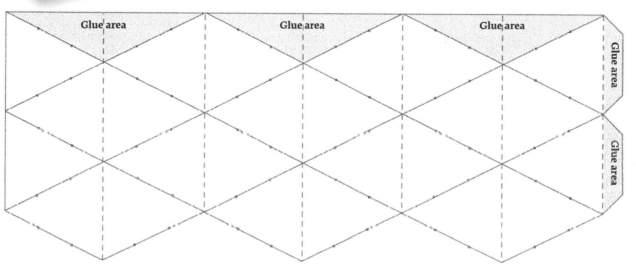

1 Draw a different tangle in each row.

2 Cut along the outline.

3 Crease the dashed lines as valley folds.

4 Crease the solid diagonal lines as mountain folds.

5 Fold the paper lengthways to form a tube. Glue the points onto the areas marked "glue area."

6 Glue the end tabs together and then insert and glue into the open tube end. You now have a flexagon that can be continually refolded to show each of the four tangles.

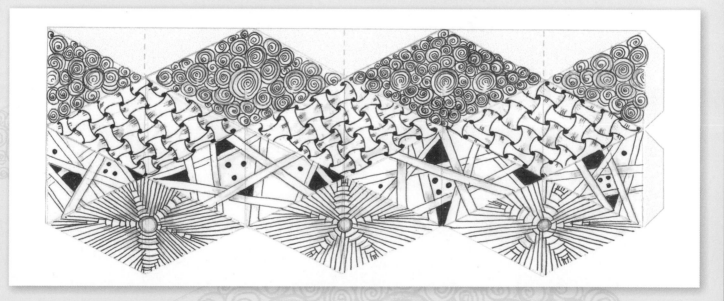

Origami crane

MARYANN SCHEBLEIN-DAWSON CZT, USA

MaryAnn is a talented origami specialist as well as a Certified Zentangle Teacher. Her motto is "Fold something . . . you'll feel better!" It is very true—try it!

Among the tangles used by MaryAnn for her crane project are 'NZeppel, Poke Leaf, Sanibelle, Knightsbridge, Florz, Static, Emingle, and Hollibaugh with Printemps. Below are the instructions for folding the crane and the finished piece photographed from different angles.

1

2

3

4

5

6

7

8

9

10

11

12

13

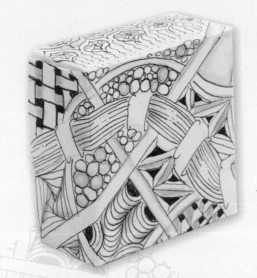

Tangles used: Zander, Hollibaugh, Fassett, Cubine, W2, Yew-dee, Crescent Moon and Paradox.

Tangles used: 'NZeppel, Flux, Poke Leaf, Footlites, and Laced on handle.

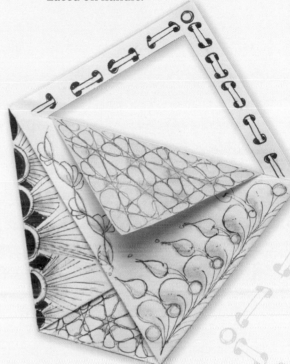

Origami bag and boxes

MONIKA CILMI, UK

Monika is a multi-talented artist, with origami being one of her skills. She created some origami projects for me to tangle. Among my favorites are this bag and two little boxes.

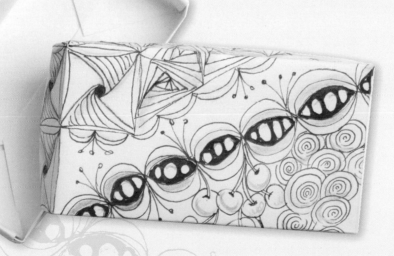

Tangles used: Puf border, Paradox, Inapod, Printemps and Poke Root.

Tangling on fabric—a Zentangle Butterfly

ANYA LOTHROP CZT, GERMANY

Born in the USA, Anya now lives in Hamburg and was Germany's first CZT. She has written a number of books on Zentangle.

Zentangle doesn't always have to be done on paper; decorating bags, T-shirts or cushions can be a rewarding and fun experience. Tangling on fabric is quite different from working on paper, however. Since fabric has an uneven texture, your pen will not move along as smoothly as you might be used to. This has one great advantage, though: drawing on the rough surface will make you work more slowly and carefully, which often leads to a much prettier and more exact result.

Finding the right pen to use can be a challenge. Most fabric markers have quite broad tips and will not allow you to draw much detail. Instead, try permanent markers such as the Identi-Pen by Sakura. After ironing, it will be permanent on fabric and washable as well. If you are using a marker of a different brand, be sure to test (and wash) it on a scrap of fabric first. Here I've tangled my favorite bag with a beautiful, patterned butterfly.

You will need
- a T-shirt, bag, or whatever you want to tangle on
- a permanent marker with a very fine tip (e.g. Sakura's Identi-Pen)
- a grey, slightly translucent fabric marker for shading
- pencil and paper
- scissors

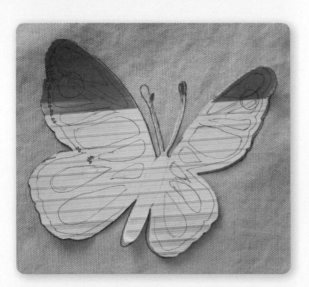

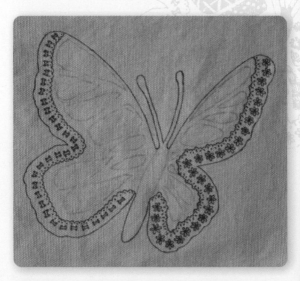

1 Pick a shape for the outline. You can either draw your own design on paper or find and print a template from the internet. Cut out the shape.

2 To transfer it to the fabric, place the paper shape on the fabric and simply trace around it with your permanent marker. If it is a large object, you may want to fix it to the fabric with pins before tracing.

3 With the grey fabric marker, add the string by dividing your outline into separate spaces. In many cases, the object you use as an outline will already suggest placement for some of the string lines.

Balloya

Tangles used:
Balloya, Btl Joos, Bunzo, CO2, Embellish, Eyelet and Ribbon, Fescu, Fife, Hibred, Leaflet, Locar, Marasu, Msst, 'NZeppel, Pepper, Quipple, Sand Swirl and W2.

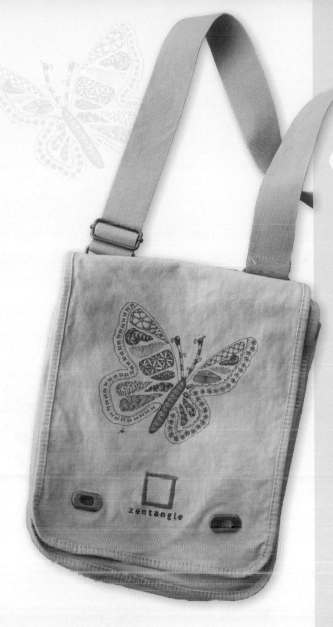

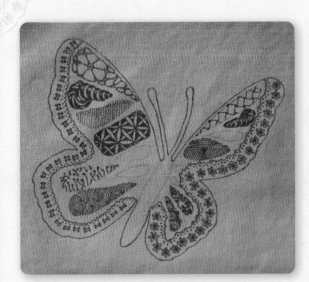

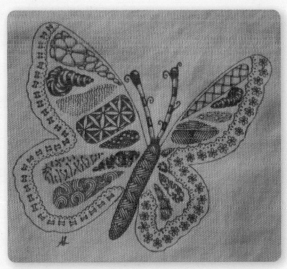

4 Start filling your spaces with tangle patterns. For the butterfly, I've chosen to leave blank spaces, but you can also fill the entire shape with patterns.

5 When you've finished tangling, add shading with the grey fabric marker. To make smooth transitions from dark to light areas, barely tickle the fabric with the pen. You may want to practise this on a separate piece of fabric first.

6 The finished butterfly makes my Zentangle bag even more special!

Seahorse Zendala

JUNE BAILEY

This lovely Zendala was done by my friend June Bailey, who comes to my Zentangle group. She has created a beautiful, intricate seascape with clever use of color. I have got to know June well and realize how much she gets out of her Zentangle practice. As the mother of two young boys, she needs a bit of "me time" when she can enjoy her creativity.

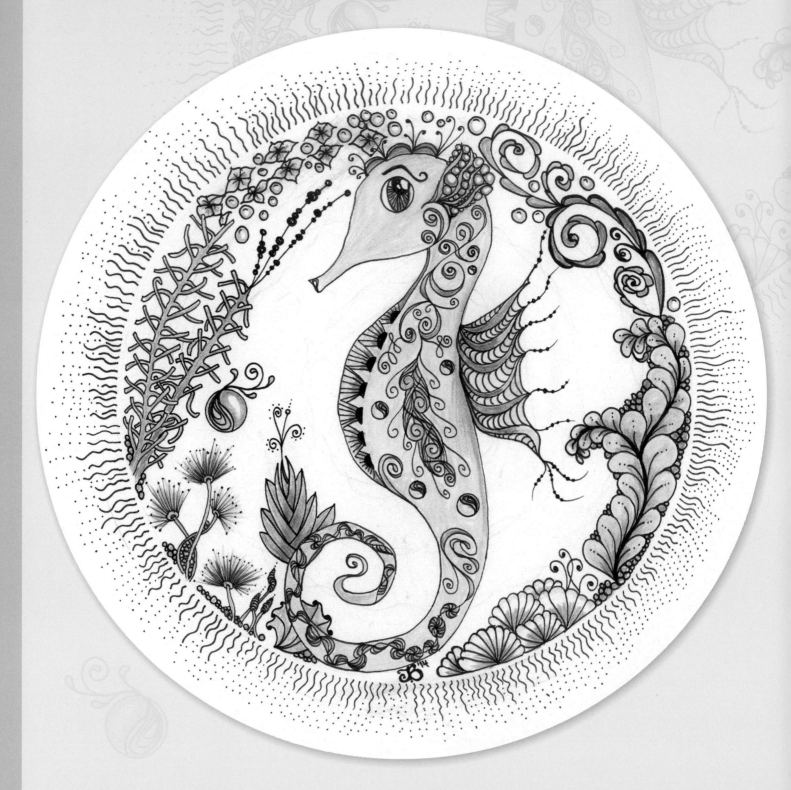

Teabag folding

This miniature form of origami was originally done using decorative teabag wrappers rather than the teabags themselves. It's a delightful way of turning artwork into decorative objects, and you'll find the process of folding and watching your designs take new shapes a meditative form of papercraft. There are some complicated teabag folds, but here I have chosen a basic one. I started by photocopying June's seascape about four times and then cutting it into eight 4in (10cm) squares.

1. Fold a square diagonally and then open it up. Fold diagonally the other way and open it again.

2. Next, turn it over, fold it in half and open it up. Fold in half the other way.

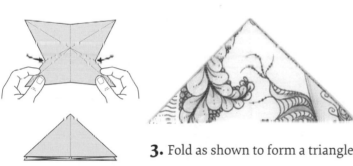

3. Fold as shown to form a triangle.

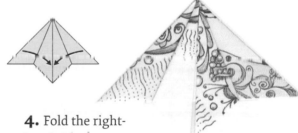

4. Fold the right-hand side down and then the left-hand side.

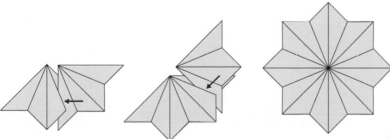

You now have the finished fold. Repeat with the remaining squares and form a flower by connecting them in a circle, using a little glue to hold them together. Adding a gem to the middle then mounting the flower on a piece of card makes a lovely card or a tag for a gift.

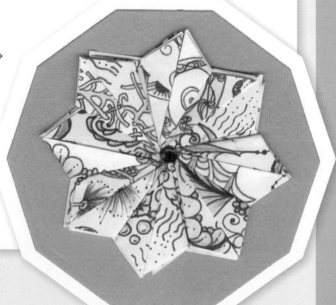

Rubber stamps

Using rubber stamps offers another source of designs for tangling. The first example here, using a Rubber Stampede stamp, is drawn on a Renaissance tile with a brown Micron pen and some highlights from a white charcoal pencil. The tangles used are Puf Border, Dooleedo, Auraleah, Brax, and Verdigogh.

The second one, using the stamp Artprints Gracious Lady, has Puffle and circles drawn with a sepia pen.

The third example is a Paper Artsy stamp, with a Za border in brown and sepia. All of these designs would make attractive greetings cards.

Here I have used flower designs from Dimension Stamps. They are just
outline stamps, leaving a lot of scope for tangling. In the large flower
I have done Auraknot. I have added stalks on the outline stamps to
illustrate how you might use them along with the completed stamps.
The second flower is Merryweather and on the third I have done Fengle.

Greetings cards with numbers and letters

Tangling your own greetings cards allows you to make one-off cards to suit the occasion. I use plastic stencils to pencil in the numbers or letters, though you can draw them freehand if you prefer. I drew these designs on a piece of 250gsm white card measuring 7 x 3½in (18 x 9cm). I then folded a 8¼ x 7½in (21 x 19cm) piece of colored card in half to make a card blank measuring 7½ x 4⅛in (19cm x 10.5cm) and stuck the white card onto this. However, the size doesn't matter as long as it fits in an envelope.

The first one is similar to a birthday card I made last year for someone reaching the age of 105. I have used Cruffle in the left-hand corner. Number one is Crescent Moon, the zero is Flux, and the number five is Fassett. I have added some Steps running across as well as Btl Joos and some Poke Root.

The second card is like one I did for my grandson, Tom. The T is Heartrope and Crescent Moon with a Zinger hanging down and a Puf border at the top; the O is Poke Root, Tipple, and some Poke Leaf; the M is Zander, Bales, Btl Joos, and N'Zeppel. There is a Morning Glory vine running behind.

Both of these cards were colored with my Koh-i-Noor Magic Pencil and mounted on a colored card.

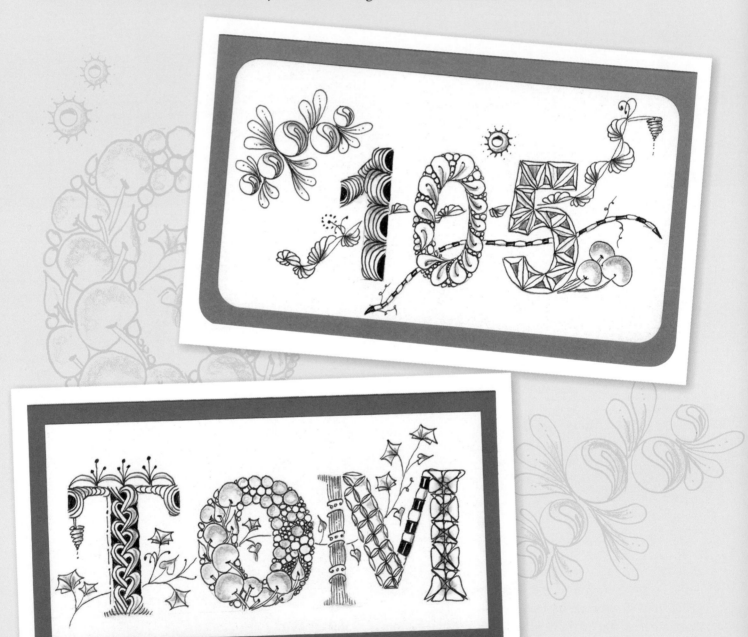

Cards for any occasion

The three little cards here are very versatile and take only minutes to make. The first one is created using die-cut flowers and tangling with Marbaix; the second is done on a Zentangle tile with Cruffle flowers and Verdigogh stems; the third one is done on blue card with a white Gelly Roll pen. The blue card was die cut before I drew the tangles on it.

Be deliberate and fluid when making the strokes

Making a concertina card

This is a lovely project to complete. I cut a piece of lilac card in half lengthwise and then folded it into a concertina—one "valley" fold and then a "mountain" fold and so on.

Starting with the cover, I used a decagon die-cut shape and drew Paradox with a purple sparkle Gelly Roll pen. I added a gem in the middle. On the inside the first page is part of a Dreamweaver stencil, and again using a colored pen I filled it with Onion Drops, Flux, and Tipple. On the next page I made a little pocket to put a tangle in and used LaCePa and Steps on the pocket. The following page is a circle of N'Zeppel and the last page is Angel Fish, Marbaix, and Widget. You could decorate the back of this too and add some pretty ribbon to tie it up.

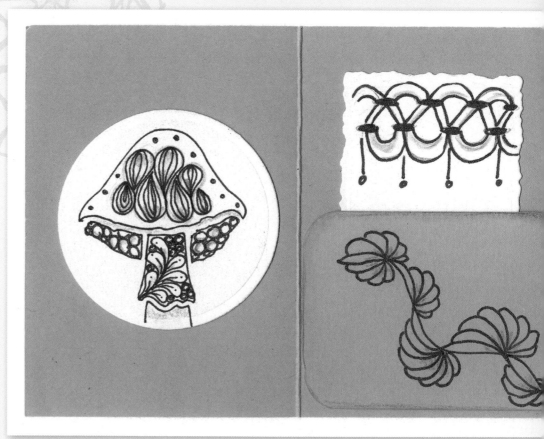

Inside pages

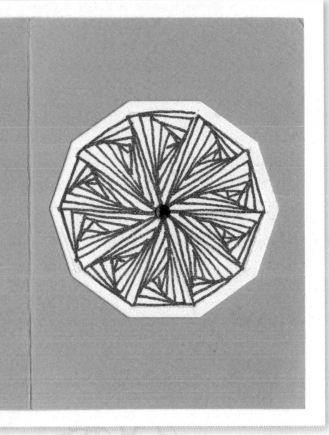

Cover design

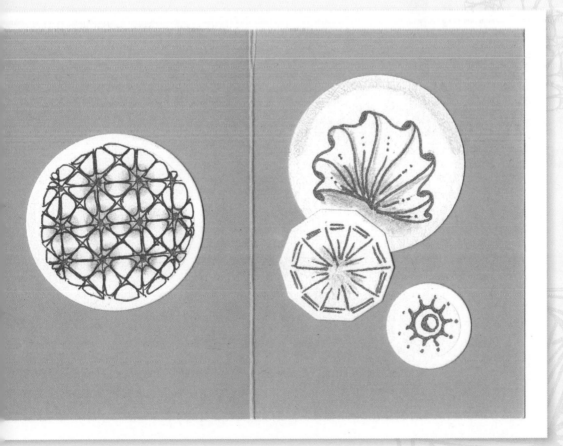

Quick cards

These three cards are made with blank cards and each one has a Zendala drawn on some artist's paper. The first one is done using part of a stencil; the tangle is Copada. The second one is part of a stencil designed by Julie Evans CZT and the tangles used are Brax in the middle, Dragonair and Tipple in the circle, and Btl Joos around the outside. The third one is the tangle Chemystery in a circle. They each have a little craft gem in the center.

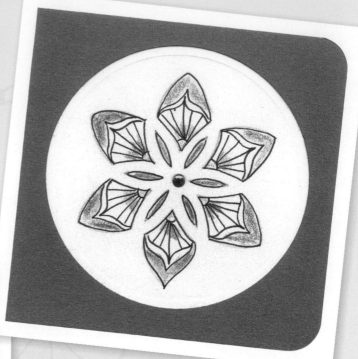

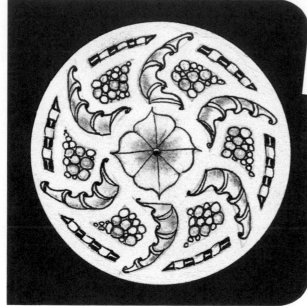

Aperture card

For this card I die-cut a circular aperture, but pre-cut aperture cards can be bought from a craft shop. I used a stencil designed by Julie Evans on the inside of the card, inside a vase stencil. I then closed the card and carried the stencil shape on to the outside of the card, creating a complete Zendala. The idea here is that the card holds a surprise when you open it. Very few tangles appear in this design: I used Poke Root, Poke Leaf, Meer and, on the front, a little Organza border. I colored it all with a Koh-i-Noor Magic Pencil.

Outside

Inside

Making tags

To create a nice added touch for your gifts, make tags on which you can write a thoughtful message to the recipients—after all, they will value your warm feelings towards them as much as the gift itself. Colored fineliners are suitable for these and glitter pens such as Sakura Gelly Roll Black Sparkle are very effective, too. Give the sparkle pens a try on colored card as well as white.

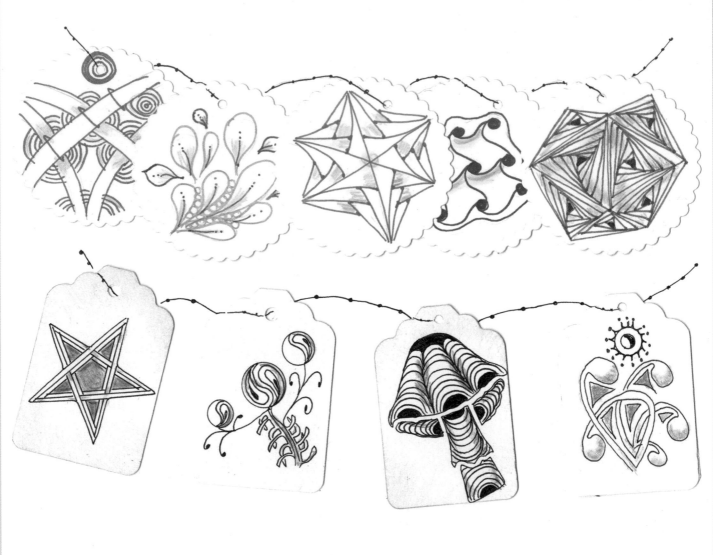

A tangle a day

One of the best things you can do for your wellbeing is to practice Zentangle every day—just ten minutes a day in a meditative frame of mind as you draw your tangles will calm and ground you. I have Carole Ohl's book *Tangle A Day Calendar* (openseedarts.blogspot.com). Below is a page from it which I tangled one evening. I just kept on adding because I found the process so relaxing; it doesn't matter that the final result is a little overdone. I used mostly Cruffle, Onion Drops, and Mooka, colored with a Koh-i-Noor Magic Pencil.

The other two tiles are examples of spending 10 minutes tangling—they are very free and easy drawings, again colored with a Magic Pencil.

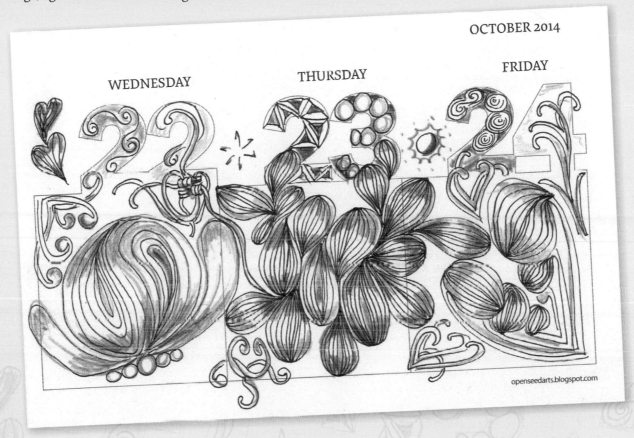

OCTOBER 2014

WEDNESDAY THURSDAY FRIDAY

openseedarts.blogspot.com

Faux vitrail project

RITA NIKOLAJEVA CZT, LATVIA

Some of Rita's Zendalas are shown on pp.59–61. Her project here, inspired by stained glass, typifies her adventurous approach.

"Faux vitrail" means "false stained glass." I've always been fascinated by stained glass, be it in church windows or Tiffany lamps and the like. Oh, the colors with the light shining through! And the lead separation strips, so expressive and cartoony!

Of course, stained glass cannot be replicated truthfully in classic Zentangle drawings, or even in ZIAs, but we can try to emulate some basic principles: for example, we could draw a few focal elements connected by strips or bands, which divide the remaining space into smaller sections. Let's do it together, on a classic Zentangle tile!

You will need:
- A Sakura Pigma Micron pen
- Derwent Inktense pencils

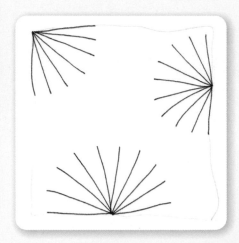

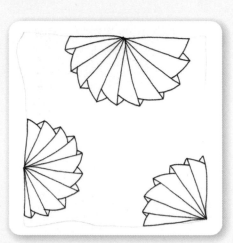

1 Phicops, by Brad Harms, is a versatile tangle that goes beautifully with Hollibaugh. Lightly pencil in a border, then draw as many Phicops on it as you like, in ink. The step-out can be found on tanglepatterns.com.

2 Again with your pencil, draw an aura around every Phicops—it will help you to place the Hollibaugh strips.

3 With your pen, draw Hollibaugh, starting and ending on the aura around the Phicops, crossing the strips, until the space is divided as you wish.

4 Now, trace the aura and the tile border between the Hollibaugh strips. That's it!

5 Of course, you might want to decorate your design further. How about embellishing the Phicops?

6 Or filling the spaces between Hollibaugh bands with background tangles of Printemps and Tipples?

7 Some shading always comes in handy, too.

Or you can go wild with color; after all, we are talking stained glass here!

Now let's do it again, but this time in the round. Gel pens are great for coloring in this "stained glass." I used my favorite Sakura Glaze pens.

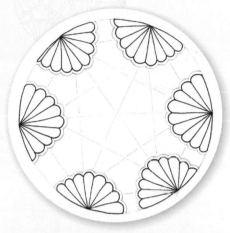

1 On a blank Zendala tile, lightly pencil in a border. On the border, draw the beautiful tangle Sanibelle by Tricia Faraone.

2 As before, pencil in an aura around each Sanibelle.

3 Lightly pencil in the paths for Hollibaugh. This step is optional, but helpful, as you might want your Zendala to look neat and orderly.

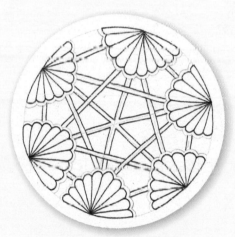

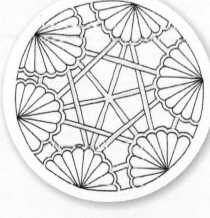

5 Finish by tracing the aura and border parts between the strips.

4 Now draw the Hollibaugh strips in pen.

I used a double layer of gel pens on the blue and purple Zendala and a single layer on the green and brown Zendala, plus shading with a Pitt Artist pen marker.

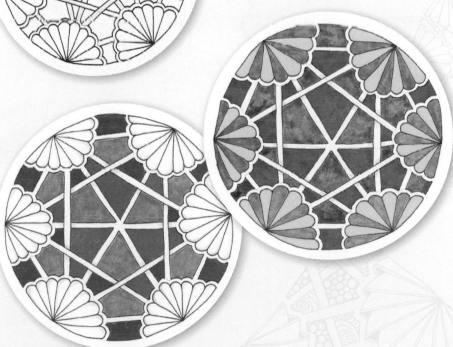

Compass mandalas

CAROLINE CLARKE

This design is based on the compass pattern shown on p.22. It was created by one of my Zentangle group, Caroline Clarke, just using the "petal" part and erasing the circle lines. I think it makes a lovely design and have copied the idea to make my own "Caroline Star" (bottom).
I tore the edge around my "star" and colored the edge before sticking it on a circle.

Caroline used Btl Joos, Crescent Moon, and Tipple with a clever bit that forms a pattern joining it to the Crescent Moon. Mine is very simple, with Btl Joos and Flux with Tipple.

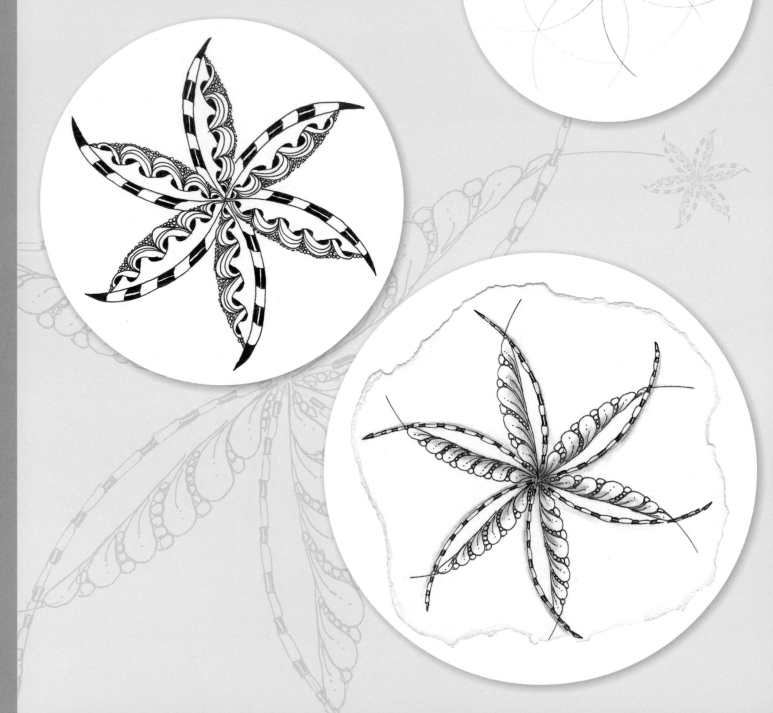

Zentangle friends

IRIS JONES & JULIA MEARS

I teach a Zentangle class at a care home once a week and one of my students is Iris Jones, 88 years old and really enjoying her Zentangle sessions. The first Zendala shown here is one that Iris has done for this book using various tangles that she likes.

The second is by one of my Zentangle group, Julia Mears. Julia seems to have quite an affinity with fish and other sea life. She drew this attractive fish first before doing all the tangles around it.

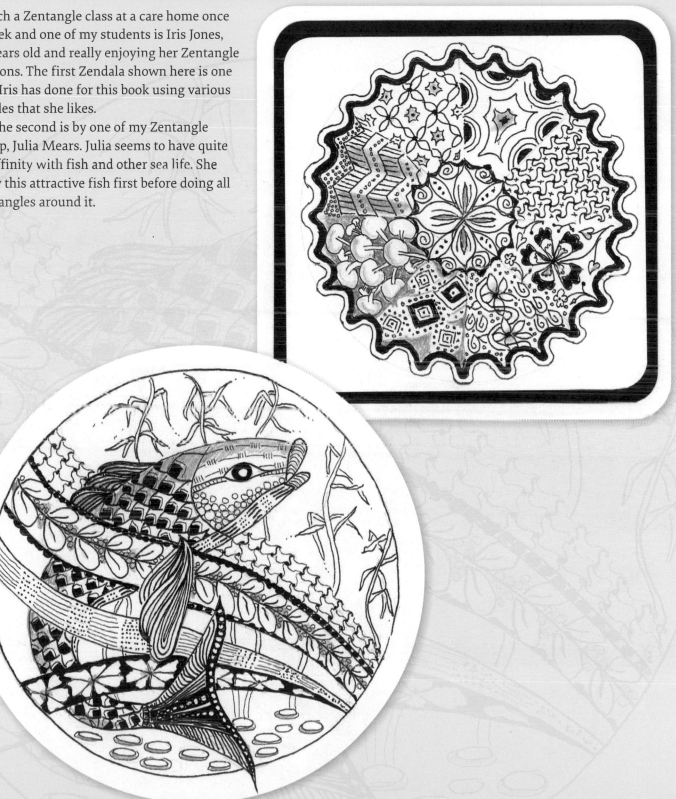

Using color in mandalas

MARY JANE HOLCROFT

Mary Jane Holcroft is a primary school teacher and an artist too. Consequently, she has a real talent for drawing mandalas with color.

I love the idea of a mandala representing a never-ending cycle; a repeating pattern that echoes the life pattern of the universe. We see circles all around us in nature, and with the aid of a microscope it is evident that circular structures are the building blocks of life. When I draw a mandala I create some kind of structure, some kind of order. Each repeated small segment comes together round a central point to make something more powerful, more expressive than it would be on its own. The mandala unifies.

The two circular mandalas here were created on Zentangle Zendala tiles. These tiles were pre-strung, allowing me to focus on the tangles and shading. I try to balance darker and lighter areas when tangling.

Poke Root and Betweed are the main players in this piece, complemented by Printemps and Zinger. The use of black makes the tangle "pop." It also helps to create an undulating effect next to the lighter Betweed.

Paradox creates the central segment here—the complexity that can be created with such a simple line always amazes me. Hypnotic, Pheasant and Crescent Moon complete the image.

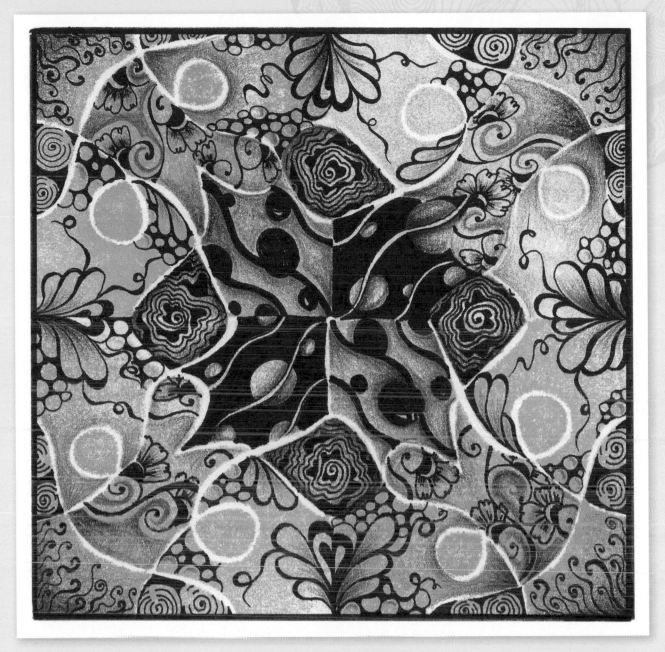

Here I used Printemps, Diva Dance, Rock and Roll, Fescu, Quipple, and Henna Drum.

Fellow CZT Arja de Lange-Huisman introduced me to the squaredala technique. She cleverly created a way of printing, using foam tiles, to make an interesting background for tangles. Her blog, elefantangleblogspot.com, contains full instructions.

The pieces here and overleaf contain some of my favorite tangles: Diva Dance, Flukes and Leaflet seem to find their way into so much of my work. I love color, so instead of shading in graphite pencil I used Derwent Inktense pencils to create depth. I simply chose slightly darker shades of the existing background colors.

Breakwater project

STELLA PETERS-HESSELS CZT, NETHERLANDS

Stella lives in Breskens in the south of the Netherlands, near some of the breakwaters that inspired her ZIA.

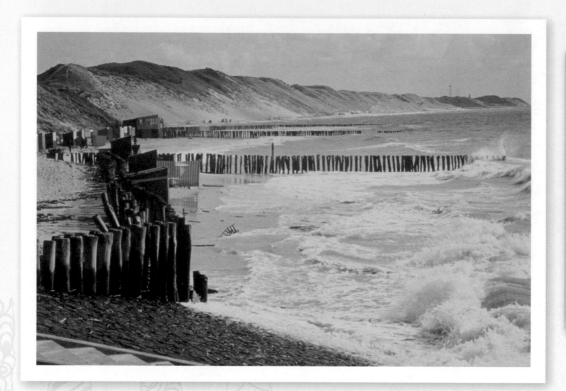

The breakwaters in the southern Netherlands are made from wooden poles and are there to protect the coast of Zeeland from the sea. Their strong graphic outlines inspire many artists and are ideal for Zentangle patterns. Try this coastal theme for yourself.

You will need:
- square white tile
- 2B pencil
- paper stump
- 0.1 Sakura Micron pen
- small shells and sand

1 With a pencil, draw your own composition of the breakwaters on the tile. These are weathered wooden poles, so don't make the shapes too straight and perfect.

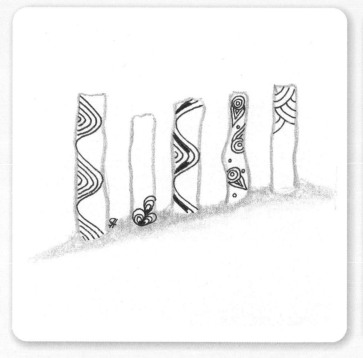

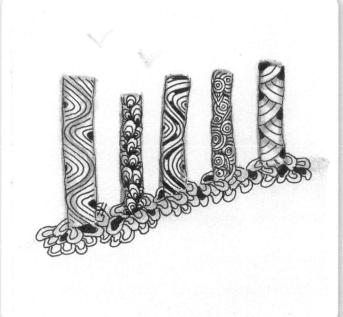

2 Choose a tangle for each breakwater—either the ones I used or your own favorites. Draw the tangles with your pen.

3 Tangle the "pebbles" around the breakwaters with Morf. (You can choose to let the breakwaters stand in sand or the sea if you prefer.)

4 Add shading with the pencil and paper stump to complete your patterns.

You can make it an even more beautiful piece of art by turning it into a seaside image. Go for a walk on a beach and gather some sand and little shells.

At home, once the sand is dry, choose the placing for the shells on the tile, then use a colorless glue to attach them. Spread glue where you want the sand to be, then sprinkle sand over it. Stand back and appreciate your work!

Tangles used: Antidots, Morf, Pixioze, Shattuck, and Wud.

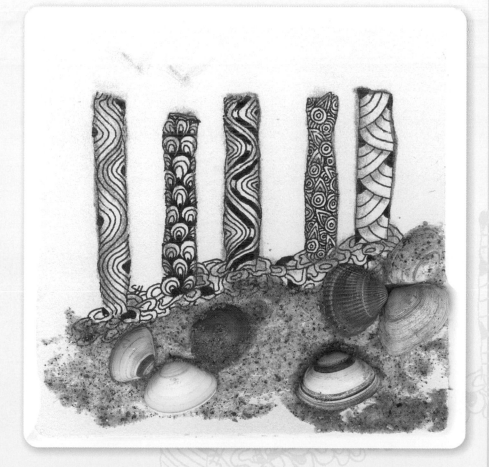

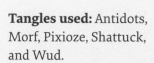

Wud by Joni Feddersen CZT

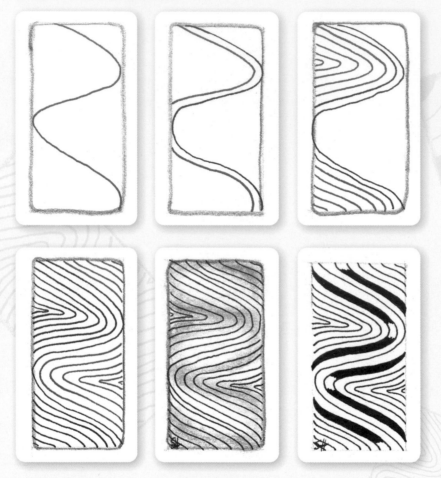

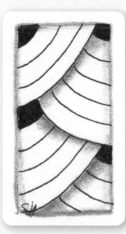

Pixioze by Margaret Bremner CZT

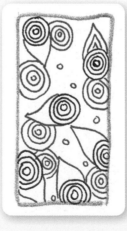

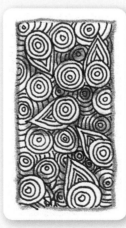

Morf by Susie Achter

Antidots by Anita Roby-Lavery CZT

A Zentangle-style holiday journal

DR LESLEY ROBERTS CZT, UK

Keeping a holiday journal is something most of us have done at some point in our lives. Looking back and reflecting on precious days spent on vacation is an effective way of chasing away the winter blues.

When I look back at my written journals there is quite an emphasis on where I went, what and where I ate, and whether I swam that day. Sometimes I record dreams if they were very vivid, as they can be when we take a break from our usual routine. My holiday journals, though, have always been predominantly visual and more creative.

I have done them in many formats but in recent years I have taken to using Zentangle tiles. I adopted this approach immediately after attending a Certified Zentangle Teacher training course in Providence, Rhode Island, in 2012. The course had heightened my awareness of the patterns and imagery around me. I wanted to capture everything I noticed and so began to draw patterns on the Zentangle tiles. Every day I drew small parts of the patterns I noticed in my environment on the front of the tile, and on the back I wrote my reflections.

The beauty of the Zentangle tile is its size – you can't write much on a 3½in (9cm) square and the area for drawing is similarly manageable. You could, of course, create a set of tiles of this size (or any size) from good-quality watercolor or printmaking paper to take with you, but the Zentangle tiles are incredibly handy and very nice to draw on.

A special holiday

In 2014 I decided to keep a journal for a very special three-week holiday in Massachusetts. Long Island and Cape Cod were just two of the coastal places we visited, with their beautiful coves and artistic communities. The tiles shown in the next few pages are some of the artworks I created during this memorable trip.

I took my inspiration from the sights around me—the seashore and its natural inhabitants, the enchanting lighthouses. I discovered that I enjoyed drawing the outline of the things that took my attention in Zentangle style. By this I mean drawing with deliberate strokes and not sketching the outline with multiple strokes until I got it "right." I then filled the outline with Zentangle patterns.

When I got home I displayed the tiles on a cork board, pinned without making holes in the paper so that I could take them down whenever I wanted and remind myself of a very happy time.

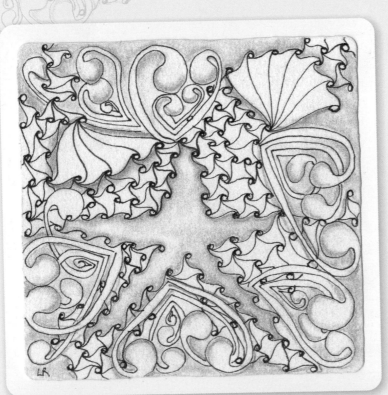

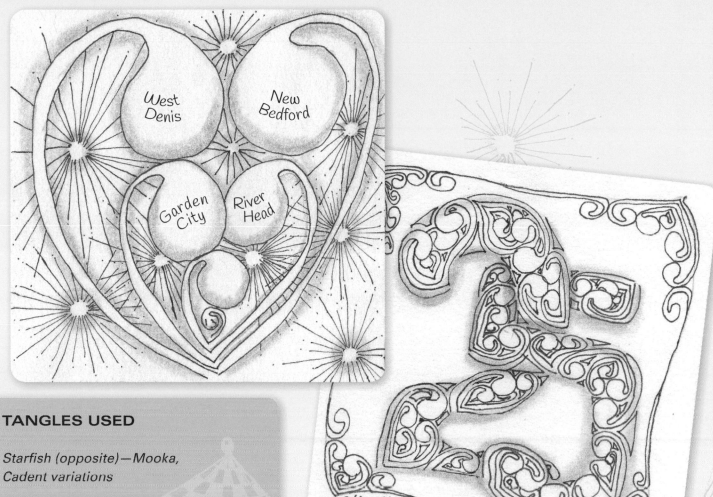

TANGLES USED

*Starfish (opposite)—Mooka,
Cadent variations*

Place names—Mooka, Ahh

25—Mooka

*Whale tail and sea—Amaze
(with some Bubbles)*

Overpage

Horseshoe crab—Tipple (sand)

*Waves—Auras for upper line, and Tipple
for the crests*

*Fish—Paradox, 'NZeppel, Cadent, Purk,
Bales, Mooka, Indyrella*

*Underwater scene—version of Mysteria
for bottom of sea and weed, with Wavy
Static variation at edges*

*Lighthouse—sea is Tagh variation
(infilled), plus Bales, Knightsbridge,
Mooka, Wavy Static*

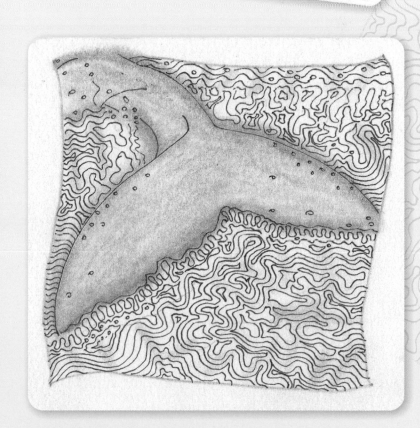

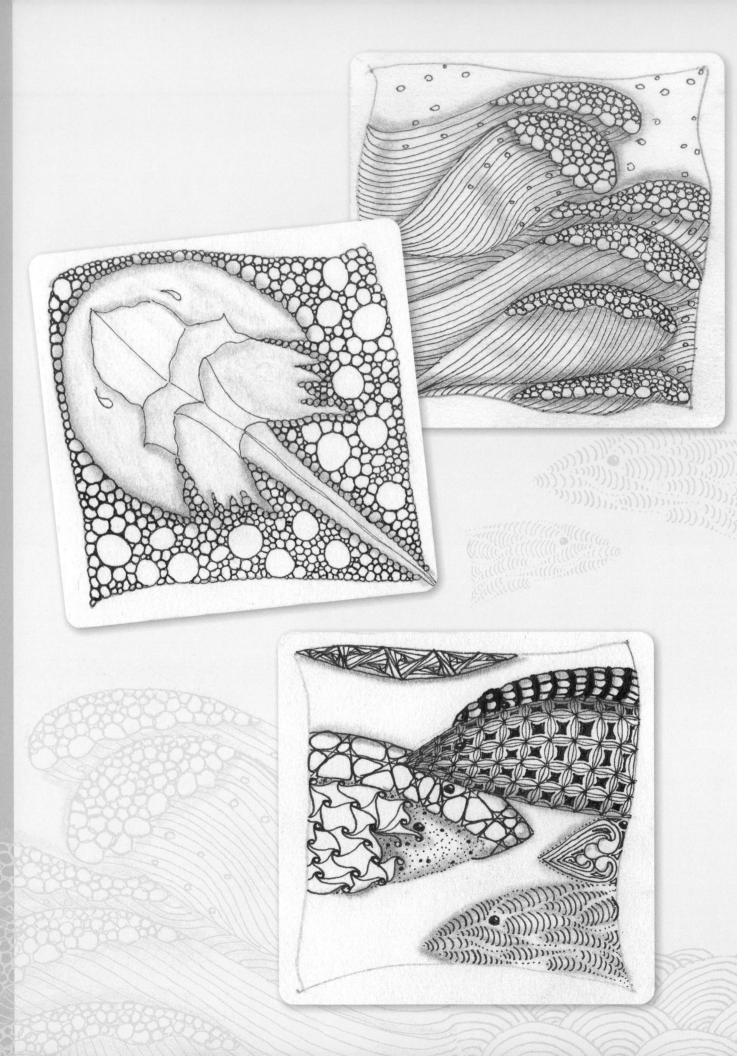

CREATE YOUR OWN ZENTANGLE-STYLE JOURNAL

The Zentangle-style holiday journal is very simple. On the front of the tile you could draw the basic outline of something that has caught your imagination, using the usual Zentangle materials. The next stage is to fill your outline drawing with Zentangle patterns of your choice. This approach takes away the fear that many of us experience when trying to draw from real life and makes it more fun, less of a difficult challenge.

On the back of the tile, you could record some of the key events of your day or your reflections on it, as well as the date and location.

After your holiday you could make the tiles into a book (leaving both sides visible) or make a box or bag to keep them in.

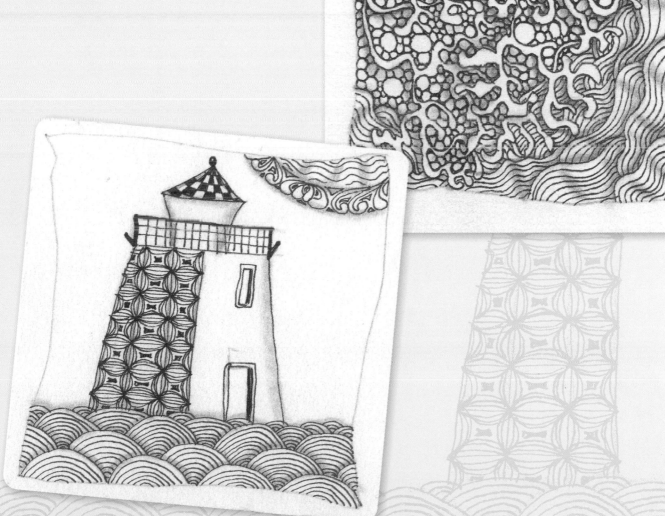

Tangling on shells and stones

DR LESLEY ROBERTS CZT, UK

Lesley finds her inspiration in many and diverse ways, and in this project you'll find ideas for tangling on surfaces from the natural world around us.

I've taught several groups of students to tangle on shells—mussels, scallops, slipper shells, periwinkles, limpets, whelks, jingles, cockles, clams, wedge shells, otter shells, barnacles, oyster shells, cuttlefish. These classes are always especially happy ones—I think that drawing on shells and stones allows us to really connect with our inner, creative, child-like self. You can see several photographs on my Facebook page, The Arts of Tangling.

Drawing on hard surfaces is quite different to drawing on paper or card, so here are some tips for tangling on shells and stones.

Which shells and stones are the ones to choose? Apart from razor shells and sea urchins, which are very delicate, you can have a go on most smooth shells and stones. Avoid those that are very shiny, chalky, or rough, with lots of holes and dents. They can give more interesting results, but shiny surfaces can resist even permanent pens, while chalky or rough surfaces can ruin your pen. Very curved surfaces can be challenging, but you can get attractive effects. Take an experimental approach—just aim to enjoy each deliberate stroke that you draw and be in the moment.

Preparing the stones and shells You might want to wash them to get sand, seaweed, or mud off, but there is no need to bleach them or overdo the cleaning. Of course, if there is a live creature still in a shell, leave it in the sea or on the rock where you found it.

Suitable pens Sharpie ultra-fineliners are very robust and about the same line width as an 0.5 Sakura Micron pen, or try Sakura Identi-pens. They are both permanent pens, designed for drawing on things other than paper, such as plastic, wood or stone. You'll find that some pens work better on different shells or stones, depending on their surface.

Tangling technique Start by appreciating the shell or stone; be really mindful of it, and become aware of any bumps, dents, curves, or patterns that make it unique. Are there any natural features which could be used instead of a string? Or to draw around or between? Is there a darker edge to the shell or stone which you might want to

follow, drawing close to it? Let the shell or stone guide where you tangle, and even what patterns you tangle. For example, will it suit organic or geometric patterns most, or a mix of both, perhaps?

Shading and color Blend pencil with a tortillion as you would on a tile—just be gentle on these harder surfaces. This can work really well on smoother shells and stones. Where they are bumpy, with holes and dents, I have used a grey Kuretake graphic pen. You cannot blend the shading with this, although you can buy several pens in various shades of grey to achieve a graduated look. Simple shading with a pencil, or one color of grey pen, works well enough, though.

Using little splashes of color can make a big difference. I tend to tangle the patterns first, and then see where adding color would enhance them. With the shells in particular, seaside colors can work well—blues, turquoises, and greens.

Longevity I have not put any preservative finish on my shells and stones, but I do keep them out of rain and direct sunlight. Various forms of varnish for art or wooden furniture could be applied if you wanted to put yours outside, as long as you have used permanent pens.

Enjoying your shells and stones Not only is tangling shells and stones a lovely way to express your individuality, the finished objects can often be quite strange and intriguing. They make lovely gifts—for yourself, and for others. They can be used as greetings "cards," paperweights or decorations. If you keep a collection on a shelf or in a basket you will notice that people turn them around in their hands to see them from all sides. You might want to meditate on one of them from time to time, or handle it during a difficult phone call. When I've taught this in classes, it's been beautiful to see how happy people are made by this simple activity.

If you have any questions about these instructions, please do email me on lesley@theartsoflife.co.uk.

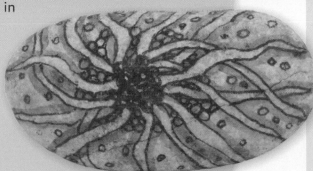

Accordion book

MARIA VENNEKENS CZT, NETHERLANDS

Maria's project is one of my favorites as I love making little books. I think a book such as this would be a lovely present for someone, and as this particular one is personalized for me I shall treasure it! The simplicity of using just one tangle per letter has given a very attractive result, and her alphabet can be used time and time again.

In this fun project you will make a small accordion-fold book where the pages are tangled letters. These could form someone's name or any another word. The book could be used to congratulate or thank someone, or to accompany a gift.

You will need:

- 1¾ x 14in (4.5 x 36 cm) cartridge or watercolor paper
- 2 x 2⅛in (4.9 x 5.4 cm) cardboard, about 2 mm thick, 2 pieces
- 2¾ x 3in (6.9 cm x 7.4 cm) thin decorated paper, 2 pieces
- pencil
- Sakura Micron 01 and 08 pens or a Sharpie
- Scissors or knife
- Glue stick
- an envelope or a colorful elastic binder to close the book (optional)

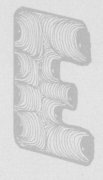

1 Take the strip of paper and fold both ends together.

2 Open it up and fold both sides to the middle fold. Repeat once.

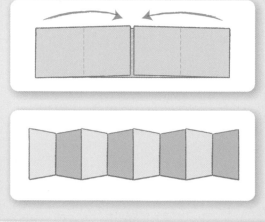

3 Open the paper and start making the accordion book by folding back and forward on the creases. Now you have a book for six letters. The pages at both ends will be glued to the covers and will stay white. If you have a short word you can leave more pages white; if you need more than six pages you will have to fold another accordion. Remove the first page of the second accordion, leaving a ¾in (1 cm) gluing strip. Glue the strip to the back of the last page of your first accordion. Make sure you start and end your accordion with pages that point towards you.

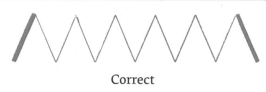

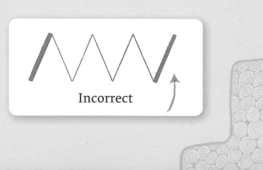

Correct

Incorrect

5 Now you are ready to draw the letters on the pages. Using the whole page, trace the outline of each letter with a Micron 08 or a Sharpie. Using a Micron 01, fill the letters with your favorite tangle patterns and shade them.

6 For the covers, take the cardboard and the decorated papers (which could also be tangled). Glue the reverse of the decorated paper and place the cardboard in the middle. Cut the four corners of the paper, making sure you leave 2mm between the cardboard and the cut. Then glue the exposed areas of the paper and fold them over the cardboard. Attach the covers to the first and last page of your book.

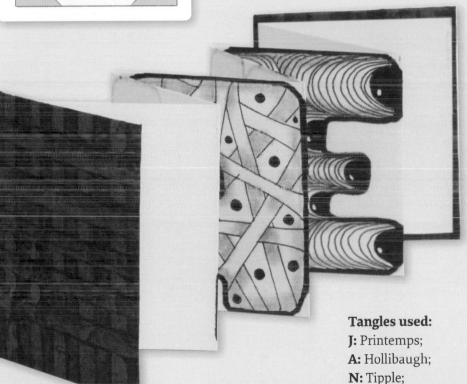

VARIATIONS

- *Use colors for your tangling.*
- *Use a colored or black paper and your gel pens to do the lettering.*
- *Change the paper measurements, making the pages slightly more high than wide. A square book is another choice—but bear in mind that the book is most elegant when it is small.*

Tangles used:
J: Printemps;
A: Hollibaugh;
N: Tipple;
E: Crescent Moon.

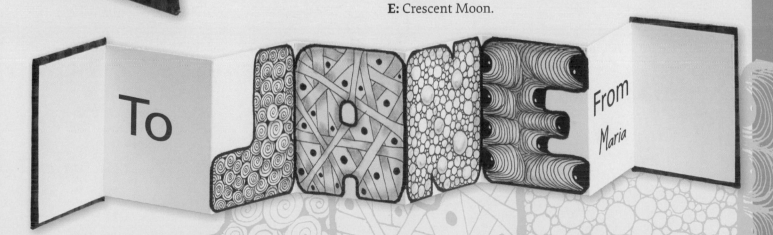

FUN FOR ALL AGES

**Zentangle appeals to everyone, from the very young
to the very old, and it's something that grandparents
and grandchildren can enjoy doing together. This
section offers some lively and uncomplicated tangles
and artworks for children to tackle with confidence
and enthusiasm.**

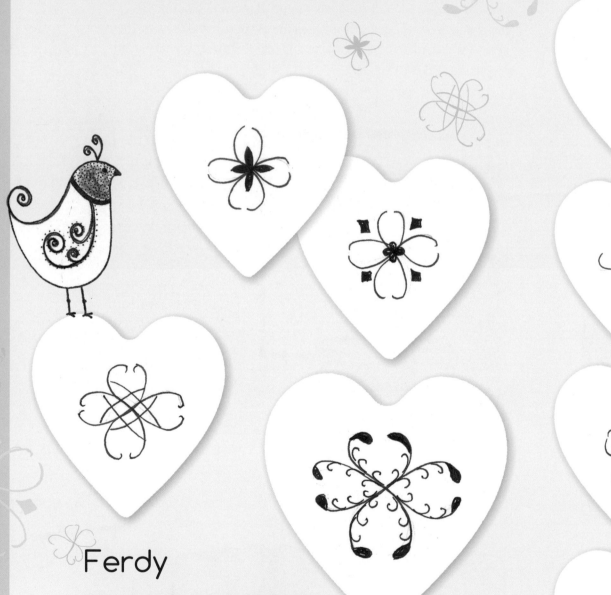

Ferdy

BUNNY WRIGHT CZT, CANADA

Ferdy is an almost heart-shaped tangle that can
be added as a embellishment anywhere, perhaps
changing the shape a little. Here are some
variations on it, too.

Jujubeedze

ROSIE HILL CZT, USA

This is a fun tangle with a great name. It makes fabulous earrings for my party girl, styled on the original flapper girl by Lyn Dines. I added some color with a Koh-I-Noor Magic Pencil. Individually, the beads would make nice Christmas decorations for a card.

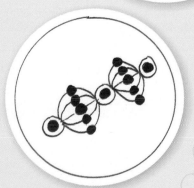

Tangles used:
Jujubeedze, Knase, Msst and Onamato.

Pixioze

MARGARET BREMNER CZT, CANADA
http://enthusiasticartist.blogspot.co.uk

This is Margaret's latest tangle, which she is rather fond of and I can see why. It is fun to do—like drawing Printemps but with some "leaves" added for a different effect. It made for lovely "wool" for my Dreamweaver lamb. The only other tangle I used was Crescent Moon for her feet.

Tipple

ZENTANGLE® ORIGINAL

Tipple is a must for any tangler—it looks good on its own and is great for filling in small spaces and backgrounds.

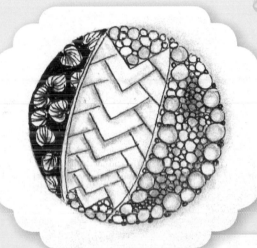

Tangles used: Lilypads, Tipple and Bilt.

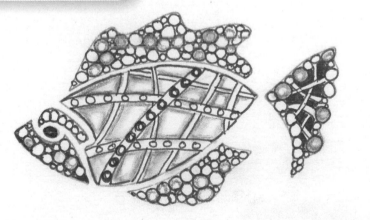

Tangles used: Hollibaugh and Tipple on a Dreamweaver stencil.

Using stencils and tracing

Using stencils and making tracings are a great way to get children tangling, as they establish a recognizable shape of a favorite object or animal. However unpracticed the tangling might be, they will still have the pleasure of showing off their work without anyone enquiring what it might represent!

Dog card

I traced a dachshund and tangled him with Printemps, Knightsbridge, Mooka, Bales, Flux, and Btl Joos for his tail. I then mounted the card on a piece of patterned paper and stuck it on a blank card, using a bit of the leftover patterned paper for a border.

Boat stencil

There are many inexpensive stencils available online, often in sets, for example transport, dinosaurs, and jungle animals. They are great for children, who can make the tangles as simple or complex as they like.

Tangles used: Fassett, Btl Joos, Paradox, and Keeko.

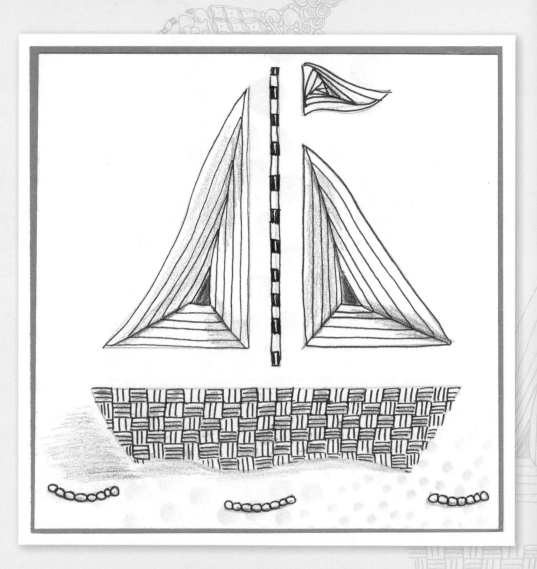

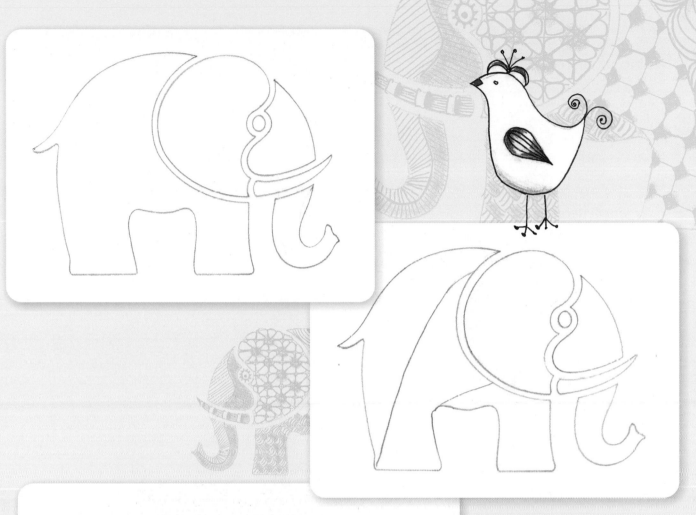

Elephant stencil

This Dreamweaver elephant has a very easy shape to tangle. First, trace the stencil outline in pencil.

Draw some strings to divide up the elephant's body to make spaces for different tangles, then add some tangles of your choice. The trunk could also be done with Zander and the ear with Kathy's Dilemma or Tripoli, while the body could be all the same tangle rather than three different ones, as here Bales is a very easy one to try.

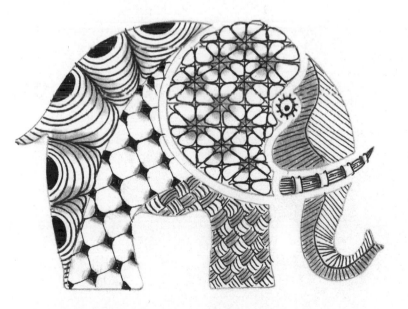

Tangles used: Crescent Moon, Florz, Keeko, Meer, 'NZeppel, and Zander.

Dinosaur stencil

Most children love dinosaurs, and indeed this is one of my own favorite stencils. You can buy a whole set of dinosaurs for very little cost. Try doing two versions of the same dinosaur, changing the tangles to see how different they might look.

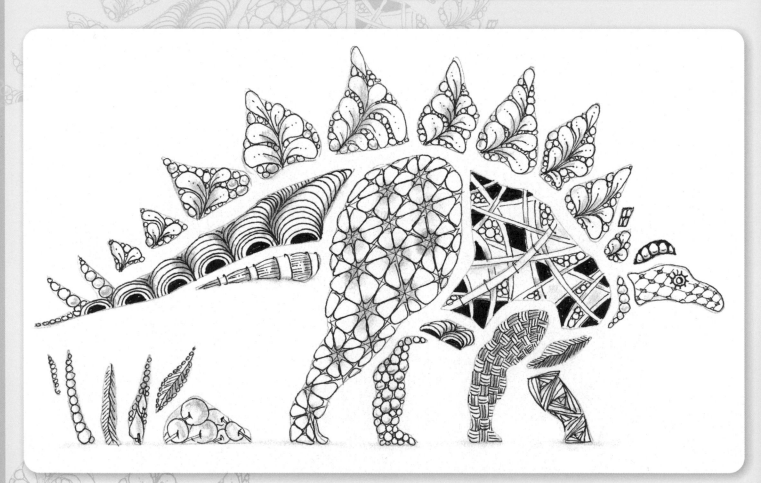

Tangles used: Flux with Tipple, Crescent Moon, Zander, 'NZeppel, Tipple, Keeko, Hollibaugh with Tipple, and blacked-out spaces, Meer and Paradox. There is a bit of Poke Root and Meer in the foreground.

Tangles used: Btl Joos, Crescent Moon, Tipple, and Marbaix.

Car stencil

Tangling several versions of this cheery car in a range of colors would produce a whole fleet that could be lined up on a child's bedroom shelf.

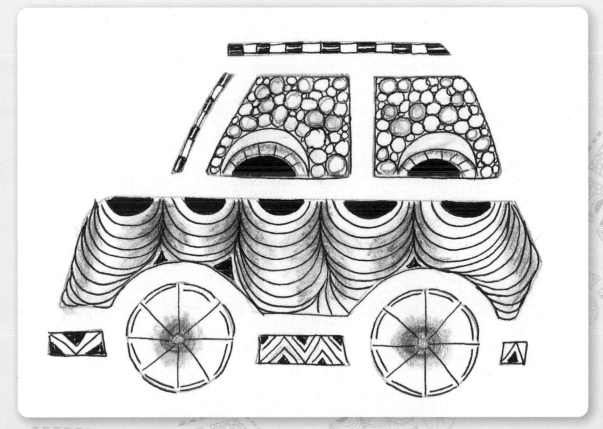

Garlic Cloves

JACQUELIEN BREDENOORD, DENMARK
http://www.frubilledkunst.dk/

I really love this tangle and often add it to a greeting card to make a corner design. It is very easy to do, so children could take pride in making a birthday card for a member of the family. As you can see by the examples, it can be used in different ways—the designs here are all done with a single tangle. It is a really good one to color as well.

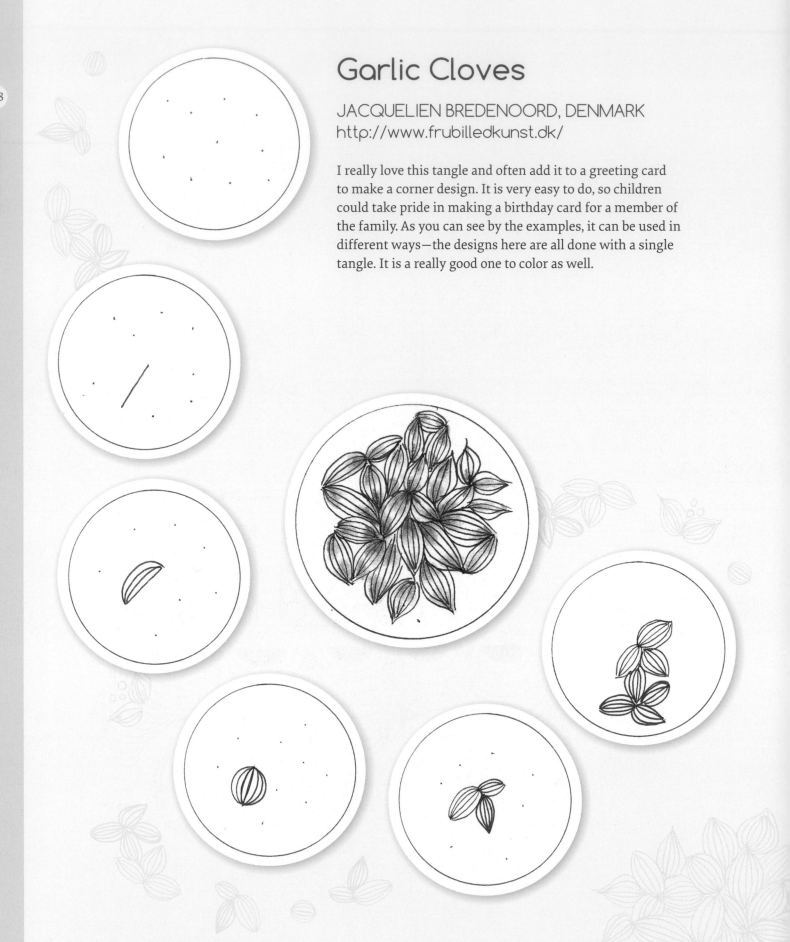

A garland of garlic cloves would make an attractive frame.

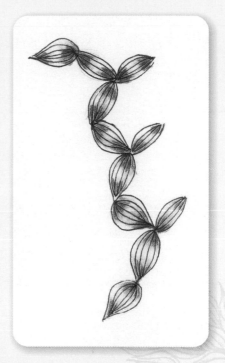

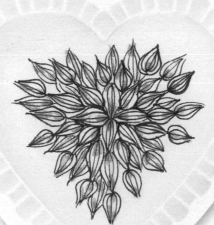

Here I have used a Dreamweaver stencil, coloring it with some distress inks through the stencil with a Clarity stencil brush. I have then started the garlic cloves in the middle and worked outwards.

I have die-cut this card with a Woodware die, using three sizes to achieve the black frame for the little picture.

I have again used the Woodware die, here creating a little picture of a girl with Garlic Cloves. The possibilities with this tangle are endless.

Making a scrapbook page

CHRISTINA DORÉ, UK

Scrapbooking is very popular in the USA, where it seems to have originated in the craft world, and is rapidly becoming equally so in Europe too. You can do a page for each event you would like to remember, whether it be a birthday party or a holiday. Traditionally the size is 12in (30.5cm) square, but I think a smaller page is more manageable for storing.

You could add some journaling to this project as well, using your own handwriting, which will be appreciated when it is handed down to future generations. Remember that Zentangle improves your handwriting, as it teaches you to slow down!

Christina took a piece of colored card and mounted a photo of her rabbit, Topsy. She made all her tangles on circles and then stuck them on to the card. To finish, she added some craft gems and die-cut letters for Topsy's name.

Tangles used: BB, Cadent, Crescent Moon, Hollibaugh, Lotus Pods, and Tipple.

Dolls

SUZANNE MCNEILL CZT, USA

I traced this paper doll from Suzanne's book *Zentangle®* 10 and changed it to make a boy as well as a girl. I used 'NZeppel for the dress on the girl, Emingle for the boy's trousers and Cadent for his waistcoat; his arms are Btl Joos and her arms are Meer. Then I created some headgear in folk-costume style for the girl. For a fun project, you could draw a line of joined-up dolls and then cut them out after tangling them, or you could use them on a card.

Tangle Folk

BILLIE LAUDER CZT, USA

In this delightful project, follow Billie's instructions to create some lovely little Tangle Folk. The clothes and hair allow you lots of opportunity to be creative.

Man

1 Start drawing at the right side of the neck and go down through the left side of the body and the inside edge of the leg and left foot.

2 Go from the left foot around and up the outside leg, then down outside the right leg as far as the right foot.

3 Go from the right foot up the inside edge of the right leg and up the right side of the body up to the neck.

4 Draw from the neck down the outside of the left arm and carry on down to form the left hand.

Woman

5 From the left hand, go up the inside left arm towards the neck and then down the outside edge of the right arm to the hand.

6 From the hand, go up the inside of the right arm to the neck and then on to form the head.

Now you have the finished Tangle Folk man or woman! Tangle him or her any way you like.

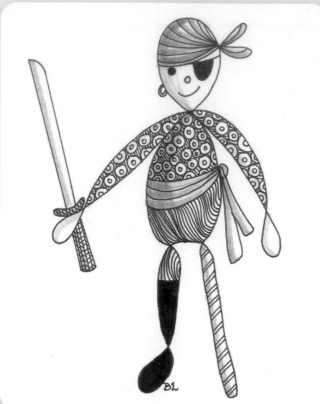

Tangle Folk ideas

Once you have got the hang of drawing Tangle Folk, you'll find you want to create a whole range of little people, roaming as far as your imagination takes you. To identify particular characters, just add typical details such as the eyepatch, scarf, and wooden leg on this pirate.

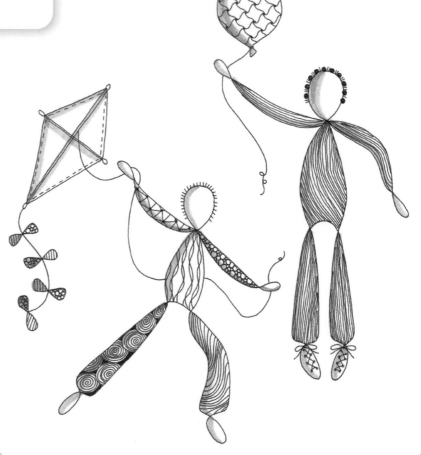

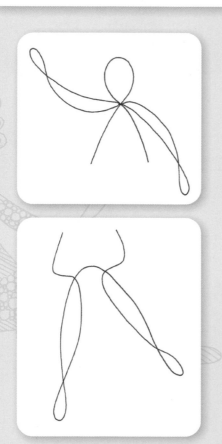

These outlines are an example of how to show your little people in action. Creating movement in your drawings takes a bit of practice.

A range of hairstyles and accessories such as hats and shoes will give individuality to your little figures—you can draw whole crowds of Tangle Folk with no two the same.

A garden scene

For this I used a tree stencil which has various circles as well. The tree is tangled with Poke Leaf, Poke Root, Printemps, and Zinger, with Shattuck for the trunk. You can add various flower or leaf-like tangles in this picture. I have used a few that I found on Pinterest and have created a few little steps for them. I have also used Verdigogh, Widget, and Joy. You may spot a couple of little Bijous (snails) in the picture!

Wheat tops

Speck tops

Mellow tops

Zinger –
a Zentangle original

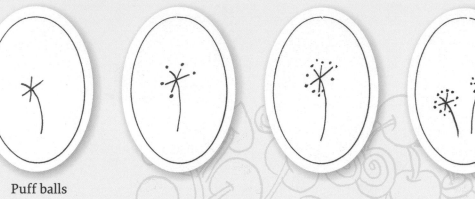

Puff balls

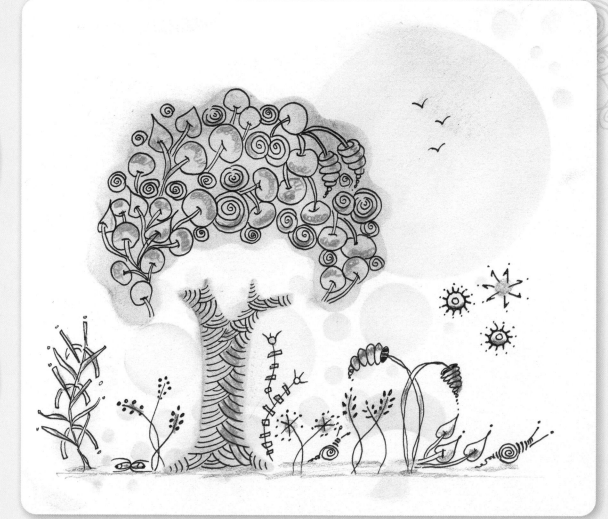

Creating a seascape

For this underwater scene ZIA, I began by adding background color through bubble-like stencils with some distress ink. I drew a lot of sea-related images before deciding I wasn't happy with the composition, so I cut out all the shapes and stuck them on a sheet of card with background color, using repositionable spray glue so that I could move the separate pieces around until they looked right.

 This is often a solution to a drawing that has not turned out right in the first place. Assembling a selection of tangled shapes is also a good way for children to compose a more ambitious picture.

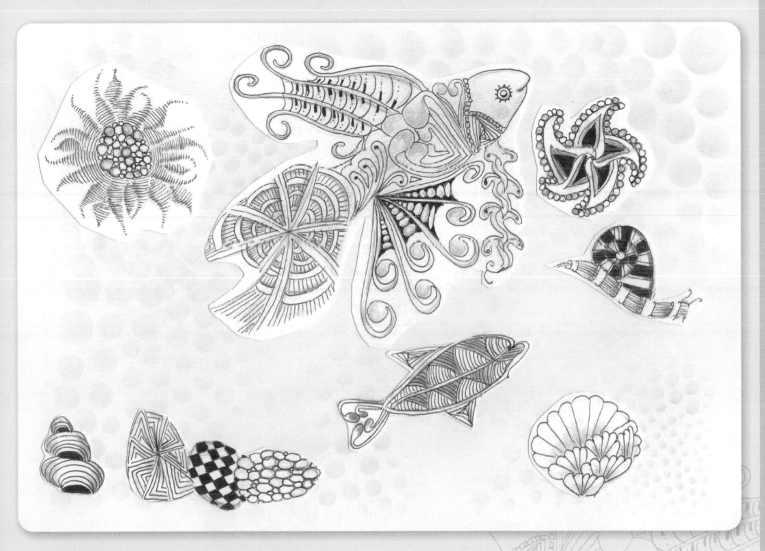

Tangles used:
Large fish: Drupe, Finery, Mooka, and Scrawlz
Small fish: Shattuck and Mooka tail
Shells: Crescent Moon (bottom left) and Sanibelle (bottom right)
Snail: Barberpole and Zander
Stones: Maryhill, Knightsbridge, and Tipple
Flora: Indyrella and Tipple
Starfish: Fengle

Hearts

This picture was done by one of my students in a care home, Rose Smith. Rose is 93 and has Parkinson's disease, so she worries that her work is shaky—but I think it just adds a little texture and could be copied by anyone who wanted to add something extra to their drawings with slightly wavy lines for a different look. Her tangles include Crescent Moon, Poke Root, and Tipple; the leaf design is her own.

Fish

The fish picture is by Julia Mears, another of my students. I love the feeling of movement in this design. The tangles used are 'NZeppel, Flux variation, Onamato variation, and Verdigogh.

A–Z OF TANGLES

In this section you will find many of the tangles used throughout the book. If the tangles you want are not here you can look them up on www.tanglepatterns.com, where you will be able to go through the index at the top to find step-outs of hundreds of tangles. If you feel you have devised an attractive tangle you can submit your own work for inclusion.

Ahh

ZENTANGLE® ORIGINAL

This is a lovely simple but effective tangle.

The first illustration uses a Dreamweaver stencil for the kimono with tangles Ahh, Bales, and Crescent Moon.

The church window has Paradox, Ahh, and 'NZeppel, both colored with blue pencils.

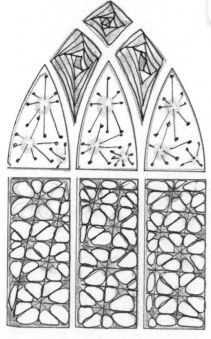

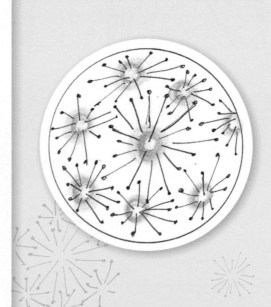

Angel Fish

MARIZAAN VAN BEEK CZT, SOUTH AFRICA

This tangle is ideal for a seascape. It is similar to Cadent (see p.153) in that the lines are joined up with an "S" shape.

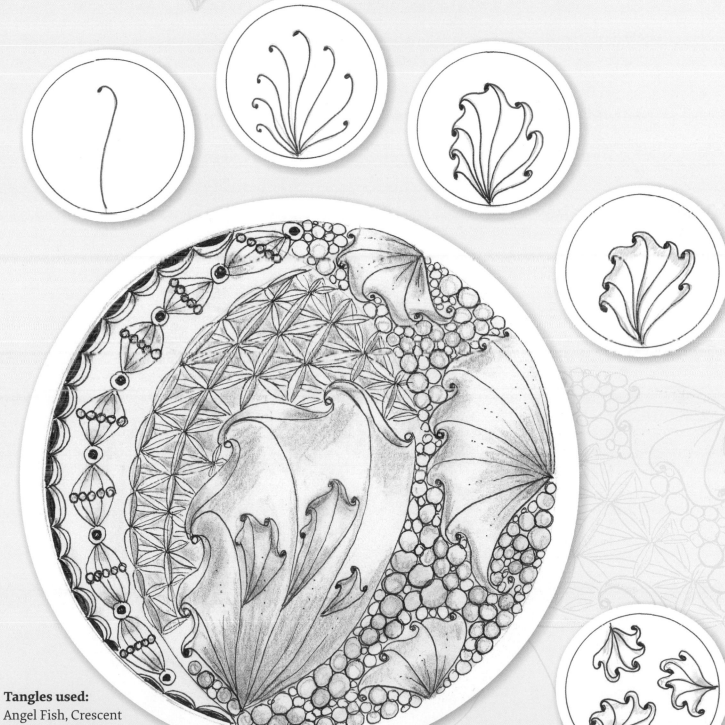

Tangles used:
Angel Fish, Crescent Moon, Jujubeedze, Merryweather, and Tipple.

Arckles

SUZANNE WILKA CZT, USA
http://tinkeredart.blogspot.co.uk

Arckles is a good border tangle. I have done a simple step-out but there are variations to be found on Suzanne's website. You need to take your time doing this and make sure that the semi-circles line up opposite each other, otherwise you will get into a real tangle!

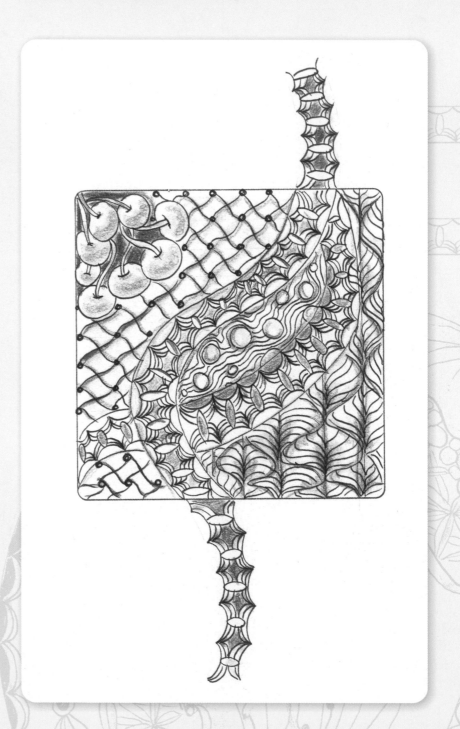

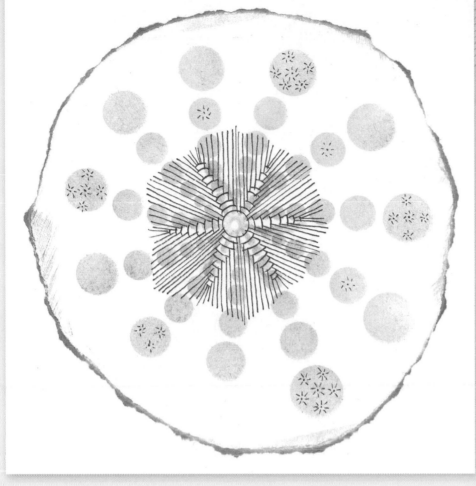

Arukas

A ZENTANGLE® ORIGINAL

This is a really clever tangle with endless possibilities, created by Molly Hollibaugh. Shading is important in this one to add a three-dimensional feel. When you are doing this tangle it is quite useful to pencil a small cross at the starting point so that you know where you began. Rotate your piece of paper as you go, and when you have completed the lines going round once, add the second circle, then continue in the same vein.

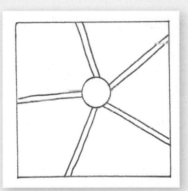

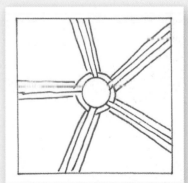

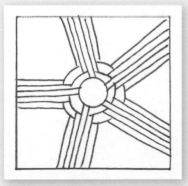

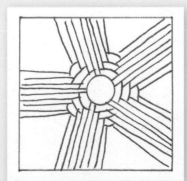

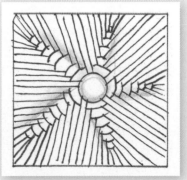

Aurabridge

RITA NIKOLAJEVA CZT, LATVIA

This is not an entirely new tangle, as it is really the well-known Hollibaugh within a frame. If you look at Rita's Zendalas on pp.59–61 you will see how she uses it. I have done three step-outs—the first as a border, the second one showing how you could use it as a different shape and the third done within a circle.

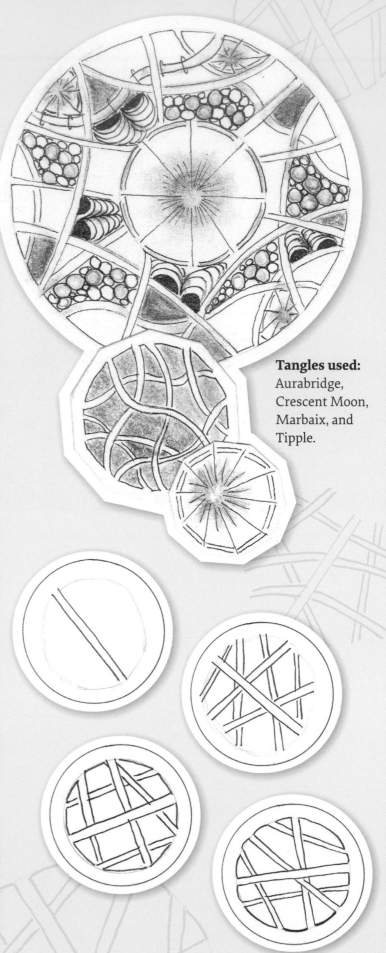

Tangles used:
Aurabridge,
Crescent Moon,
Marbaix, and
Tipple.

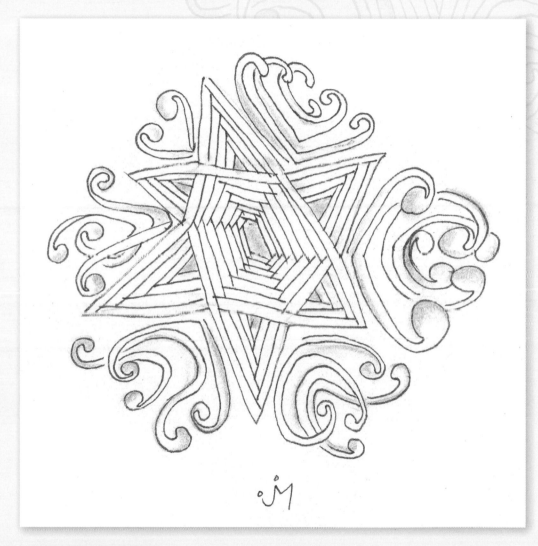

Auraknot

A ZENTANGLE® ORIGINAL

This is quite a tricky tangle, so I used a star template to make every stroke a straight line. Once you feel confident at drawing it you can then try an irregular star shape where you can incorporate curves as well as straight lines. Keep on rotating your tile as you do each stroke until you reach the middle.

Tangles used:
Auraknot and Mooka.

Auraleah

CARLA DE PREEZ, SOUTH AFRICA

To draw this leafy tangle, start with a relaxed line and draw a semi-circle halfway along it on one side. On the other side, draw a more flattened semi-circle longer than the first, making sure both ends meet the line. Continue in this way, working on alternate sides and enlarging the semi-circle each time.

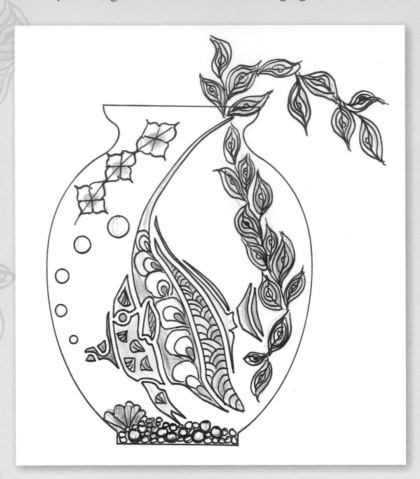

Tangles used:
Angelfish, Auraleah, Brax, Shattuck, and Tipple.

Auseklis

RITA NIKOLAJEVA, CZT

This tangle would make an attractive festive decoration or card.
I used a Gelly Roll pen for the blue coloring.

Tangles used: on the fish, Crescent Moon, Fassett and Shattuck; beside the fish, a variation of Auseklis.

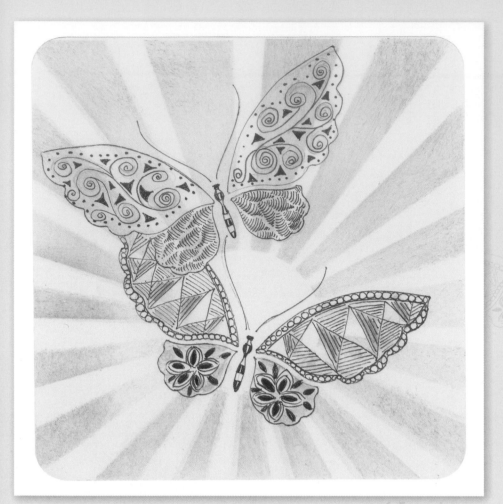

Tangles used: Ibex and Indyrella on the top butterfly; Avreal on the second butterfly, with flowers on the lower wings. Both have Btl Joos for the body.

Avreal

A ZENTANGLE® ORIGINAL

This tangle by Rick and Maria makes a very attractive border. The butterfly stencil is by Dreamweaver.

Hold your writing instrument lightly

Balo

HSIN-YA HSU CZT

Some care is needed when you do the initial zig-zag as it needs to be fairly even to get the pattern going. I enjoyed doing this on a Renaissance tile (from www.zentangle.com). I used sepia and red pens as well as black with the shading in pencil.

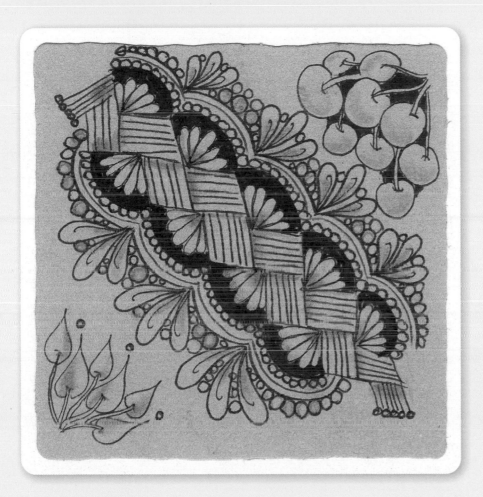

Tangles used: In the middle is Balo, with Flux around it, and in the corners I have used Poke Root at the top and Poke Leaf at the bottom

Bookee

LAURA HARMS CZT, CANADA)

This tangle is a pleasingly simple one to follow but very effective.

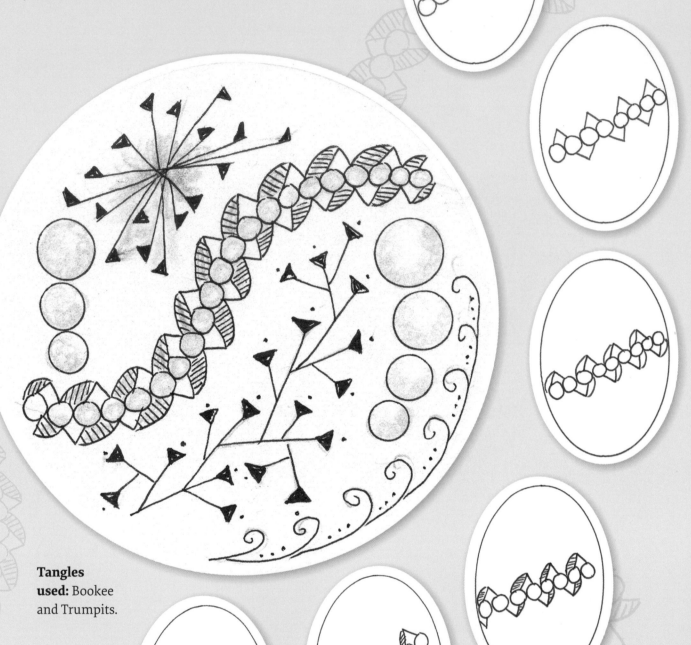

Tangles used: Bookee and Trumpits.

Borbz

RITA NIKOLAJEVA CZT, LATVIA

This great tangle from Rita looks simple but a lot of practice is required to get it looking good. Look for it in Rita's Zendala on p.60. I used a French curve as a template to get the shape for this illustration.

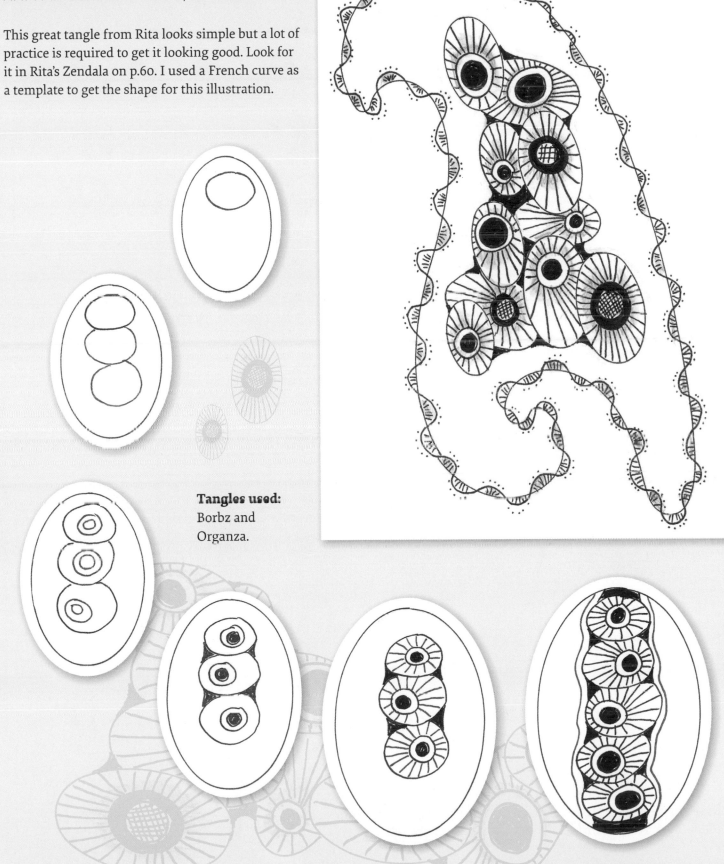

Tangles used: Borbz and Organza.

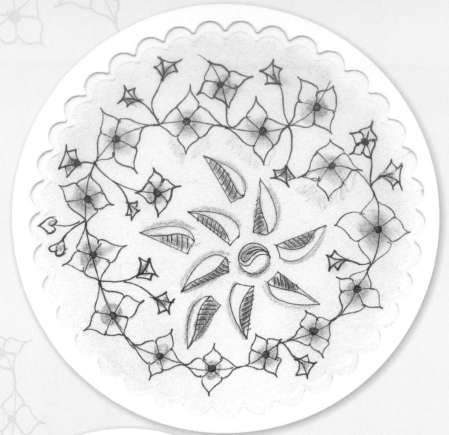

Tangles used: Brax and Meer variation.

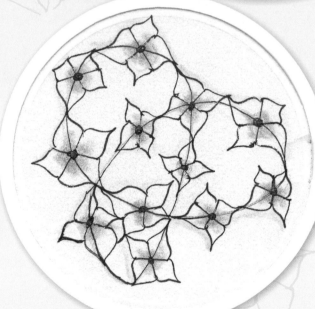

Brax

HELEN WILLIAMS CZT, AUSTRALIA
http://alittlelime.blogspot.co.uk

This is a very pretty tangle and fairly easy. You can do it on a grid to make it even easier, joining the "flower" tips. Each little Brax can be used on its own as well. It can be a lovely flowing pattern, as shown here, done within a circle. Add color for a different effect.

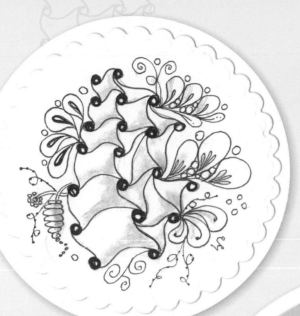

Cadent

A ZENTANGLE® ORIGINAL

In the first illustration I started with a die-cut scalloped circle and then drew Cadent in the middle with some Flux and Zinger around it.

Below, I die-cut a circle in white card and stuck it on a larger one in blue. I started with some Cadent in the middle, drew a grid around it and turned the grid into Florz. I then added a frame with some more tangles. I did the grid in pencil and then erased the pencil after using the black pen to give a different look to the tangle.

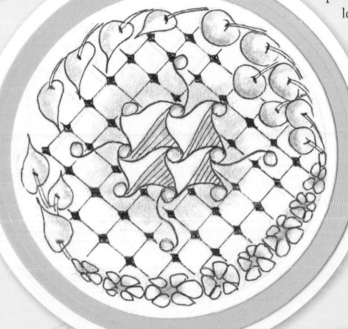

Tangles used:
Cadent variation,
N'Zeppel, Poke Root,
and Poke Leaf with
Florz in the background.

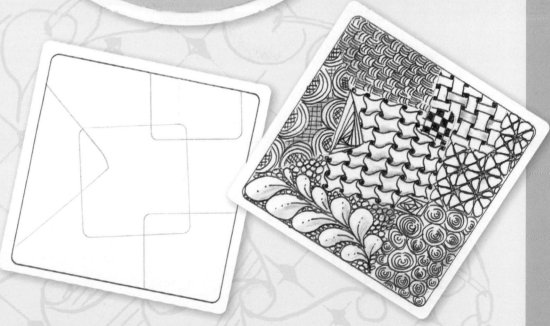

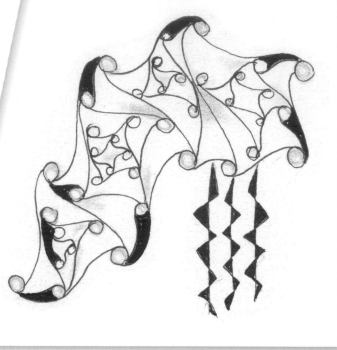

Cadox

MARGARET BREMNER CZT, CANADA
http://enthusiasticartist.blogspot.co.uk

Tangles used:
Cadox and Rain

Margaret is an artist from Canada and has written many books as well as contributing to books by other authors.

This is a variation of Cadox with one "square" of Cadox inside another, rotating each time as in the diagram—how many you can add depends on the size of the first one. You can then do variations of Cadox as shown in the illustrations.

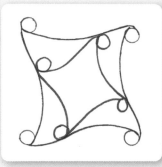

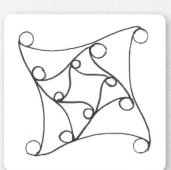

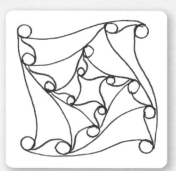

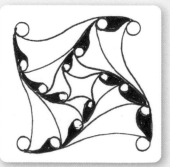

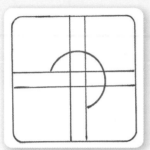

Tangles used:
Chemystery, Hollibaugh,
Luv-a and Tipple.

Chemystery

MARYANN
SCHEBLEIN-
DAWSON CZT, USA

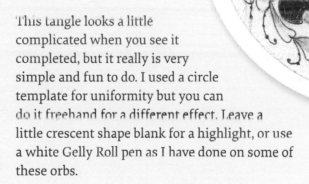

This tangle looks a little
complicated when you see it
completed, but it really is very
simple and fun to do. I used a circle
template for uniformity but you can
do it freehand for a different effect. Leave a
little crescent shape blank for a highlight, or use
a white Gelly Roll pen as I have done on some of
these orbs.

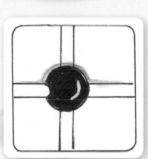

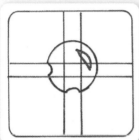

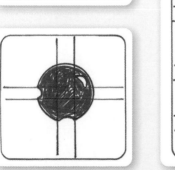

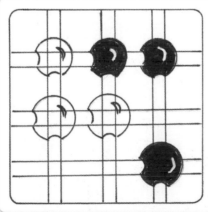

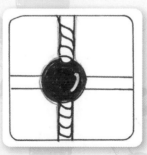

Copada

MARGARET BREMNER CZT, CANADA
http://enthusiasticartist.blogspot.co.uk

Copada is a really pretty pattern and not difficult to do. It makes an attractive border, whether it is straight or curved as in the illustration. Here I made a Zendala with Copada around the outside and a grid pattern in the middle, a zigzag running through the squares and alternating vertical and horizontal lines. I added a little color for effect.

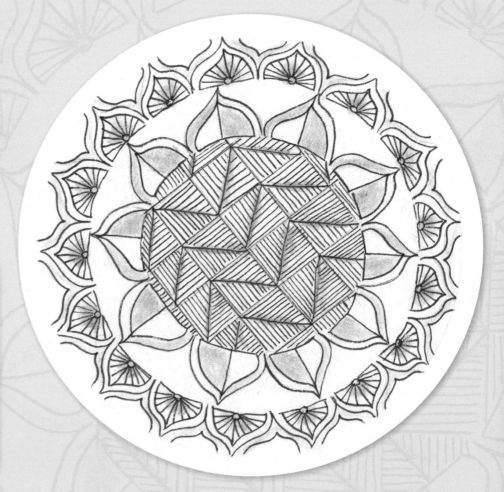

Crescent Moon

ZENTANGLE® ORIGINAL

This is a good example of a tangle with an aura. You can really change the look of this tangle, as you can see on my tile.

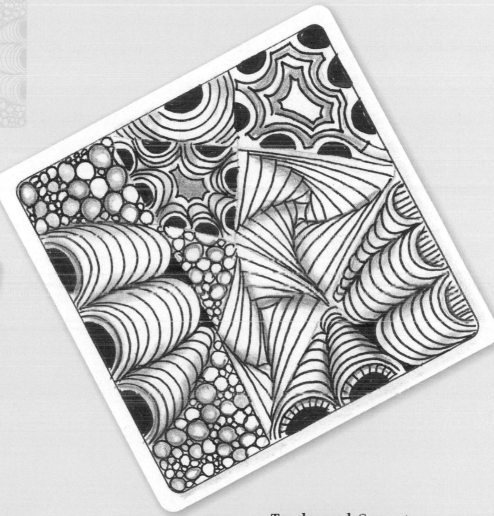

Tangles used: Crescent Moon, Paradox and Tipple. String 010 was used for this tile.

Cruffle

SANDY HUNTER CZT, USA
http://tanglebucket.blogspot.co.uk

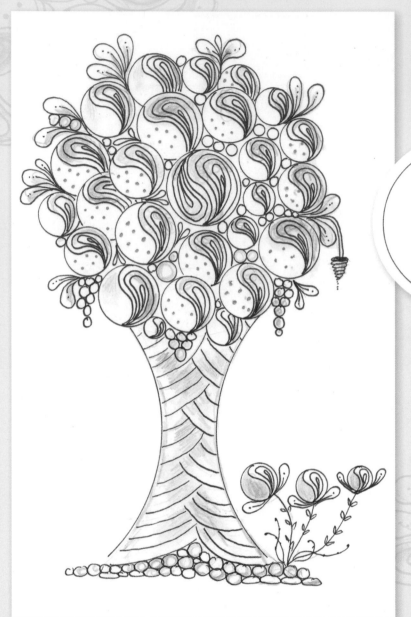

Cruffle is one of my favorite tangles as it is very easy to do and so effective. I sometimes use a protractor with circular apertures in it to achieve a uniform look. It's a tangle that I find good for decorating cards—see p.92, where it appears in the corner of the 105 card. Check out Sandy's blogspot for lots more ideas for Cruffle.

Tangles used:
Cruffle, Flux, Shattuck
variation, and Tipple.

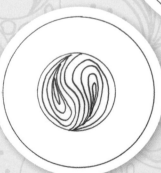

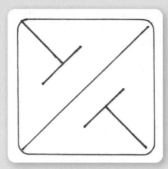
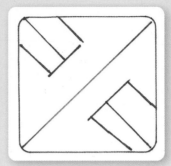
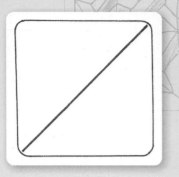

Crusade

WAYNE HARLOW CZT, USA

I really enjoyed tackling this one as Wayne had done the
step-out and shown a bigger picture with many Crusade
tangles, accompanied by a note saying that it would be
a good weekend challenge to work out how it was done.
It took me a while, but once I realized that it was a grid
(which can be straight or wavy) and that the corners need
to meet up with another corner, I soon got the hang of
which way to turn the whole thing so that I could start
by doing the diagonal line in the right place. So there
is a little hint of how it is done! Shading has given it an
interesting architectural quality.

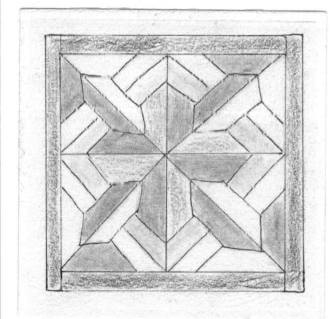

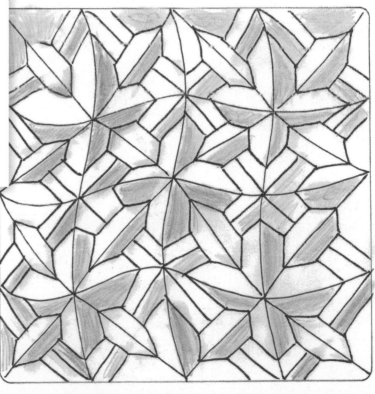

Cruze

CAREN MLOT CZT, USA
facebook.com/TangleMania

This is a fascinating tangle that needs a little practice to begin
with but is well worth the effort as it looks very effective. Check
out Caren's Facebook page for more ideas on how to use it.

Tangles used: Cruze and Luv-a.

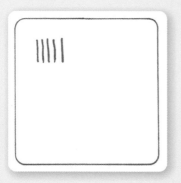

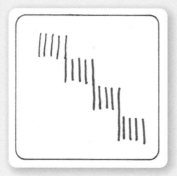

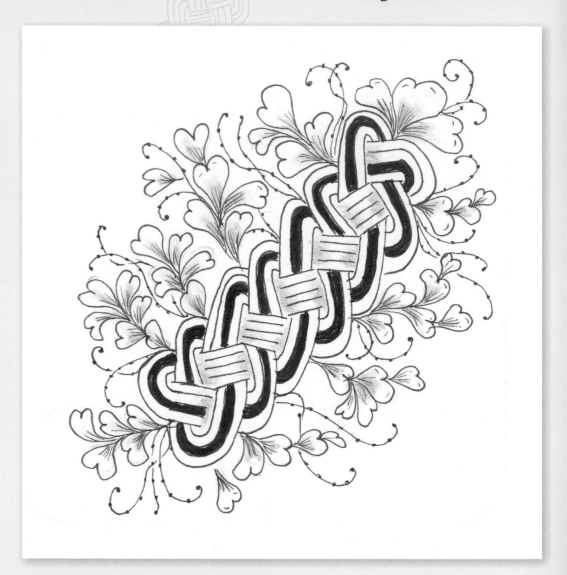

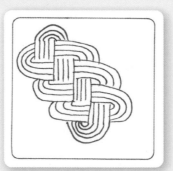

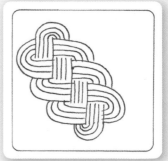

Curly Bracket Feather

HELEN WILLIAMS CZT, AUSTRALIA
http://alittlelime.blogspot.co.uk

This is a lovely tangle by Helen which needs to be done quite carefully. Remembering that it's basically a bracket such as you would use in handwriting makes it easier—you may benefit from turning it in the direction that you would naturally draw a bracket. Go to Helen's blogspot for expert advice on drawing her tangles.

Here I have made a die-cut bookmark with a feather on it. I inked the edges with Distress Ink and colored the feather with a Koh-i-Noor Magic Pencil. It is shown with a die-cut leaf on which I have done a simple pattern.

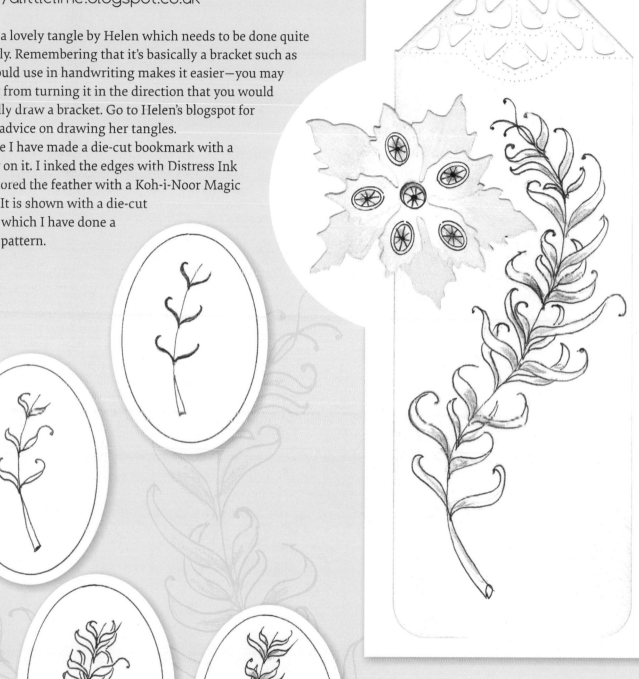

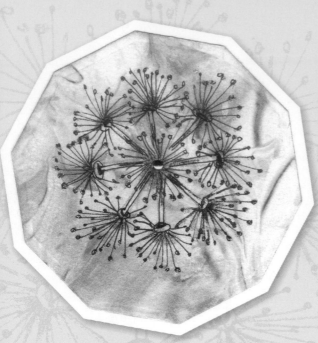

Dandi

SANDHYA MANNE CZT, INDIA

This is a lovely dandelion tangle that you'll find in various places in the book. The lines representing the stalks of the seedheads can cross over each other, adding interest. I like to use a Black Sparkle Gelly Roll pen for the seedheads and sometimes add a little Stardust glitter glue too.

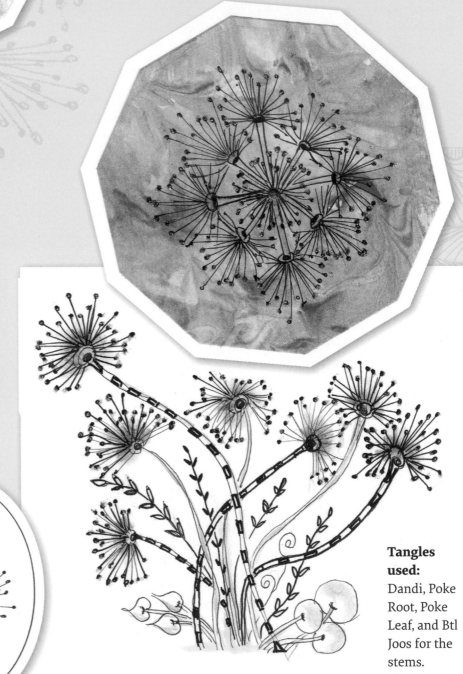

Tangles used: Dandi, Poke Root, Poke Leaf, and Btl Joos for the stems.

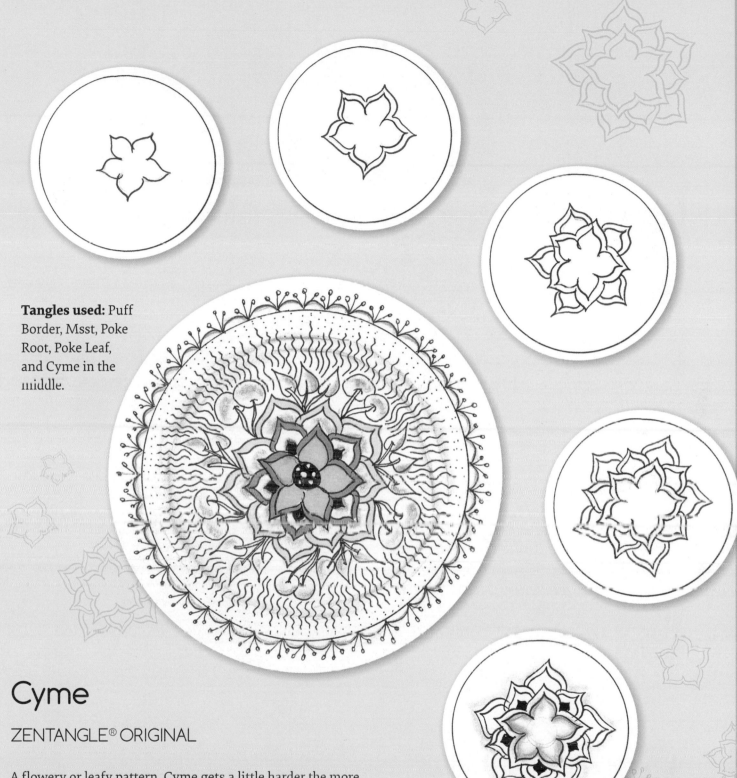

Tangles used: Puff Border, Msst, Poke Root, Poke Leaf, and Cyme in the middle.

Cyme

ZENTANGLE® ORIGINAL

A flowery or leafy pattern, Cyme gets a little harder the more you keep adding to it, so start small in the first instance. I added a little color here with Promarkers—they are alcohol inks and very easy to use, as they color in very smoothly. They bleed through to the back of most card stock, but this is not a problem if you are going to mount your work onto another piece of card.

Waltz

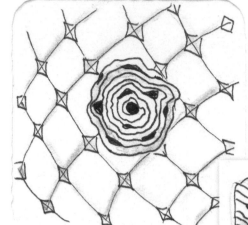

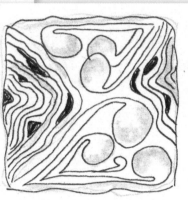

Foxtrot

Tangles used:
Divadance Rock 'n' Roll with Florz variation and Divadance Foxtrot with Mooka, both done on Bijou tiles.

Divadance

A ZENTANGLE® ORIGINAL

Divadance has three different styles: Waltz, Foxtrot, and Rock 'n' Roll. I have stepped-out all three. It took me a few goes to get this tangle right when I first started to use it.

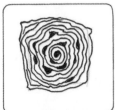

Rock 'n' Roll

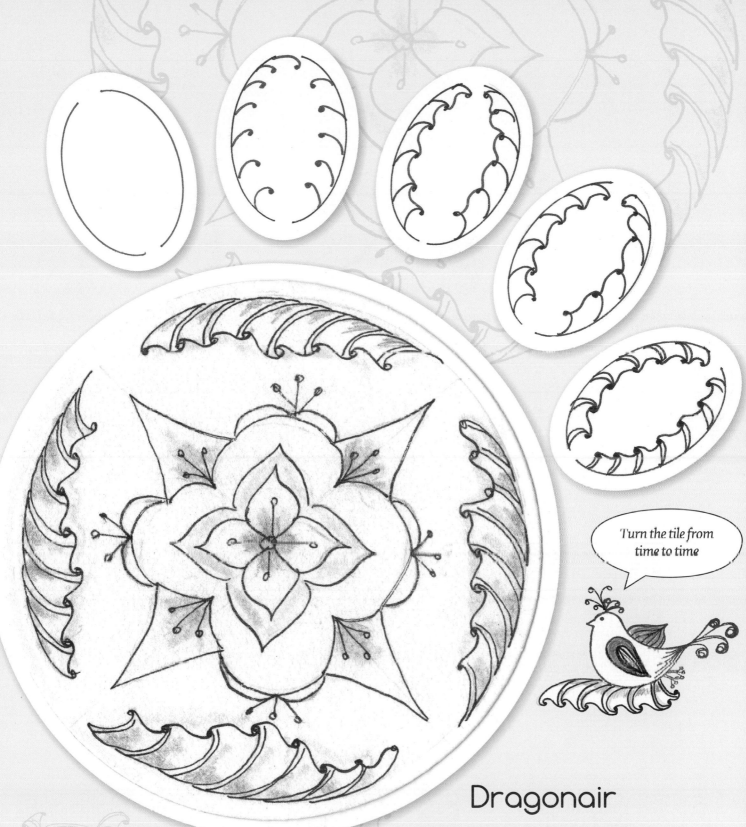

Turn the tile from time to time

Dragonair

NORMA BURNELL CZT, USA
http://fairytangles.blogspot.co.uk

Dragonair is a very popular tangle and on Norma's blogspot you will find lots of ideas for it. In this illustration I put Dragonair around the outside with a Brax "flower" in the middle with an aura around it. I added a little Puf Border as well.

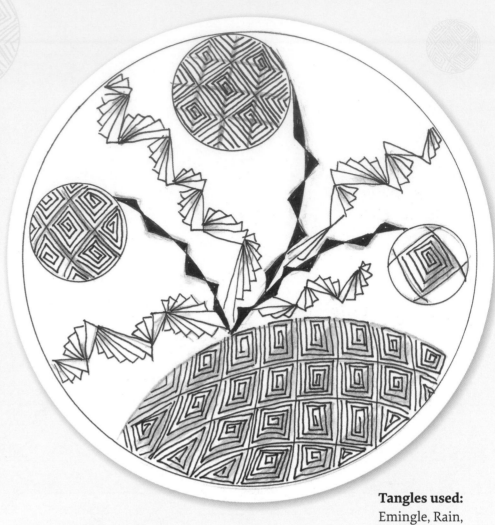

Tangles used:
Emingle, Rain,
and Steps.

Emingle

A ZENTANGLE® ORIGINAL

You can do this pattern as a uniform
grid or make it uneven. It can be shaded
in many ways, as shown below.

Fassett

LYNN MEAD CZT, USA

Lynn is an inspirational teacher who shares her ideas generously at Zentangle seminars. This is a really fascinating tangle with many variations.

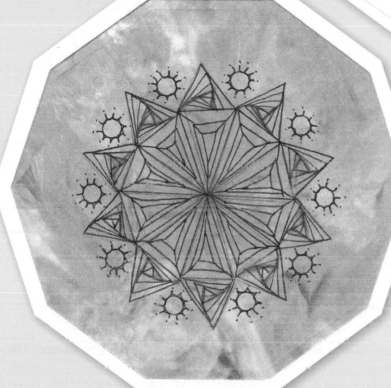

Tangles used: Fassett in the center with Paradox around the edge and Widgets on a shaving foam background.

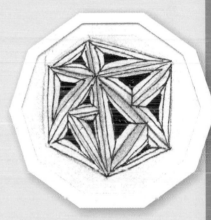

Draw triangles randomly.

In each triangle, draw one or two more evenly spaced triangles.

Starting at each corner of the smallest triangle, draw a line connecting the corners.

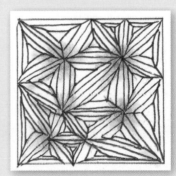

Add shading.

Fassett can be drawn with various grids, as shown in the diagrams. This adds to the versatility of Lynne's tangle.

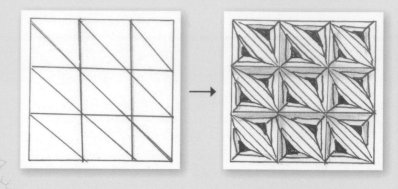

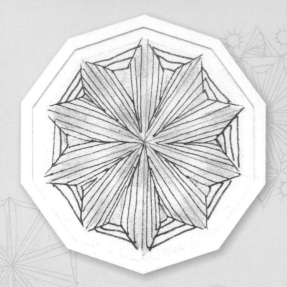

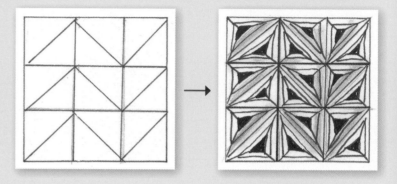

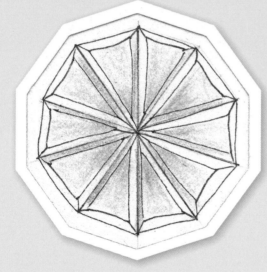

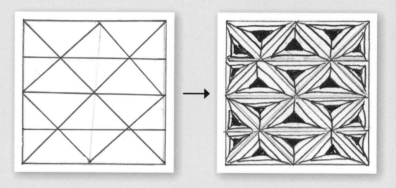

This variation uses one triangle only inside the outer triangle.

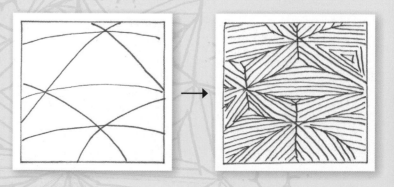

Feathers

HELEN WILLIAMS CZT, AUSTRALIA
http://alittlelime.blogspot.co.uk

Helen is one of the most inspirational artists in the Zentangle world, and her e-books are full of beautiful artwork—*Light and Shadow* is particularly good if you want to explore the art of shading. Feathers is not difficult but needs a little care.

Tangles used:
Feathers and Mooka.

Fengle

A ZENTANGLE® ORIGINAL

This tangle can be done in an even manner
or with "petals" of different sizes.

Tangles used:
Fengle, Tipple and
Cruffle with Flux.

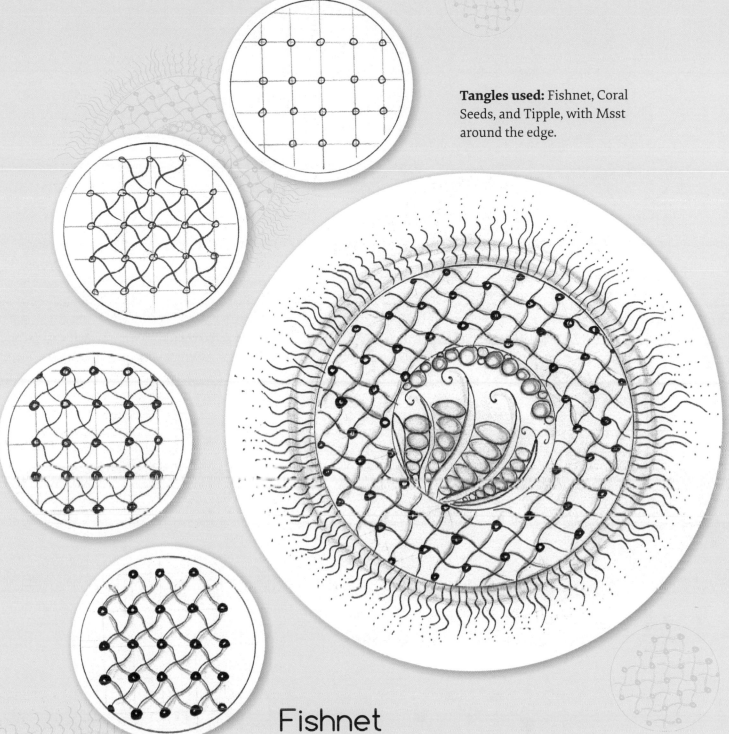

Tangles used: Fishnet, Coral Seeds, and Tipple, with Msst around the edge.

Fishnet

MARIËT LUSTENHOUWER, NETHERLANDS

A very effective background pattern, Fishnet is harder than it looks. A grid in pencil makes it easier. Have fun with the shading.

Tangles used: Flux with Tipple, Mooka, Jujubeedze, Leaflet, and Florz in the center.

Florz

ZENTANGLE® ORIGINAL

Florz can fill in many gaps in your ZIA work and may be varied quite a bit, depending on the size of the "diamonds" that you draw. The shading can be very effective if you take time to make a shadow on one side of the diamond. I added some color to my tile by using Copic markers and stencil—the color bled quite a bit on the Fabriano paper.

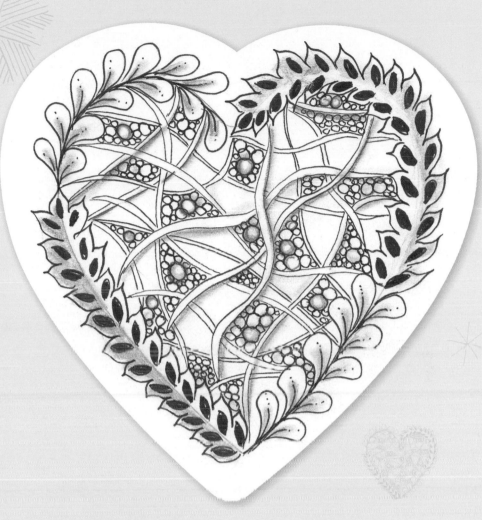

Frondous

ZENTANGLE® ORIGINAL

I really like this leafy pattern and find it goes well with Flux. In the middle of this heart-shaped design I have used Hollibaugh as a string filled in with Tipple. Hollibaugh bands can be straight or curvy.

Heartline

HELEN WILLIAMS CZT, AUSTRALIA
http://alittlelime.blogspot.co.uk

This is another great tangle from Helen and an easy one to do.

Tangles used:
Arukas, Crescent Moon, Flux, Heartline, and Printemps.

Frost Flower

KARRY HEUN, USA

This is a great tangle for adding to your Christmas cards and decorations, for example as I have used it here on a Woodware rubber stamp.

Tangles used: Frost Flower in the circular designs; in the tile, Ferdy, Phicops, Frost Flower, Joy, Tipple, and Flux.

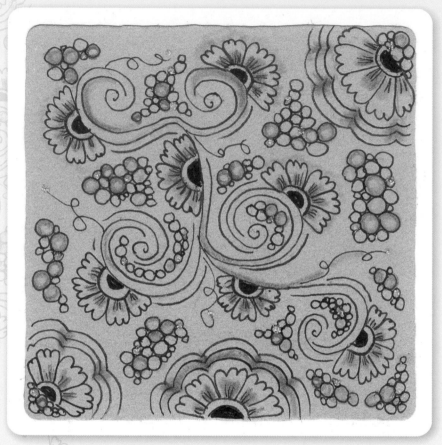

Henna Drum

JANE MACKUGLER CZT, USA

This is a very pretty tangle. I have worked on a Renaissance tile and used brown and sepia pens. The brown pen shows up particularly well on a Renaissance tile. I have done the whole tile with Henna Drum except for some Tipple to fill the gaps.

Hollibaugh

ZENTANGLE® ORIGINAL

Hollibaugh cannot be left out of an A–Z of tangles as it is one of the most relaxing tangles to draw and can be done in so many different ways. The bands can be varied in width and in shape—straight or curvy or both. The background may be filled in with black or with other tangles. Shading makes it more dramatic. Here I have added a few black dots for effect.

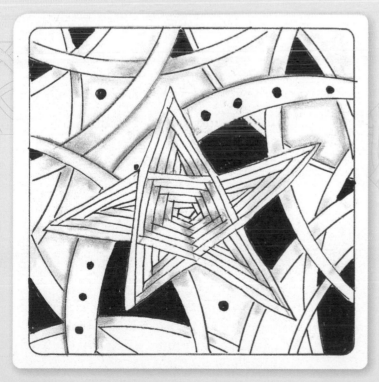

Tangles used: Auraknot
and Hollibaugh.

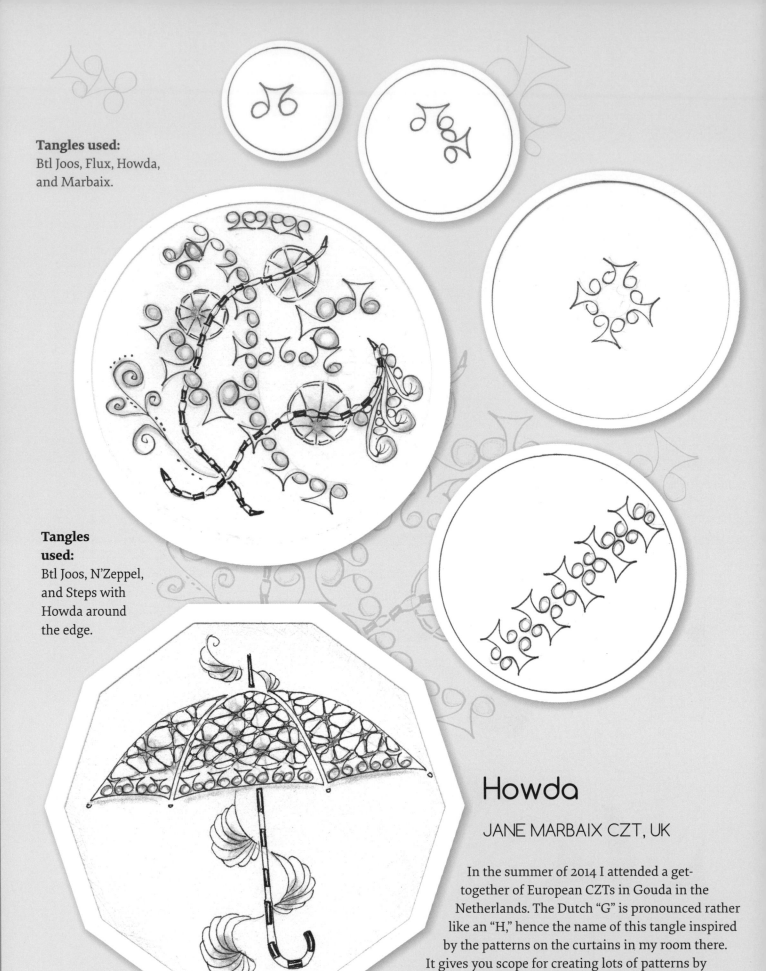

Tangles used:
Btl Joos, Flux, Howda,
and Marbaix.

Tangles used:
Btl Joos, N'Zeppel,
and Steps with
Howda around
the edge.

Howda

JANE MARBAIX CZT, UK

In the summer of 2014 I attended a get-
together of European CZTs in Gouda in the
Netherlands. The Dutch "G" is pronounced rather
like an "H," hence the name of this tangle inspired
by the patterns on the curtains in my room there.
It gives you scope for creating lots of patterns by
adding on to the base pattern—just keep adding on to
see where it takes you.

Tangles used:
Indyrella and
Tipple.

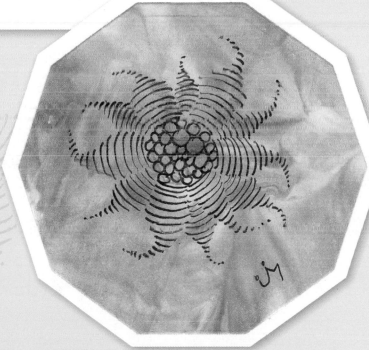

Indyrella

A ZENTANGLE® ORIGINAL

This is another of Molly Hollibaugh's tangles. Practice is the key to
this one as it's not quite as easy as it looks—you need to make sure
there's a slight gap between each individual section. Adding some
extra curve to it looks good. Here I've used it in the Dove stencil by
Dreamweaver and on a die-cut decagon with the background colored
using the shaving foam method (see p.79).

Ixorus

A ZENTANGLE® ORIGINAL

Draw the bands first, then if you keep rotating each time you add the half circles, putting one underneath the band and one on top all the way round, you will get the hang of it. Ixorus is a bit like Crescent Moon as you keep adding halos to the moon shapes.

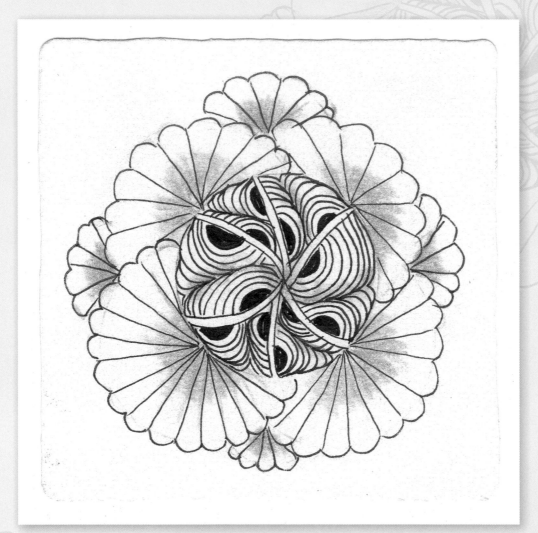

Tangles used:
Ixorus and Sanibelle.

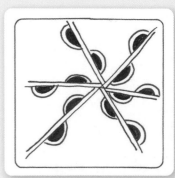

Leaflet

HELEN WILSON CZT, AUSTRALIA
alittlelime.blogspot.com

This is just one of many tangles from the artist Helen Wilson; visit her blogspot for a very inspiring look into her art. I have only recently begun using Leaflet but it's one that grows on you quickly!

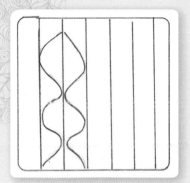

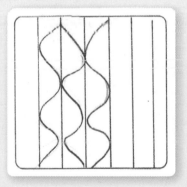

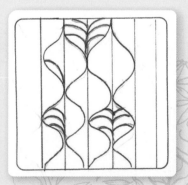

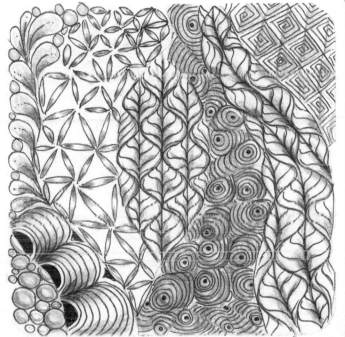

In this "stacked and tangled" ZIA, I have used the tangles Flux, Quandary, Leaflet, Tipple, Crescent Moon, Printemps, and Emingle. The color was achieved with Faber-Castell pencils.

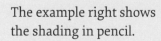

The example right shows the shading in pencil.

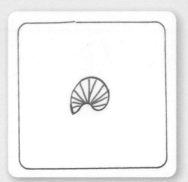

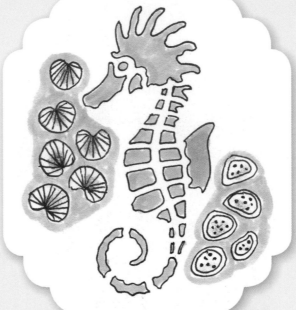

Lily Pads & Lily Pods

MARGARET BREMNER CZT, CANADA
enthusiasticartist.blogspot.co.uk

Margaret has created many tangles and I think these two belong together. They are simple but effective tangles and I have used them here with my Seahorse Dreamweaver stencil, which is colored with a Copic Marker.

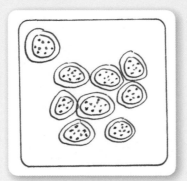

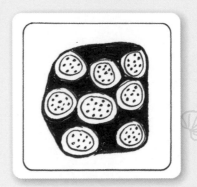

Logjam

WAYNE HARLOW CZT, USA

This is another one of Wayne's great tangles. Logjam is not difficult—shading makes all the difference to the final result.

Tangles used:
Copada and Logjam.

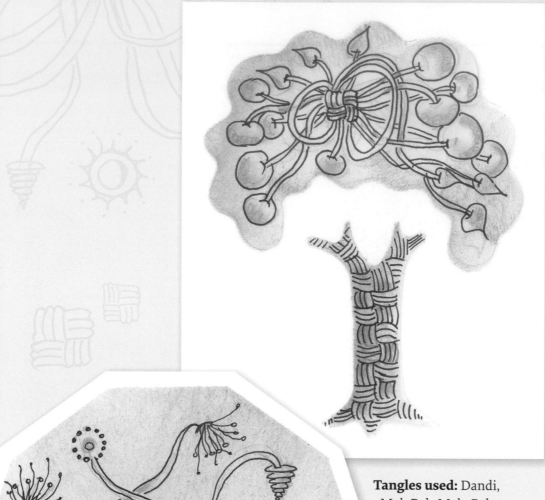

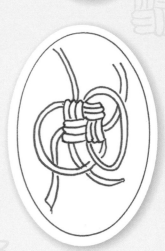

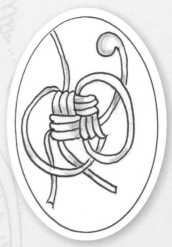

Tangles used: Dandi, Mak-Rah-Meh, Poke Root, Zinger, Widget, and Keeko (tree trunk).

Mak-Rah-Meh

MICHELLE BEAUCHAMP CZT, AUSTRALIA
http://shellybeauch.blogspot.co.uk

If you have ever done macramé you will recognize this very clever tangle as just like the basic knot.

Marbaix

JANE MARBAIX CZT, UK

My first tangle of my own, this is very simple if you do it in the steps I have shown. I have included a variation by Lynn Mead that she has used in her dew drop project (see pp.16–17); the edges are curved to make it more flower-like. A little more care is needed for this one and you may find it easier to divide each of the four sections into three (see below).

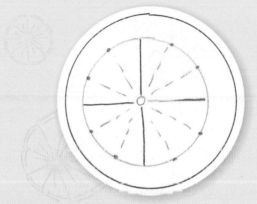

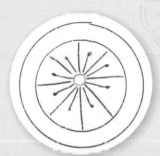

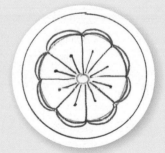

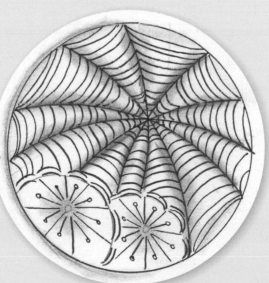

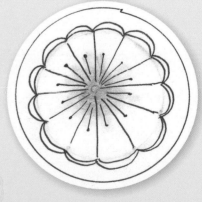

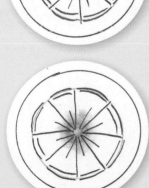

This small Zendala is just Crescent Moon and Marbaix with some shading.

Marbaix

JANE MARBAIX CZT, UK

This was my first tangle creation, inspired by an envelope I received. Here I have used a Dreamweaver vase stencil.

Tangles used:
Brax, Marbaix, and Trumpits.

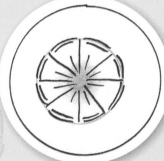

Maryhill

BETSY WILSON CZT, CANADA
http://craftsbybetsy.blogspot.co.uk

This is a really fascinating tangle which magically transforms into a windmill. It is fun to play around with and would make an attractive center for a Zendala. In the larger mandala Maryhill is used with Paradox in every other triangle—it is quite similar and blends in well.

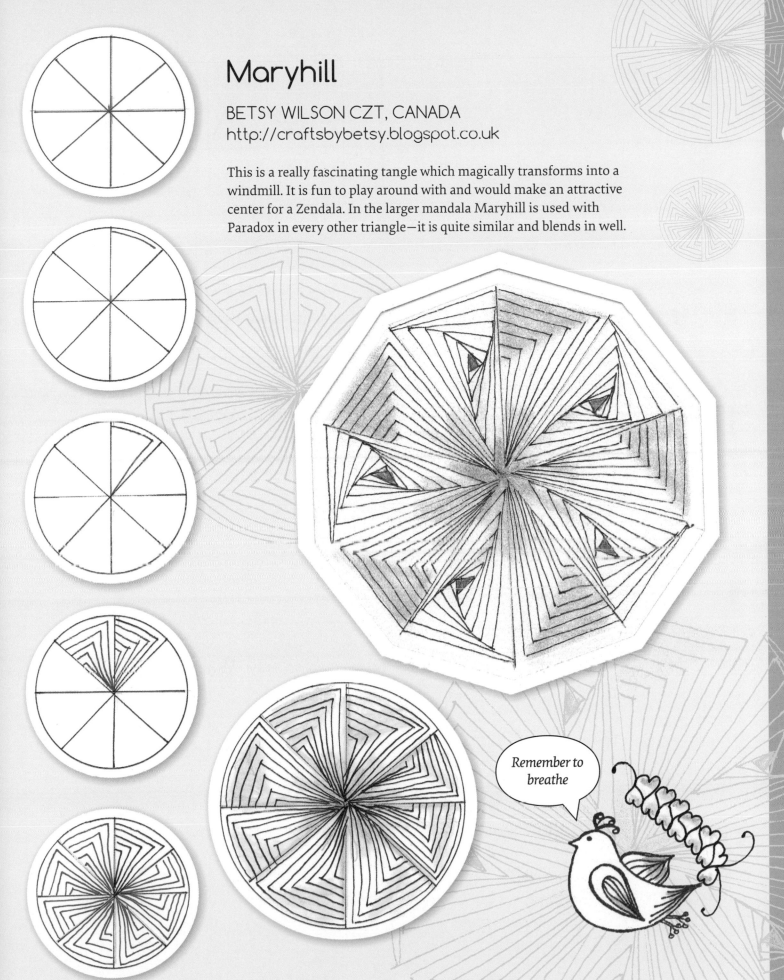

Remember to breathe

Matuvu

RITA NIKOLAJEVA
CZT, LATVIA

This is a very clever tangle, deconstructed into an easy step-out to follow. It looks a bit like knitting or knots. Vary the look by making the bottom or top loops bigger.

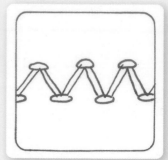

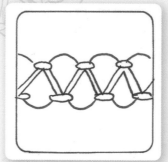
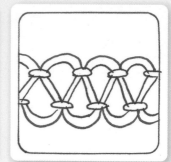

Tangles used:
Matuvu and Showgirl.

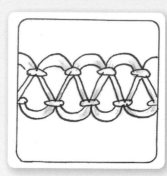

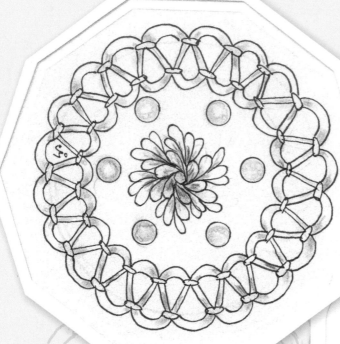

Tangles used:
Matuvu and Fans.

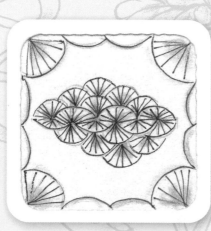

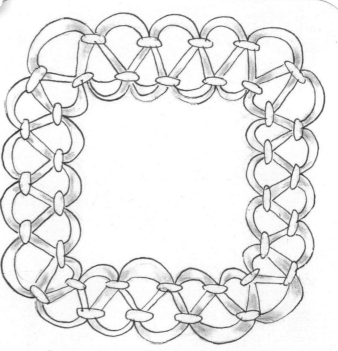

Tangles used:
Hollibaugh, Miander, Crescent Moon, Tipple, Poke Root, Poke Leaf, 'NZeppel and Henna Drum.

Miander

MIMI LEMPART CZT, USA

Mimi was on the very first teachers' seminar that Rick and Maria did and is going back next year to experience it again. I love Mimi's tangle—it looks very simple but needs quite a bit of care. However, it is one that you can play around with depending on how you shade it or color in some of the triangles and squares. Go to Mimi's blog to see some of her other great tangles.

Merryweather

SANDY HUNTER CZT, USA
http://tanglebucket.blogspot.co.uk

This is a grid pattern which doesn't need much explanation—just take your time and then have fun shading it.

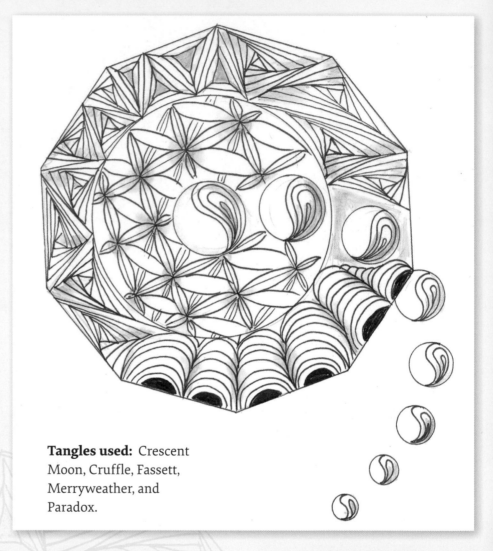

Tangles used: Crescent Moon, Cruffle, Fassett, Merryweather, and Paradox.

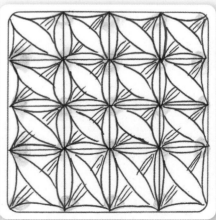

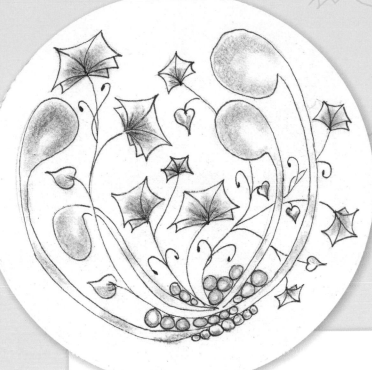

Tangles used:
Mooka, Morning Glory, and Tipple.

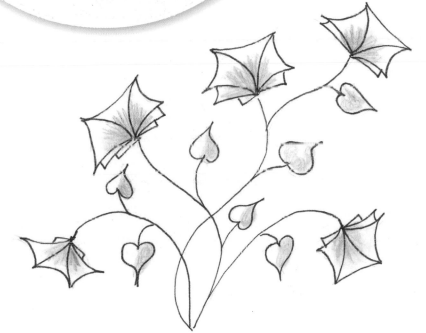

Morning Glory

HELEN WILLAMS CZT, AUSTRALIA
http://alittlelime.blogspot.co.uk

This is a lovely, simple, flowery tangle, so I have made my Zendala very simple to illustrate it. Look on Helen's blogspot for lots of inspiration.

N'Zeppel

A ZENTANGLE® ORIGINAL

This tangle is one that I use all the time. I have done the step-out using a uniform grid, but there is a random version where you draw a non-uniform string and then fill in with the squashed orbs like this one. One of my friends remarked that she loved my genie lamp stencil, so I have used it as a lamp in this Zendala—but if you rotate it you will see that it is actually a fish!

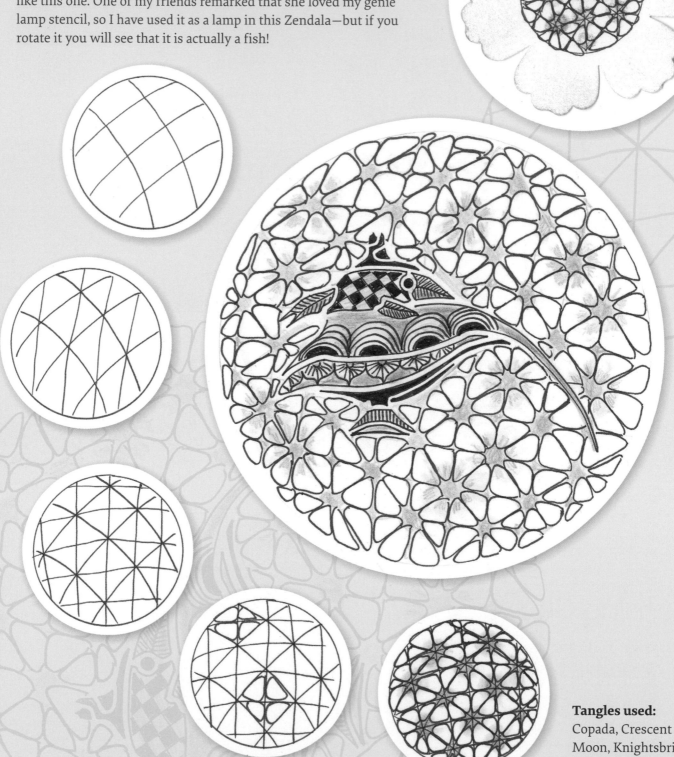

Tangles used:
Copada, Crescent Moon, Knightsbridge, and N'Zeppel.

Tangles used: Onion Drops, Flux, Mooka, and Tipple.

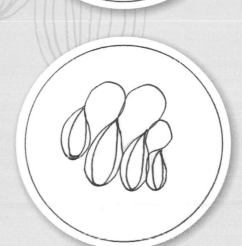

Onion Drops

SHASTA GARCIA, USA

This tangle is fun to do and not complicated, though the lines need to touch the top of the initial shape for the right effect. After a while the first outline flows well. Adding color makes this tangle even more attractive.

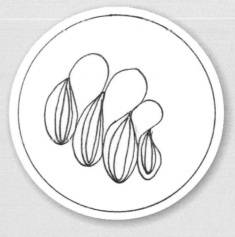

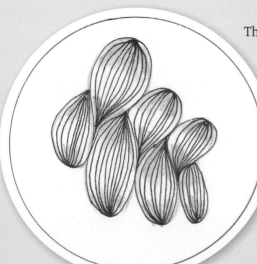

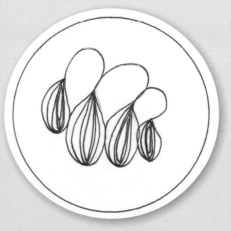

Tangles used, clockwise from top:
Borbz, Mooka, Auraknot, Brax,
Fassett, Arukas, Angel Fish,
Auraleah, Copada,
and Bookee.

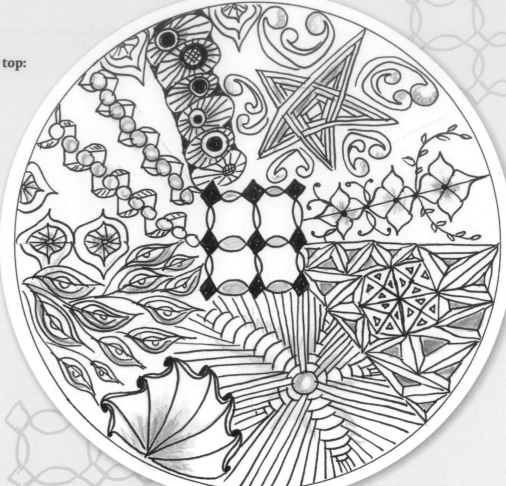

Oof

A ZENTANGLE® ORIGINAL

This tangle by Rick and Maria is fairly
simple. It lends itself to variation by adding
something extra within the circles,
as in the small illustration, or
by blacking out some of the
diamonds as I have done
in the center of
my Zendala.

Oolo

AMELIE LIAO CZT

There are CZTs all over the world, including China, Japan, and the far east. I have colored my artwork here with a Koh-i-Noor Magic Pencil.

Tangles used on Jelly Fish stencil by Dreamweaver: Oolo, Btl Joos, Crescent Moon and Meer.

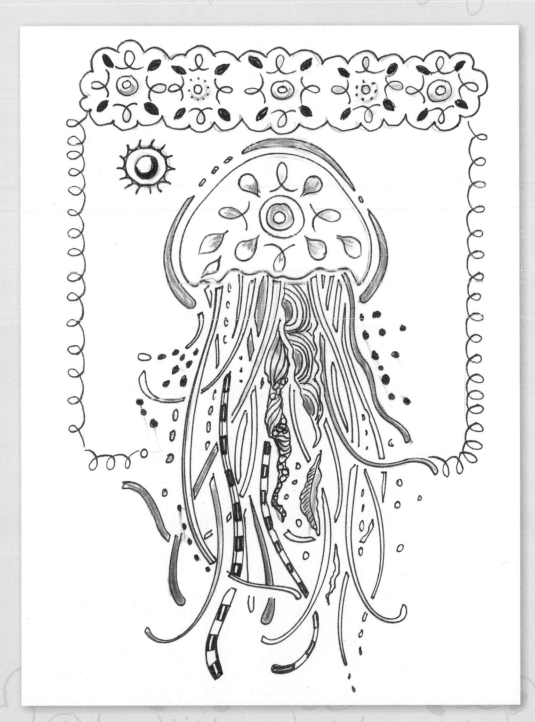

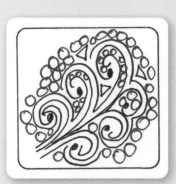

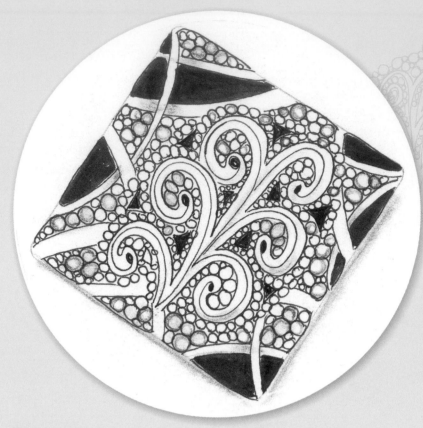

Opus

ZENTANGLE® ORIGINAL

This is a tangle with an aura, which means you need to avoid using it small size as it is difficult to do the aura. Tipple is used as part of the Opus.

Breathe

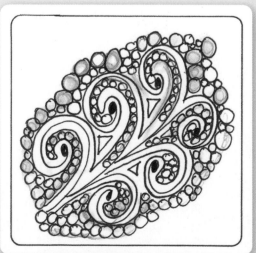

Papermint

SANDY HUNTER CZT, USA
www.tanglebucket.blogspot.com

This is a lovely simple new tangle by Sandy Hunter. Sandy says there was no particular inspiration for her creation; she loves to watch the lines appear and go wherever her tile takes her: "There are definitely 'comfort patterns' that pop up in my tangles a lot, like Tipple, Printemps, Flux, variations of Poke Root and strings of beads. I gravitate towards round things, tiny details and irregular edges because they're such fun to draw!"

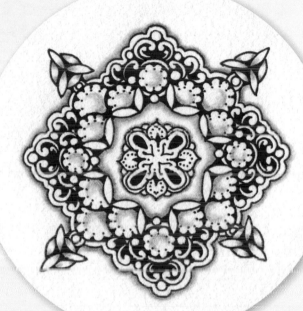

Tangles used: Papermint and Mooka variation.

Tangles used: Papermint, Poke Root variation, Beadlines variation, Sand Swirl, Antidots, and Quandary variation.

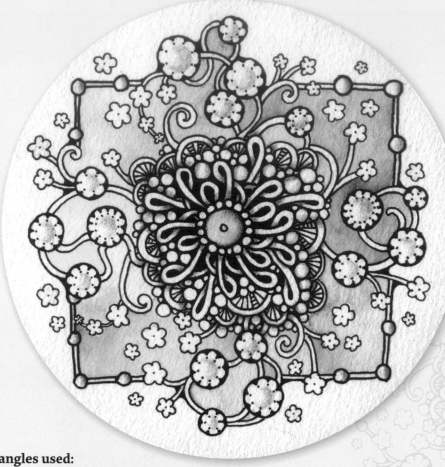

Tangles used:
Papermint, Bridgen
border, and Dimplets.

Tangles used:
Papermint,
with variations.

Paradox

A ZENTANGLE® ORIGINAL

This is known as Rick's Paradox because Rick Roberts created it. I have done my artwork on a Zentangle Renaissance tile (available from www.zentangle.com), using brown and sepia pens as well and shading it with a white charcoal pencil. On the small die-cut shape I have done Paradox in a square for a different effect.

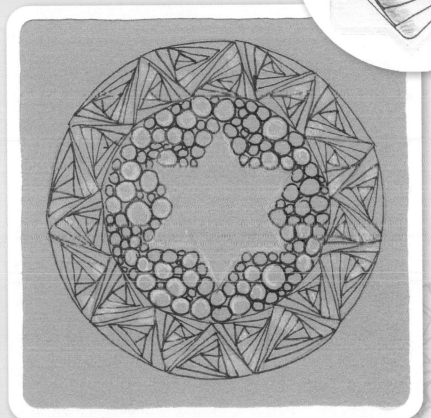

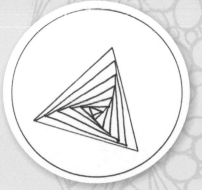

Tangles used: Paradox and Tipple.

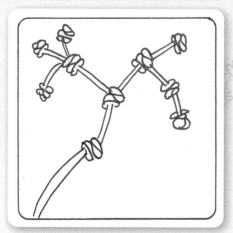

Pendrils

A ZENTANGLE® ORIGINAL

This is a bit like a series of knots. Maria does wonders with it, so it is worth looking it up on www.tanglepatterns.com.

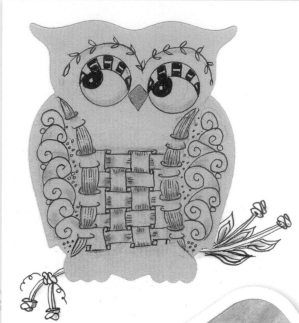

This die-cut owl is sitting on a Pendril branch. The tangles used are W2, Zander, and Btl Joos on the eyelids.

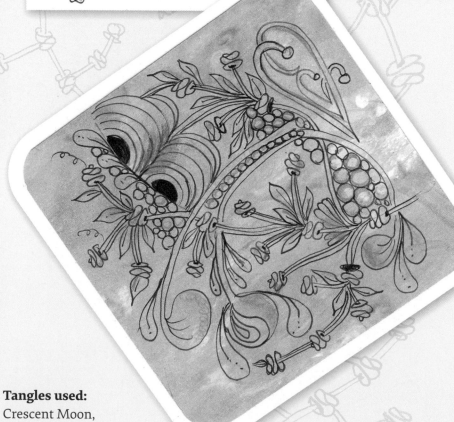

Tangles used:
Crescent Moon, Mooka, Flux, Tipple, Cruffle, and Pendrils.

Pia

MARGARET BREMNER CZT, CANADA
http://enthusiasticartist.blogspot.co.uk

This is just one of Margaret's many tangles. It has numerous variations—try inventing one of your own.

Look at the tangle from a different perspective

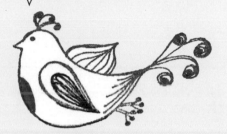

Tangles used: Copada, Bookee and Pia; Ribbon running through the decagon.

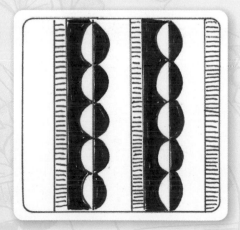

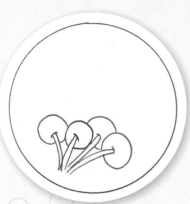

Poke Root

ZENTANGLE® ORIGINAL

This is definitely an old favorite for most tanglers. It looks best if the "berries" are different sizes, but the main thing is the shading. It also looks good with the background filled in with black or with some Tipple added around it.

Tangles used: Betweed, Poke Root, Poke Leaf, Onamato, Cubine, and Jujubeedze (in a circle of four).

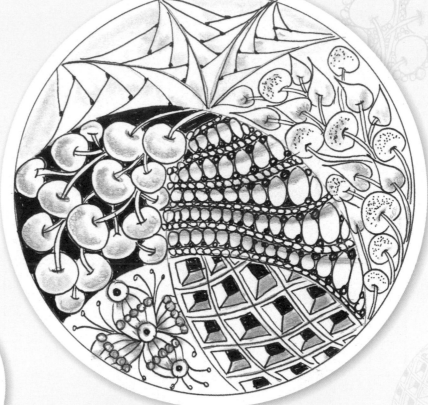

POMX2

MEI HUA TENG [AKA DAMY]

Damy's pretty grid-pattern tangle is easy to replicate. You can vary the look by changing the size of the diamond shape.

Tangles used: POMX2 in the center with Pia around the outside.

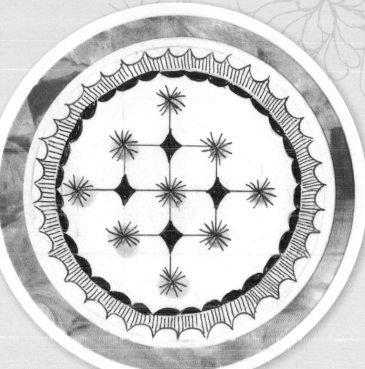

Tangles used: Showgirl is in the center with a circle of leaves and on the outer circle is POMX2.

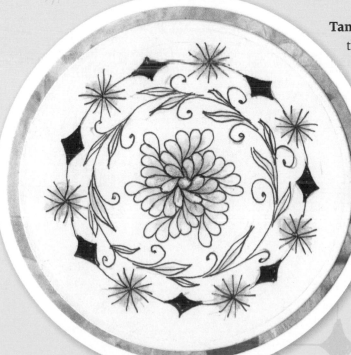

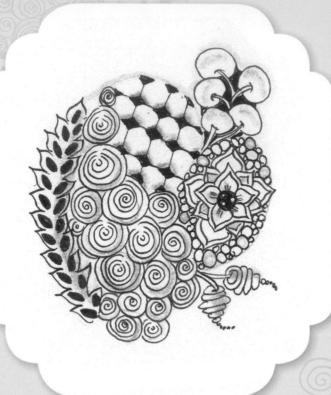

Printemps

ZENTANGLE® ORIGINAL

There are two ways of doing this tangle. The first
is the simple form of just drawing a spiral and the
second is leaving a gap to form a highlight or sparkle.
It is a tangle that "goes behind," so draw them close
together and let them go behind as little or as much as
you like. My little picture is done on a Dreamweaver
die-cut shape with a random string.

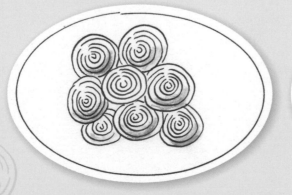

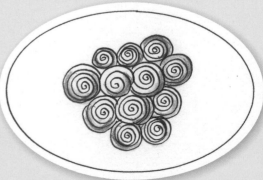

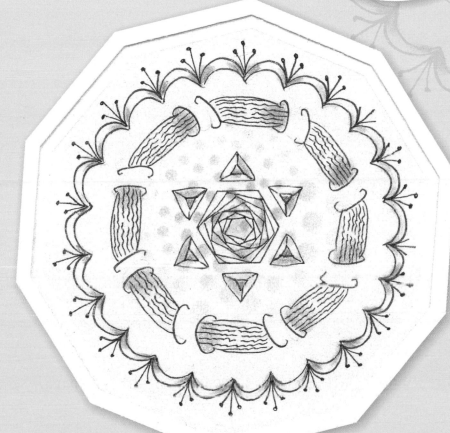

Tangles used:
Puf Border, Zander,
Fassett, and Paradox

Puf Border

SUZANNE MCNEIL CZT, USA

This really is a lively tangle, and June Bailey has used it on
her seahorse Zendala to great effect (see p.88).

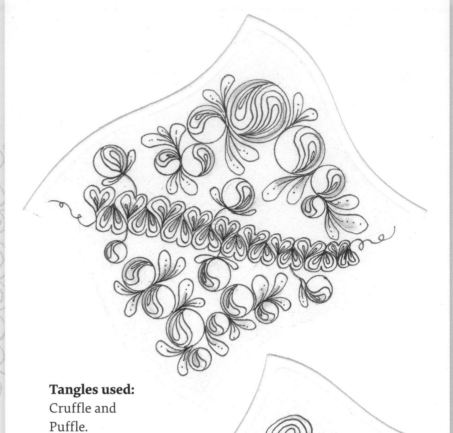

Tangles used:
Cruffle and
Puffle.

Puffle

SANDY HUNTER CZT, USA
http://tanglebucket.blogspot.co.uk

This tangle is like drawing hearts to start with, but you can vary
the pattern from two to four lobes.

Purk

ZENTANGLE® ORIGINAL

This is very popular and you will see it in a lot of Zentangle Inspired Art. In the tile here I have Purk and Keeko crossing each other with a Hollibaugh background. Each space in Hollibaugh has been filled in with a tangle.

Tangles used: Oolo, Purk, Keeko, Marbaix, Fassett, Hollibaugh, Tipple, Bales, Crescent Moon, and Macramé.

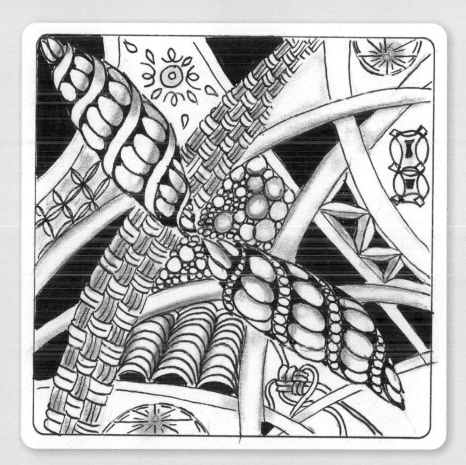

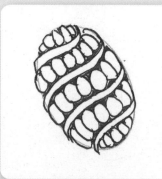

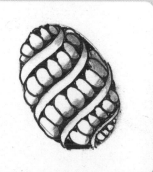

Punzel

A ZENTANGLE® ORIGINAL

The success of this tangle depends on smooth curves, so do it very carefully and practice, practice, practice!

Tangles used:
Betweed, Onomato, Poke Leaf, Punzel and Zinger.

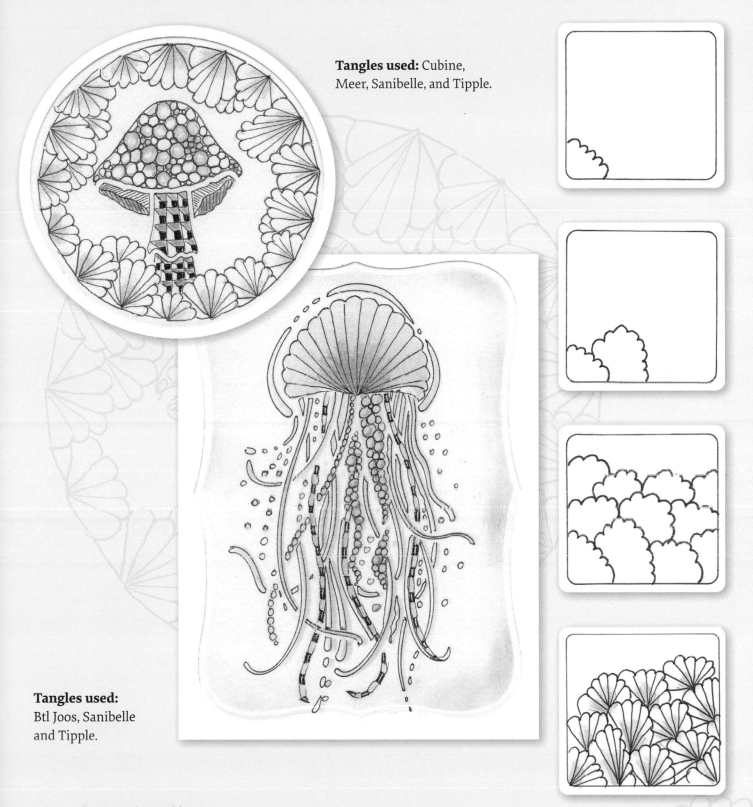

Tangles used: Cubine, Meer, Sanibelle, and Tipple.

Tangles used: Btl Joos, Sanibelle and Tipple.

Sanibelle

TRICIA FARAONE CZT, USA

Tricia comes from Rhode Island and the beautiful Sanibelle Beach inspired her to do this tangle. It is featured in June's seahorse Zendala on p.88 and I have used it here in Jelly Fish and Toadstool stencils by Dreamweaver.

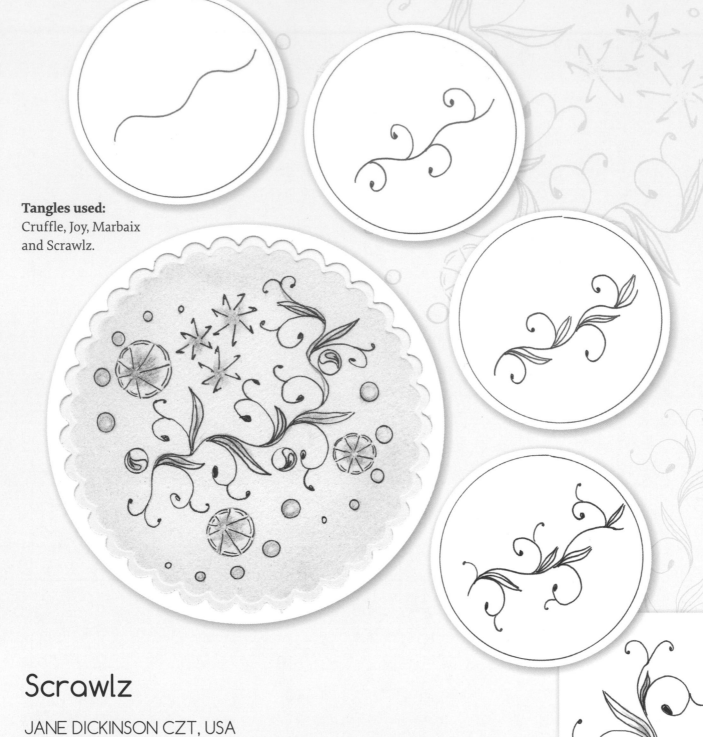

Tangles used:
Cruffle, Joy, Marbaix
and Scrawlz.

Scrawlz

JANE DICKINSON CZT, USA

Jane says: "I have been a CZT since 2010. As with so many people, Zentangle
entered my life at a very difficult time, exactly when I needed a haven of
simplicity and calm. Meeting the founders, Rick Roberts and Maria Thomas,
revealed why Zentangle is the accessible, unpretentious, lovely artform
that it is. Zentangle continues to guide both my daily and life decisions and
through it I have connected with some amazing people who have discovered
the extraordinary in themselves."

 Jane's account explains what Zentangle means to so many people. I found
Scrawlz to be such a pretty tangle to do and I love the simplicity of it. It
would make a delightful border or embellishment on a greetings card.

Shattuck

A ZENTANGLE® ORIGINAL

Shattuck looks a little complicated, but you just need to follow the step-out carefully. You will find this tangle often fills a gap somewhere in your designs.

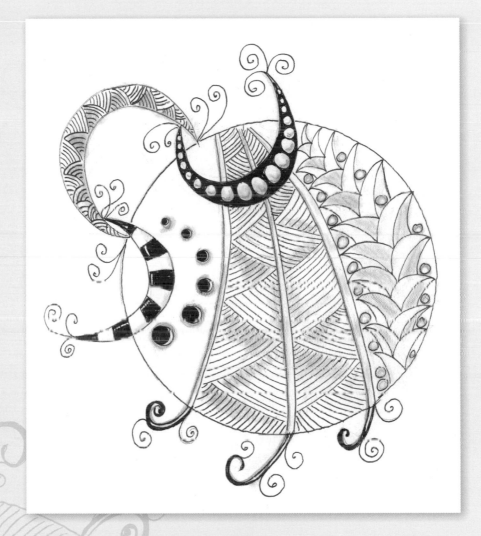

Tangles used: Btl Joos, Dooleedo variation, Linq, Shattuck, and Tipple variation.

Showgirl

VICKI BASSETT, USA

This is a lovely flowery tangle, starting in the middle and working outwards.

Have a look at Rita Nikolajeva's Zendalas on pp.59–61 and you will see it done perfectly. Here I have used the seahorse stencil by Dreamweaver, adding a little color and applying some Black Sparkle Gelly Roll pen on Showgirl.

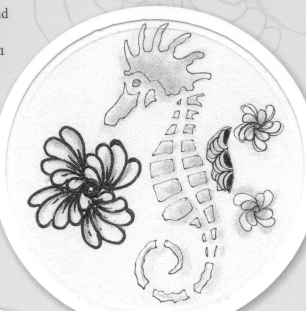

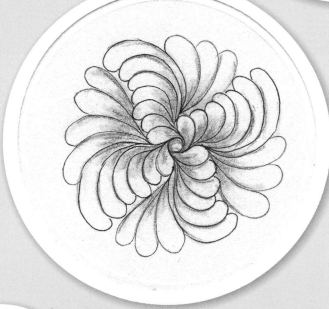

Tangles used:
Crescent Moon and Showgirl.

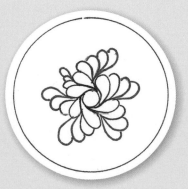

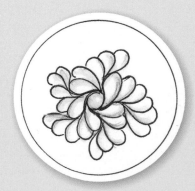

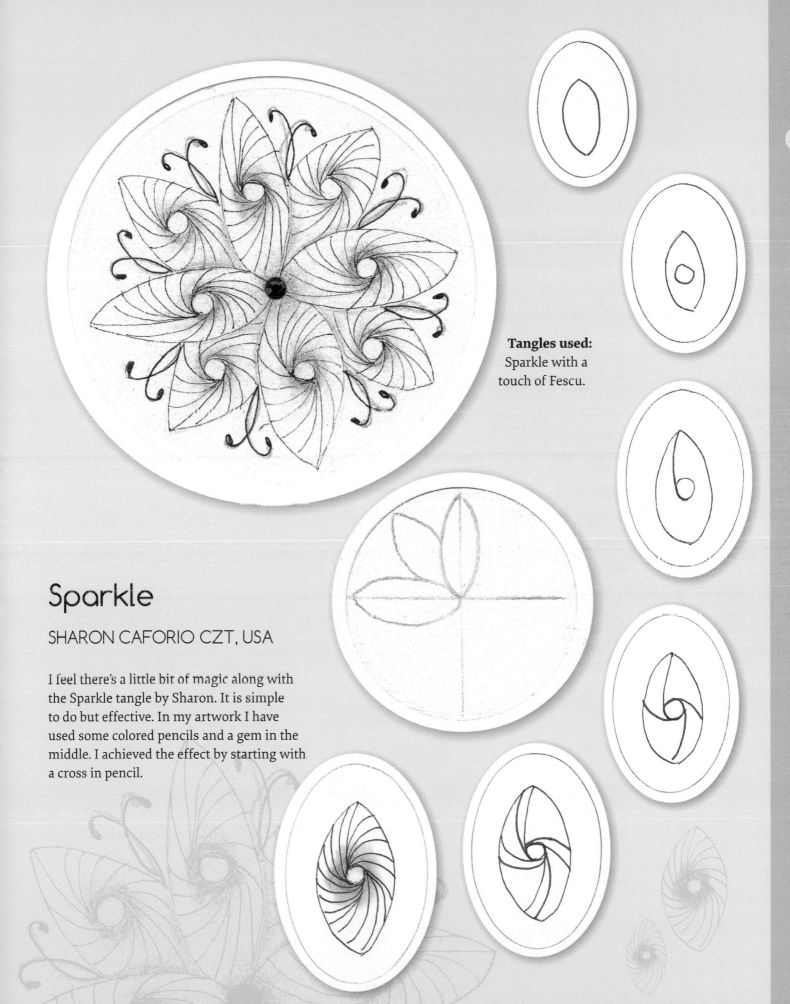

Tangles used:
Sparkle with a
touch of Fescu.

Sparkle

SHARON CAFORIO CZT, USA

I feel there's a little bit of magic along with
the Sparkle tangle by Sharon. It is simple
to do but effective. In my artwork I have
used some colored pencils and a gem in the
middle. I achieved the effect by starting with
a cross in pencil.

Static

ZENTANGLE® ORIGINAL

Static can be created with either a straight zig-zag or a curvy one. The straight one is easier to shade and quite a lot of care has to be taken with the curvy one. Two types of shading are shown here.

Tangles used: Straight line Static, Tipple, and Keeko.

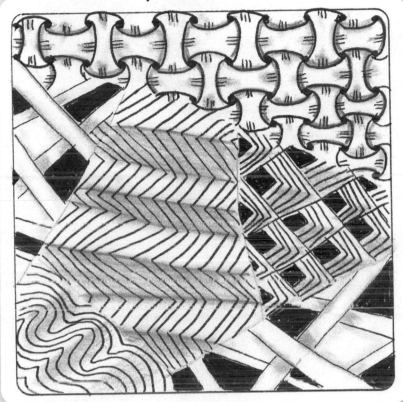

Tangles used: Flukes, Huggins, Hollibaugh, and straight line and curvy Static.

Steps

HELEN WILLIAMS CZT, AUSTRALIA
http://alittlelime.blogspot.co.uk

You can have lots of fun with this one and I have shown
three different ways of doing it. The first is a straight
line with straight lines added; the second is a curvy line
with straight lines added and the third is a curvy line
with curvy pattern added. Look at Helen's blog for lots of
other ideas.

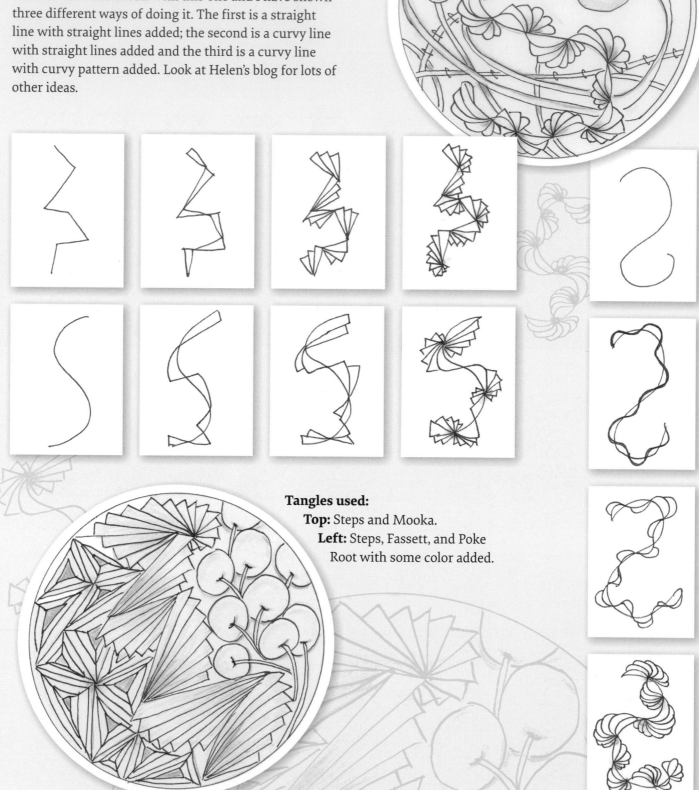

Tangles used:
Top: Steps and Mooka.
Left: Steps, Fassett, and Poke
Root with some color added.

Ta-da

MARGARET McKERIHAN, AUSTRALIA

An easy tangle, Ta-da is a good one for variations. I have done a simple heart shape and filled in the background around the oval shapes. It is very simple, with just Ta-da used.

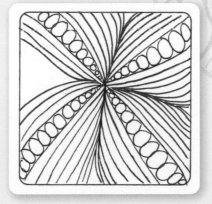

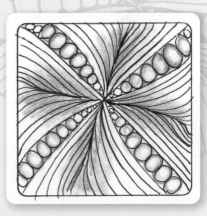

Tagh

ZENTANGLE® ORIGINAL

This is a popular tangle, though I haven't used it a
great deal myself. To see it created perfectly, look at
Wayne Harlow's fairy wings on p.57.

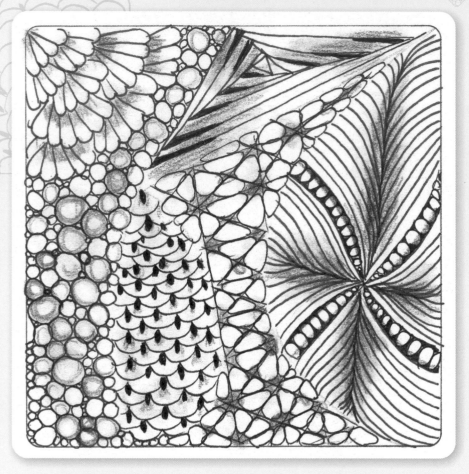

Tangles used: Sanibelle, Tipple, Paradox,
Tagh, 'NZeppel, and Ta-da.

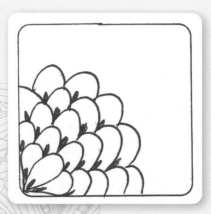

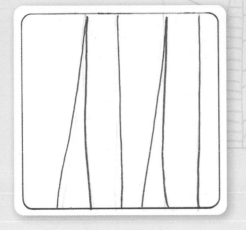

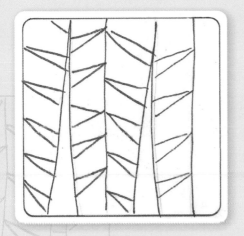

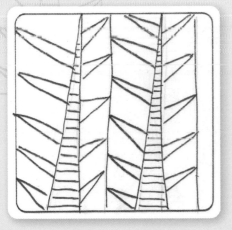

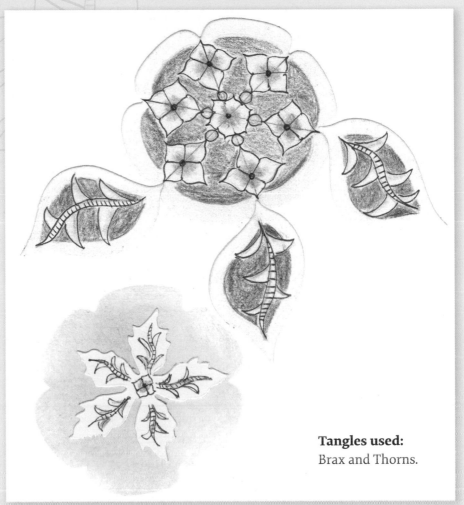

Tangles used:
Brax and Thorns.

Thorns

SUZANNE MCNEILL CZT, USA

This pattern is from Suzanne's book *Zentangle 7*, which has many inspiring designs. As you can see, the tangle can be drawn with straight or curvy stems.

Tangles used:
Cruffle and
Whirlee.

Whirlee

LYNN MEAD CZT, USA

Whirlee is named with the seedpods of the sycamore tree in mind. It is fun to play around with. The first Zendala is done by dividing the decagon in pencil from corner to corner and then doing Whirlee in a circle, all in the same direction.

Tangles used:
Whirlee back to back, filled
in with Flux and Fassett in
between.

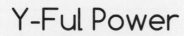

Y-Ful Power

SHOSHI, UK
shoshiplatypus.co.uk

I "met" Shoshi (real name Sue) online and have been corresponding with her for a while. A truly inspirational person, she has had a traumatic time with her health and has taken to Zentangle in a big way, finding it has helped her through a very difficult time (see pp.68–9).

I did not find this one easy, but I discovered that starting with a pencil grid helped me to do the step-out as it needs to be fairly uniform to start with before you start experimenting.

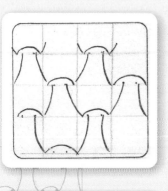

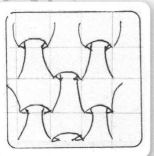

On my tile I have just used Y-Ful Power with a little Crescent Moon. It is encased in Abundies with a little Flux at the bottom.

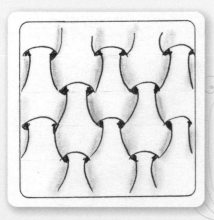

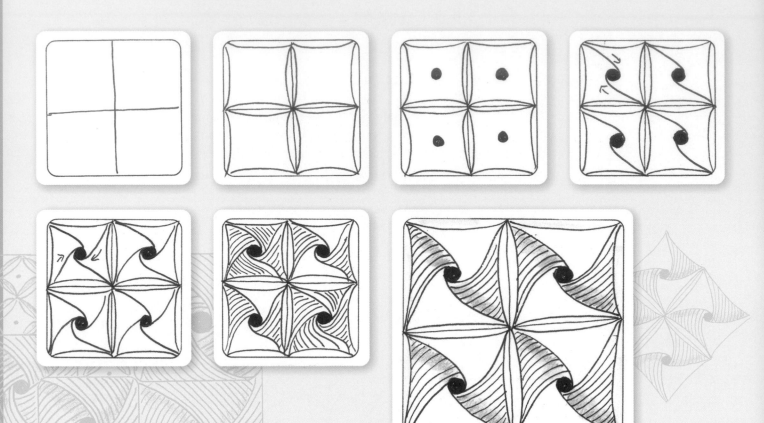

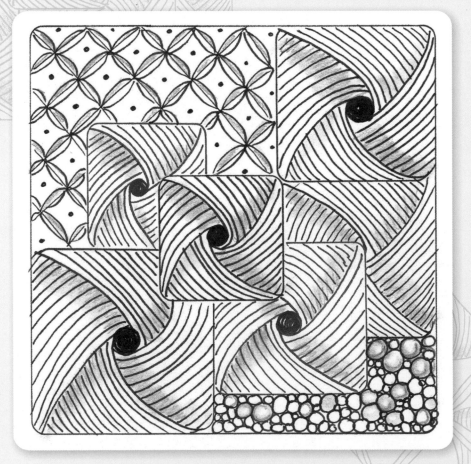

Yew-dee

PEG FARMER CZT, USA

This is one of those very satisfying patterns when you look at the results. It can be varied very easily. In my example I have made a black and red tile using only Yew-dee, Bales, and Tipple.

Zander

A ZENTANGLE® ORIGINAL

I use Zander a lot, as it is a good tangle for running through a larger design. I like to curve the bottom and top lines to make it look as though the bands are tightened around the stem. I have left highlights in the middle to give a rounded effect and added shading on one side of the band. In the artwork, I drew the other tangles in the spaces created by Hollibaugh.

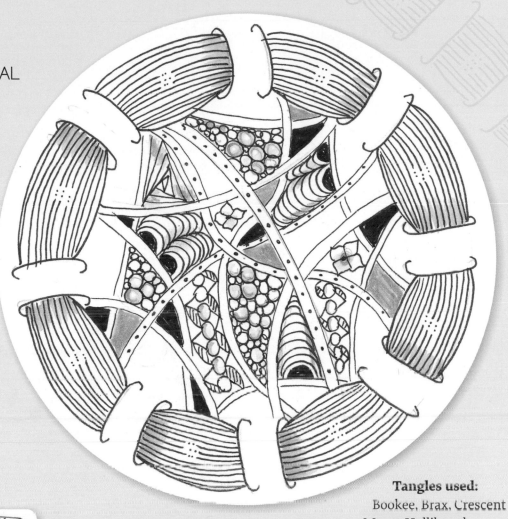

Tangles used:
Bookee, Brax, Crescent Moon, Hollibaugh, Paradox, Tipple, and Zander.

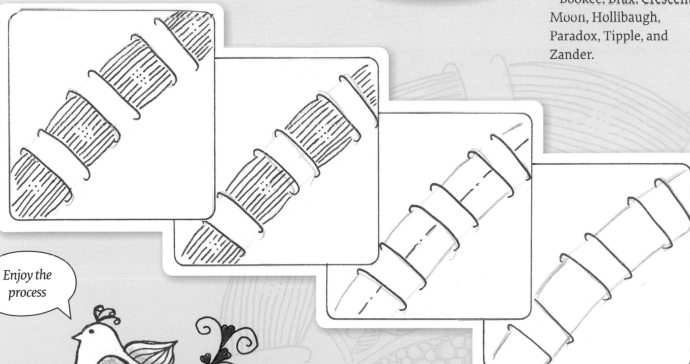

Enjoy the process

Zenith

ZENTANGLE® ORIGINAL

This tangle was created for one of the training seminars in Providence, Rhode Island that Rick and Maria run for future CZTs. I really like it as it makes a lovely border or a pattern running through a ZIA.

In this illustration I created a random string and then filled in the shapes with various patterns. I have used Zenith in two different ways that look quite different, adding some black contrast for effect. I like this ZIA from all angles.

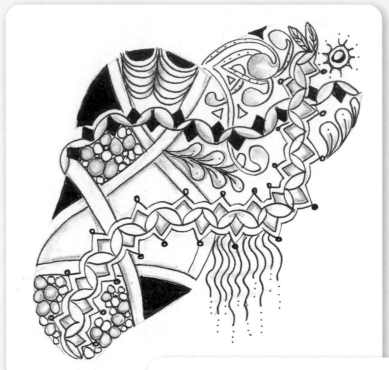

Tangles used:
Crescent Moon, Mooka, Widget, Flux, Msst, Zenith, Hollibaugh, and Tipple.